THE MAN IN THE
HIGH CASTLE

THE MAN IN THE HIGH CASTLE
CREATING THE ALT WORLD

ISBN: 9781789092608

Published by Titan Books
A division of Titan Publishing Group Ltd.
144 Southwark St.
London
SE1 0UP

FIRST EDITION: DECEMBER 2019
1 3 5 7 9 10 8 6 4 2

DID YOU ENJOY THIS BOOK?

We love to hear from our readers. Please e-mail us at:
readerfeedback@titanemail.com or write to Reader Feedback
at the above address.

To receive advance information, news, competitions,
and exclusive offers online, please sign up for the Titan newsletter
on our website: www.titanbooks.com

**While wanting the show to be true to the concept,
and history, of the original work, we respect, in this book,
the legal and ethical responsibility of not perpetuating the
distribution of the symbols of oppression.**

THE MAN IN THE
HIGH CASTLE

CREATING THE ALT WORLD

TITAN BOOKS

CONTENTS

THE GREATER NAZI REICH 112

ALTERNATE WORLDS 176

ACKNOWLEDGMENTS 192

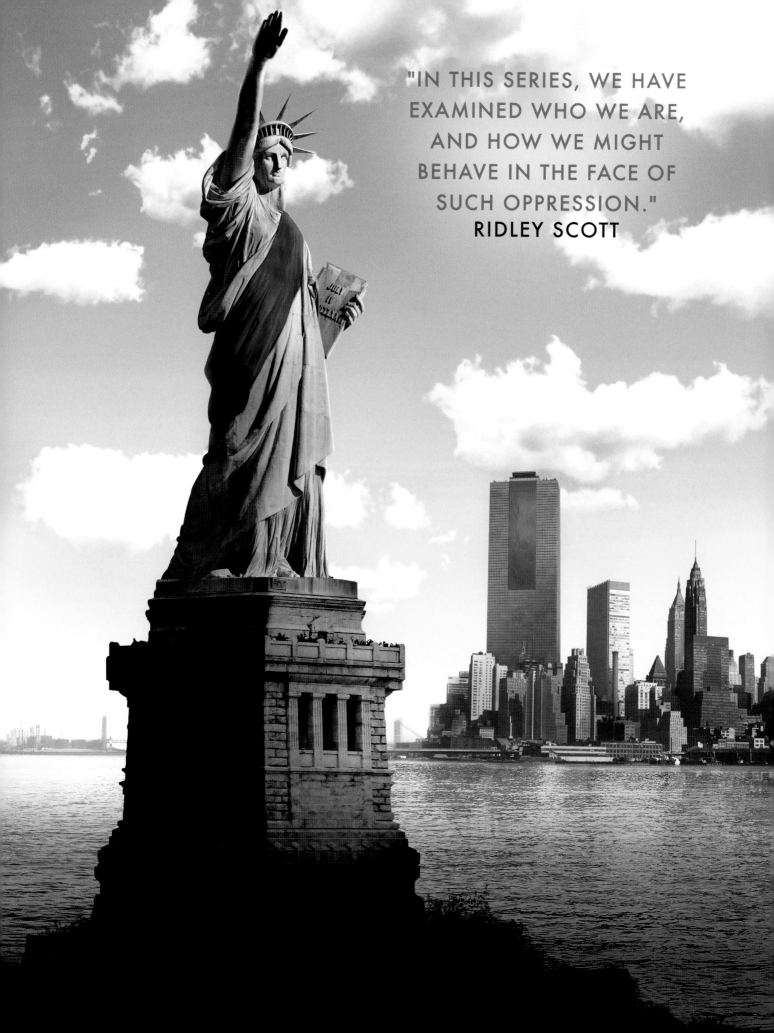

"IN THIS SERIES, WE HAVE EXAMINED WHO WE ARE, AND HOW WE MIGHT BEHAVE IN THE FACE OF SUCH OPPRESSION."
RIDLEY SCOTT

RIDLEY SCOTT

Do Androids Dream of Electric Sheep? was a challenging multi-layered glimpse into a dystopian future of majestic evolution but portraying a society also in decline and decay.

What emerged was the film *Blade Runner* with its engineered creatures known as replicants, and their story laid bare the question: "What does it mean to be human?"

These grand ideas were a fantasy at the time, but thirty years on, and bioscience has advanced so rapidly – all the possibilities of human replication are now!

Philip K. Dick was an author of extreme ideas, and *The Man in the High Castle* poses another idea that was most certainly a possibility fifty-five years ago! The Nazi invasion was just twenty-one miles from the United Kingdom's coastline until the allies prevailed, and war was finally over. This present generation does not grasp that possibility which is now seen as *distant* history. Documentaries and books can dilute the events as something of the *distant* past – putting that into perspective through my experiences.

I lived in Germany between 1947 and 1952, a child of Colonel Francis Scott. We lived in a Nazi's house in the American zone in Frankfurt, and this story is still very real and vivid to me.

Our story poses the diverse question. What if the Nazi and Japanese union prevailed, and the world was taken over by the doctrines of authoritarianism, anti-Semitism, and racial outrage? Would this have continued? The answer is most certainly yes, and is already showing itself in many cultures today.

Already, United States and Germany both have far-right extremist groups blossoming in underground organizations.

In this series, we have examined who we are, and how we might behave in the face of such oppression. Some part of us may join into the 'New Order,' and others may react as underground resistance.

We see into the 'normality' of Nazi leaders and their home life, how they might enjoy the best of what our society offers. The Nazi movement was very advanced and industrialized in technology, science, design, music, art, and intellectual propaganda. We reproduced this with great attention to detail.

Under any extreme condition, there is always resistance, and people who 'dare' we call 'HEROES.'

Our heroes are Juliana Crain whose passion is to take down the Nazi Reich. Frank Frink's artist/partisan and his underground journey. Tagomi's obsession to end Japanese occupation of the West Coast and to bring peace back to the land that was known once as the United States of America.

'Flowers into concrete' is often used to describe the American spirit that insists on freedom over all injustices and totalitarianism. Anywhere. Anytime.

I hope you Enjoy and Engage,

THIS SPREAD: Season one promotional poster (left). Executive producer Ridley Scott (below).

INTRODUCTION

How do you bring to life history's worst nightmare? That was the challenge facing the creators of *The Man in the High Castle*, the Amazon Studios television adaptation of Philip K. Dick's classic novel. The book won the Hugo Award in 1962 for Best Novel for its unsettling and philosophical portrayal of an alternative history where Nazi Germany and Imperial Japan emerged victorious in World War II. In the years since, *The Man in the High Castle*'s influence has continued to grow. Dick's harrowing story has come to define alternate-timeline fiction, asking one of mankind's most frightening questions and providing provocative answers that leave the reader with much to decipher.

The Man in the High Castle debuted on January 15, 2015 and became the most-viewed pilot in Amazon Studios history. Over its four-season run, it has captivated fans with its dark themes, complex characters, and textured world building. Set fifteen years after the Allies surrendered, with the planet now under German and Japanese rule, *The Man in the High Castle* offers a pensive look at a very different post-war America.

Dick's daughter, Isa Dick Hackett, who oversees the Philip

BELOW: Isa Dick Hackett and Stephen Root after filming the series finale.

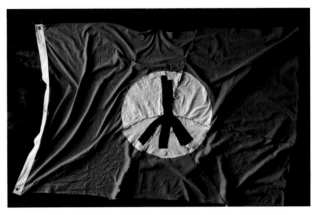

ABOVE (clockwise from left): A map of the fascist states in the alternate world, a prop department bike from on set, the season three promotional flag.

K. Dick Estate and Electric Shepherd Productions, and is an executive producer on *The Man in the High Castle*, knew her father's book was not the type of story that makes for a by-the-book adaptation. The alt-history plot provides the overall theme, but the novel is far from a straightforward tale. There are more than a dozen plot strands woven throughout, many of them open-ended with little overlap. While maintaining the same central thrust of the novel was never in question, extrapolations and liberties would need to be taken if the book was going to succeed as an ongoing series.

"It's a very unconventional structure, which wouldn't lend itself directly to straight adaptation," Hackett points out. "There had to be an engine. There had to be a story moving us through. We didn't want it to become [just] an action show driven by the desires of the characters to take the country back in a literal way and restore it to what we would imagine it should be."

That storytelling engine would be assembled around four main characters: Juliana Crain, Obergruppenfuhrer John Smith, Trade Minister Noriyuki Tagomi, and Kempeitai Chief Inspector Takeshi Kido. These characters, in tandem with the others in the sprawling cast, slowly interconnect during the course of the series. Much as they are in the book, Juliana and Tagomi are central figures on the show. But unlike in the novel, they become closely linked in the TV adaptation as the mystery of the alt-worlds at the heart of the *High Castle* story unspools.

The book's various and seemingly unrelated storylines were dictated in part by the distaste Hackett's father found in constructing a world in which the Reich was the dominant power. "The setting is primarily San Francisco and the Neutral Zone," says Hackett. "There's a reason he didn't invest as much in the Nazi side of things. The research alone so disturbed him, there was no real desire to dwell in that narrative space."

Hackett says her father's goal was not to write a story simply about good versus evil. Dick had once said, "The enemy is fascism wherever it exists," and his book was, in many ways, a warning. "At its core, it's an anti-fascist novel," Hackett says. "And the ways in which people resist in the novel are slightly different than what we see in the show. We intentionally avoided an endpoint of full resolution of the central conceit. We felt that there was a lot of potent story in just depicting that conflict between the fascist forces and not trying to sugar-coat things."

Translating *The Man in the High Castle* to another medium proved a long, arduous process. It took nearly a decade to bring the project to life as well as a not-inconsequential amount of elasticity from the producers. As the caretaker of the Philip K. Dick estate and its vast library of influential works, Hackett was committed to finding the right partners to help realize her father's creative vision. At first, that vision involved a theatrical release.

"Television series were not nearly as bold and inventive back then as they are now," Hackett explains. "Obviously the story is perfectly suited for television. But originally, it was always the plan to make a feature film. And there were a number of high profile filmmakers who were interested in doing it at the time."

In 2007, during the promotional work for the twenty-fifth anniversary and release of the final cut of *Blade Runner*, Ridley Scott mentioned his interest in *Man in the High Castle* to Isa Dick Hackett. The filmmaker's 1982 dystopian classic, *Blade Runner*, was based on Dick's novel, *Do Androids Dream of Electric Sheep?* Scott also happened to be a big fan of the original novel, and was eager to get involved, according to Hackett. "He'd loved *The Man in the High Castle* for a long time. We could only hope on *High Castle* to have anything close to the legacy in television that *Blade Runner* has in film. I'm eternally grateful that Ridley decided to step into *High Castle* as well."

Two attempts to adapt *The Man in the High Castle* as a four-part TV miniseries, for the BBC and SYFY, never got off the ground for various developmental reasons. Then Hackett received a call from David Zucker, the head of television for Scott Free Productions, the company founded by Ridley Scott and his late brother, Tony Scott, and they discussed adapting this as a series for Amazon.

"THE ENEMY IS FASCISM WHEREVER IT EXISTS"
PHILIP K. DICK
AUTHOR

BELOW: David Zucker and Isa Dick Hackett speaking at a panel.

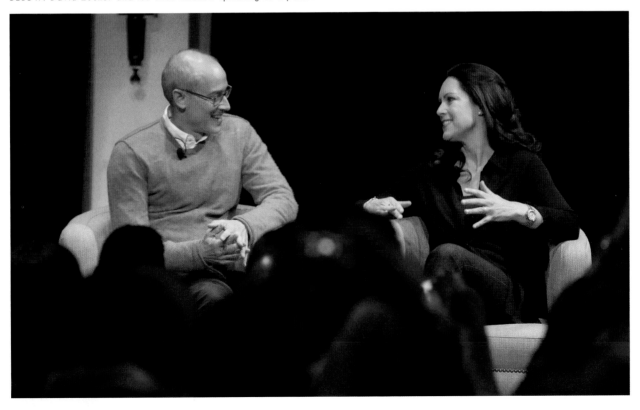

But… there was a but. Amazon's unconventional production process at the time involved committing to only filming a one-hour pilot, then making it available to the public. That way, the company could gather and assess the viewing data. It's a great opportunity for producers, but one that carries with it substantial risk. Hackett says, "My concern was that if we produced a pilot which wasn't then picked up, we'd essentially be left with an hour adaptation which would continue to be available to viewers and might interfere with my ability to adapt it as a feature."

Several factors helped Hackett make up her mind. "One, the synergy of working with Amazon and having a built-in audience of quite a few readers was really attractive," she says. "And two, because they were really just ramping up, it felt like a great opportunity to be a big fish in a small pond at that time."

Frank Spotnitz was the other key member of the *High Castle* team. Spotnitz is a veteran Peabody Award-winning writer/producer who wrote dozens of episodes for *The X-Files* and co-wrote and produced the two feature film spinoffs.

He spent years working alongside Scott Free and Electric Shepherd Productions to adapt *The Man in the High Castle* for television, beginning with the adaptation attempt for SYFY. Spotnitz was the executive producer for the first three seasons and scripted the first two episodes of the series. "I think Frank was able to conceive fundamentally how these alternative universes, that we ended up exploring from season two onward, would really come to rise in this world," says executive producer David Zucker. "It required an intellect and a creative vision that I don't think many writers could have seized upon."

Hackett would like to think the current Golden Age of television would have pleased her father. "There is something very special about the opportunity to create a world and then be able to live in that world and with its characters. I do think he would appreciate the narrative opportunities, especially for this sort of non-conventional storytelling. There's something really satisfying about that and I do think he would appreciate that," Hackett says. "And as long as it's consistent, of course,

BELOW (clockwise from top left): Actors' chairs on set for Juliana and Joe, Frank Spotnitz in Tagomi's office, Takeshi and John's actor chairs, Alexa Davalos and Isa Dick Hackett behind the scenes.

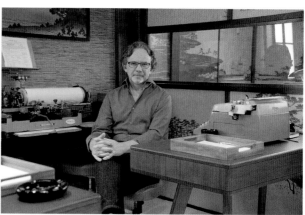

ABOVE: Isa Dick Hackett and Stephen Root on the Die Nebenwelt set.

with the spiritual intent of the novel, which our show is, then I think he'd think it was terrific."

As the person who oversees the publishing rights to her father's library, Hackett has seen the TV series have a direct impact on book sales. "During the first season, *The Man in the High Castle* made the New York Times best sellers' list and that never happened in his lifetime – and certainly didn't when the novel was first released [in 1962], so that's the power of this medium in terms of its impact on the exposure of the literature. For that reason alone, I think he would have been proud."

Nearly forty years since his untimely death, Philip K. Dick remains a powerhouse influencer in pop culture. His ruminations on futurism and mankind's uneasy relationship with technology are irresistible to Hollywood producers. More than a dozen films based on Dick's stories have been released in theaters since 1982, with several others currently in various stages of production. *The Man in the High Castle* represents, by far, the most successful television adaptation of a Philip K. Dick work to date.

BELOW: Alexa Davalos in an emotional goodbye in the first season (left). Cary-Hiroyuki Tagawa filming a traveling scene (right).

JAPANESE
PACIFIC
STATES

POPULATION: 50 MILLION

AREA OF INTEREST: SAN FRANCISCO

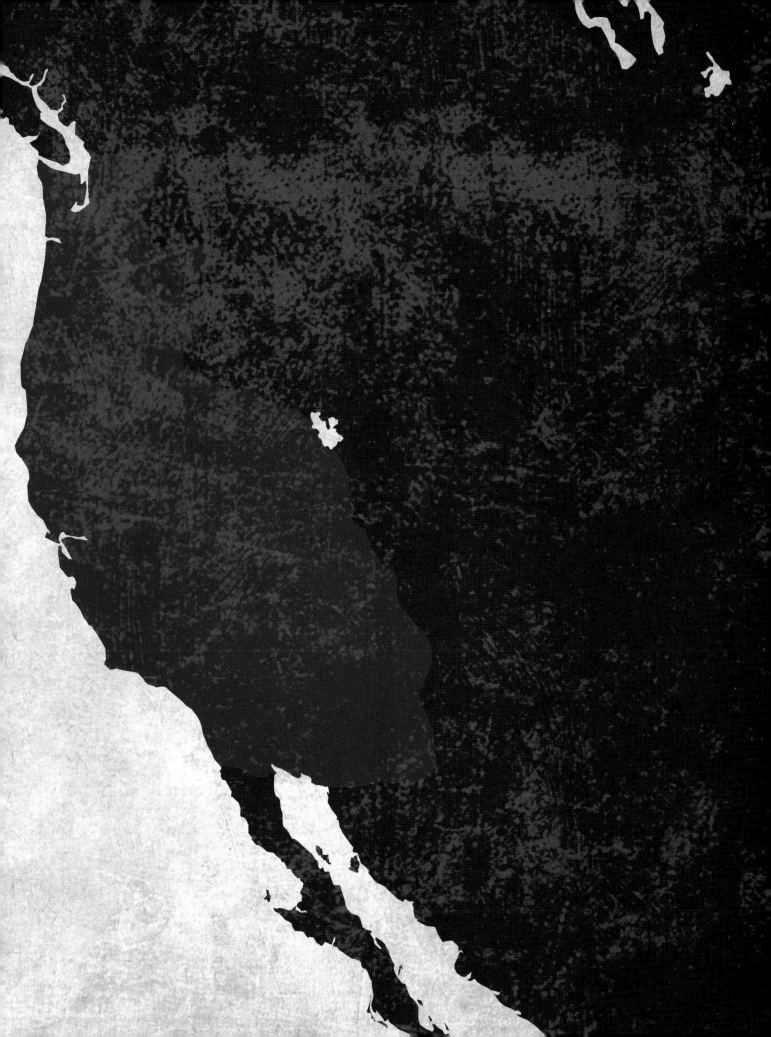

EDELWEISS:
THE OPENING TITLE
SEQUENCE

The opening title credits set the tone for *The Man in the High Castle*. Created by Patrick Clair of the design firm Elastic, the sequence juxtaposes film-projected imagery of paratroopers against Mount Rushmore and Nazi rocket ships with the Statue of Liberty, providing a summation that walks the viewer right into the story. "We used the title sequence to help tell the story that the show itself isn't telling," explains Dan Percival. "It helps set the stage. The *High Castle* title sequence does that very well in showing the Reich becoming a superpower."

The opening credits evolved each season. The season two version includes shots of the Golden Gate Bridge and Japanese war planes – better representation of the bi-coastal nature of the series' main plot. "We always felt the original title sequence was heavily skewed toward the Nazi part of the story, so we wanted to rebalance it with imagery from the Japanese states and tell the story of both coasts," says Percival.

By including shots of a destroyed Washington D.C. as well as the Volkshalle dome in Berlin, the audience gained more insight into how America was defeated, without a single word of dialogue.

And then there's that haunting rendition of the Rodgers and Hammerstein's song 'Edelweiss,' performed by singer Jeannette Olssen. The dissonance of hearing a staple from *The Sound of Music* as the soundtrack to the rise of the Reich was intentional, according to composer Dominic Lewis. "It's this lovely, sweet song, and we offset it and made it very weird and unsettling and horrible," he says.

"That's the whole point, that on the surface it seems quite normal. Then you get sucked into it, the strings come in and it just feels super unnerving, weird, and creepy. To me, that's how the music on this show should feel like. Familiar, and then taken in a dark direction."

THIS SPREAD: The title sequence features historical landmarks plus a snapshot of an alternate map.

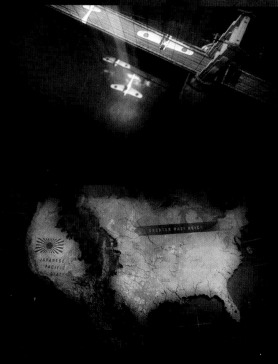

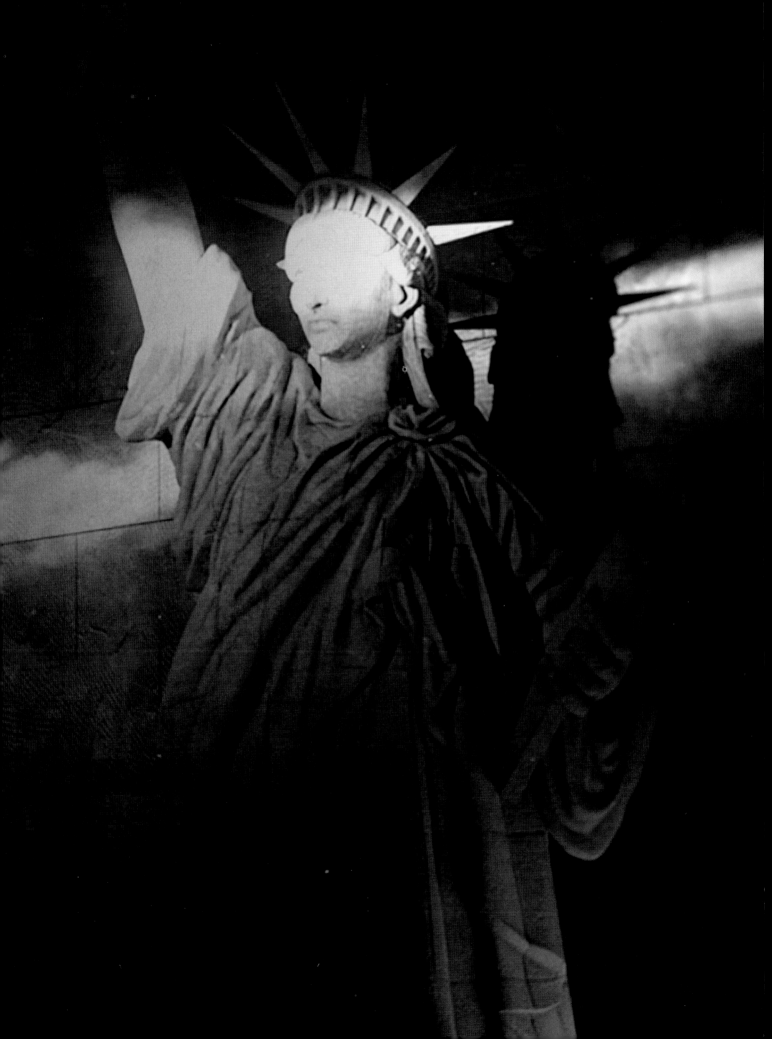

SAN FRANCISCO

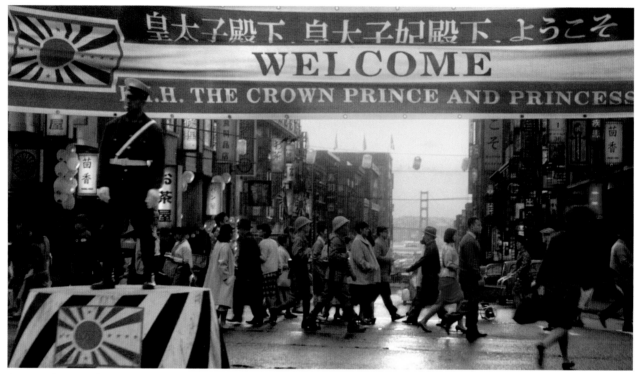

ABOVE: The city of San Francisco prepares for the arrival of the Crown Prince and Princess.

In creating the aesthetic for this crucial city in the High Castle world, production designer Drew Boughton hit the books to manufacture their own spin on history. "We looked at vast amounts of World War II images and reference material. That led us to figuring out what was quintessentially American in the postwar period, and avoiding or removing that from the world, and then trying to predict what would have been quintessentially fascist Germany and fascist Japan's world building ideas."

Run-down vehicles, rickshaws, and dense, crowded streets suggest an empire in decline. Buildings such as the Nippon government building have none of the sheen or sleek architectural design seen in the American Reich. Mired in a tense Cold War with the Nazis, Japan has fallen behind due to stalled technological progress and reliance on German-controlled oil pipelines. There is a cultural stagnation since the end of the war that makes the San Francisco of this world vastly different from the counter-culture hub it was becoming in ours.

Different color palettes were used to help identify key show locations, using the actual colors of objects, wardrobe, and vehicles. "We did an incredible amount of research to get a feel for that time period, and the elements we needed to incorporate," says prop master Dean Barker.

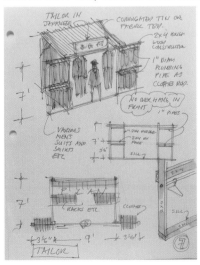

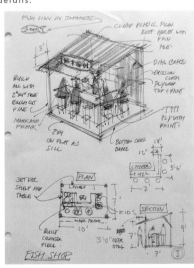

TOP: An early concept sketch of the busy streets of San Francisco.

ABOVE: A flower truck (left) and street food stall (right) are just two of the many physical sets.

BELOW: Three early sketches of the market stalls provide dimensions and set decoration details.

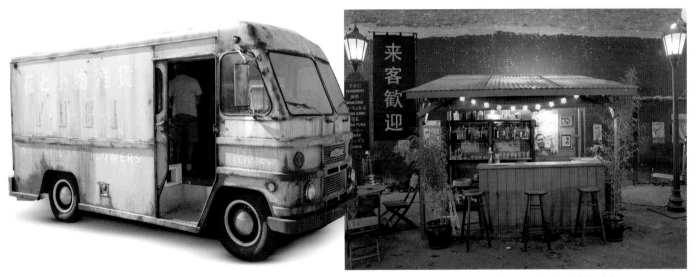

THIS PAGE: The set decoration for San Francisco included the creation of numerous alternate world adverts and posters.

"It's a difficult city to recreate. The specific architecture of San Francisco is a difficult thing to find anywhere else," says location manager Paul Russell. "But Vancouver and San Francisco are more similar than you would think. You've got the hills, you've got the geography, and you've got the Bay and the water." Computer-generated imagery was used to complete the San Francisco replication. That would involve filming the narrow streets and cobblestones of Vancouver's Chinatown area to provide the framework, with the visual effects layers added in postproduction to complete the picture of San Francisco.

One of the show's impactful moments set in San Francisco was the burning monk sequence in 'Sabra.' An oil-shortage protest leads to a monk setting himself on fire. It was inspired by the real-life self-immolation of Thich Quang Duc in Saigon in 1963, in protest over the South Vietnamese Diem regime. That was no visual effects trickery. Stunt coordinator Jeff Aro was actually set on fire by his wife, fellow stunt coordinator Maja Aro.

"I did. I lit him on fire," Maja Aro says. "Those sort of stunts, they don't come around every day. We pitched hard to the studio that we wanted to do it practically, that it would look more real, more visceral."

Jeff Aro wore fire-protectant clothing underneath the monk robe, and had his bare skin covered with a quarter-inch layer of a protective gel to guard against the flames. The scene – which lasted ten seconds – was captured on the first take. For the stunt couple, it was a risk that paid off. "From what I've heard from people that have watched it, it had that impact," Aro says, "which is exactly what we wanted to achieve. We wanted the audience to have that personal connection with what they saw."

Another scene inspired by real life events was the unexploded bomb discovered by the resistance below a San Francisco restaurant in 'Escalation.' "The writers room was based in London then," explains writer Wesley Strick. "We would order out for lunch every day from restaurants in Spitalfields Market. One day we were waiting and waiting and there was no sign of lunch. We called the restaurant, and turns out they found an unexploded World War II ordinance buried underground. So we all suddenly had a eureka moment in the writers room, and realized that in our San Francisco, they could easily have found an unexploded Japanese bomb. And it all came from a bunch of angry writers who were hungry. That was really the basis of the whole episode."

BELOW: Stunt coordinators Jeff and Maja Aro filming the protesting monk scene.

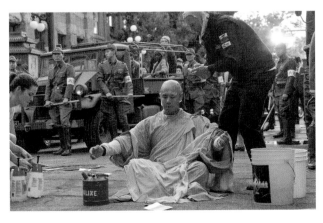

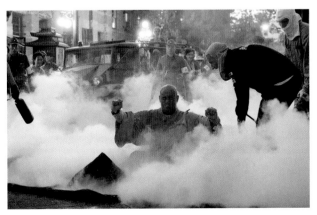

EVERYDAY WEST COAST AMERICA WARDROBE

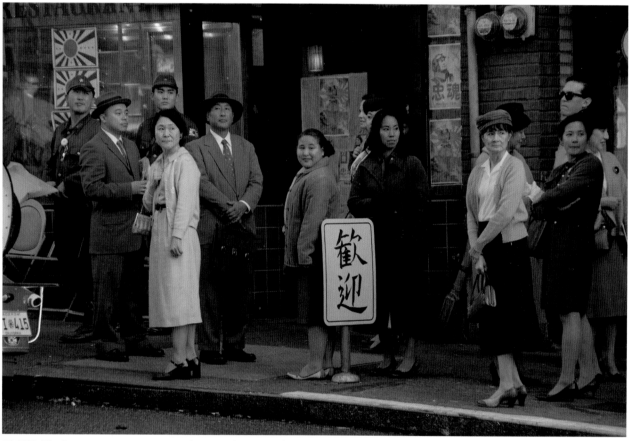

ABOVE: The busy street scenes required a period costume for every background character.

When formulating the style guide for the series, costume designer Audrey Fisher did not want to lean too far into the elaborate choices sometimes seen in works of science fiction. "For this show, it was all about conformity and a strong silhouette that's recognizable," notes Fisher. Following the color palette aesthetic used to identify each of the show's major regions, Fisher and her team determined the textures and fabrics that would be worn by the people residing in San Francisco.

Catherine Adair, who joined as costume designer in season three, wanted the clothes of the West Coast to exemplify the strong influence the Japanese occupation had on the residents in that city. "We blended Japanese fashion with American fashion and design just after the war to create a lot of our looks," Adair says, explaining why kimonos were commonly worn in the region.

The clothes worn on the West Coast are more plain and muted, with earthier colors. To reflect the depressed state of

the economy in the Japanese Pacific States, most of the people there wore clothing – long baggy skirts and layered sweater looks – that reflected the working-class status representing the majority of citizens. The exceptions to this would be government officers such as Tagomi, wealthy private citizens like the Kasouras, or Okami, the Yakuza crime boss. They were outfitted in tailored suits befitting their societal status and prosperity.

The right accessories can be hugely helpful to an actor on a period show like *The Man in the High Castle*. "For me the instrumental part of my wardrobe are the glasses," says Joel de la Fuente, who portrays Kido. "They're vintage, one-of-a-kind glasses found for the pilot by Audrey Fisher, our initial costume designer."

De la Fuente had to convince Frank Spotnitz to not ditch the glasses over fears of regurgitating old stereotypes of bespectacled Japanese soldiers. "While we were shooting the pilot, I said, 'Frank listen. I'm all for not having a stereotypical character. But I think we need these. Once I put those glasses on, it changes the way I hold my face. It's like putting on a mask in a weird way. I need those glasses to give me permission to do the things that I have to do in this part.'"

BELOW: A small snapshot of the wide variety of West Coast costumes.

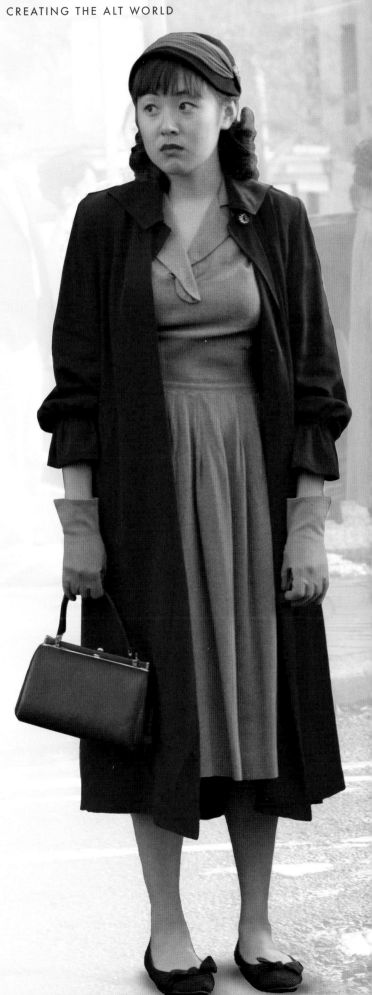

23

JULIANA CRAIN

Before she agreed to play Juliana Crain, Alexa Davalos was ready for an extended break from acting. But when she received the script for *The Man in the High Castle*, there was no turning back. "It just had me," she says.

The actress was familiar with Philip K. Dick's novel. "I was already intrigued and then I read the first script," she recalls, "and… there was no way to ignore it. I tried. I really did."

Davalos felt an immediate kinship with Juliana. Over time, she would become incredibly protective of her character, in part because she had an idea of where she could, and should, go. "Who she is in the book is ultimately who I wanted Juliana to become, but we couldn't start there," Davalos says. "I very much felt like the custodian of my character, and certainly there were other actors who were custodians of their own. And we fought like crazy to maintain that integrity."

She credits Frank Spotnitz for fostering a collaborative atmosphere that welcomed input from actors. "Frank is a rare bird. He's incredibly gracious and he puts the story before anything else. He's not somebody who is 'my way or the highway,'" Davalos says. "We had some really fascinating little shifts and changes that we were able to do together, and he was the first person to say, 'You know what, that's a better idea, let's do that.' He was incredibly collaborative, and I know this project meant a lot to him."

From the moment in the show's pilot her sister Trudy gave her the film canister labeled *The Grasshopper Lies Heavy*, Juliana became the fulcrum of the world in *The Man in the High Castle*.

She connected with Nazi agent Joe Blake in the Neutral Zone. After saving Blake's life – and putting herself in the crosshairs of the resistance for that action – Juliana was forced to kill him in one of the show's most shocking moments. What is seen onscreen is eerily similar to the events in the source novel. Recognizing the importance of the scene, the director and the producers, as well as Davalos and Luke Kleintank, all worked together to make sure this crucial turning point was properly executed. "What it wound up being is true to the book and true to the characters," Davalos says, "and I'm quite proud that we fought as hard as we did for that."

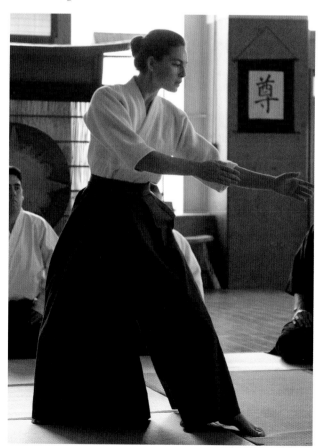

"I VERY MUCH FELT LIKE THE CUSTODIAN OF MY CHARACTER"
ALEXA DAVALOS
JULIANA CRAIN

RIGHT: Juliana practiced the art of aikido.

24

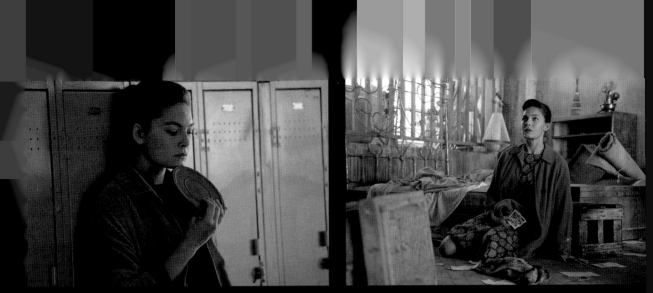

ABOVE: Stills from the first season of Juliana contemplating new information.

ARNOLD AND ANNE WALKER

Anti-Japanese sentiment runs strong among Americans living under occupation in the Japanese Pacific States. Anne Walker, Juliana Crain and Trudy Walker's mother, blames the death of Juliana's father on the Japanese. She resents that her daughter practices their "karate" (aikido). Anne's refusal to accept Trudy's death is an early hint of the spiritual connection in the High Castle world. She felt that she was alive because alt-Trudy had arrived.

Her husband Arnold Walker secretly worked as an intelligence officer for the Japanese Pacific States since 1946. When Juliana confronts Arnold about his job, he claims he swallowed his pride and did it to keep his family safe. "I did what I had to do," he says. Arnold told the Kempeitai Trudy was involved with the resistance, and thought he had helped her. He is devastated and guilt-ridden to learn she was killed due to his actions. Arnold and Anne later fled San Francisco after Juliana warned them the Germans were planning a nuclear strike.

BELOW: Arnold and Anne were urged by Juliana to leave San Francisco.

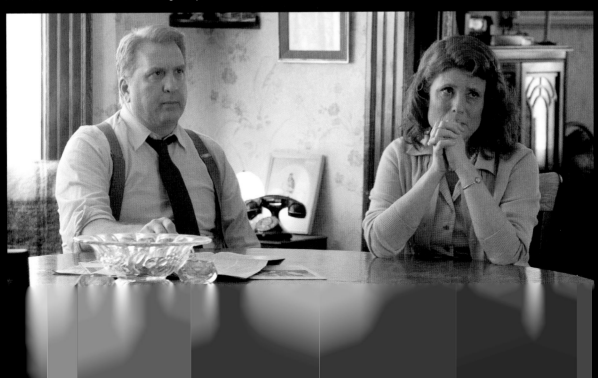

In meeting Wyatt Price, Juliana discovered her true purpose: To provide hope. Meeting Juliana inspired Wyatt to get back in the fight. In the final season, they come together again as they help lead the resistance efforts, but not in the traditional romantic way. "I think after everything she's been through and after everything she's survived and the emotional loss that she's gone through… this is a woman who cannot connect on that level. But [Juliana and Wyatt] trust one another, they are fighting the same cause, and there is an implicit trust, and that is the basis of their relationship. I think that there's something unique about that, in that I think in so many shows we see a man and woman and of course they're going to wind up together. They're a very unique duo, those two, and I think it wound up being very, very true."

Much like Juliana and Tagomi's strong connection in the series, due to their ability to travel to the alt-worlds, the actors themselves enjoyed a tight bond. "Cary and I had a really unique relationship because we just trusted each other implicitly. We knew our characters so well that there was this actual freedom in being able to just explore those scenes in character really. He was just an incredible, incredible scene partner. I so loved working with him."

Saying goodbye to Juliana Crain was not easy for Davalos. "You spend five years doing something and working with the same people, and creating this world together. It's hard to even put into words really what she means to me," she says. "I love Juliana very much. I'll miss her."

ABOVE: Alexas Davalos on location for Canon City (left). Filming an interview during season one (right).

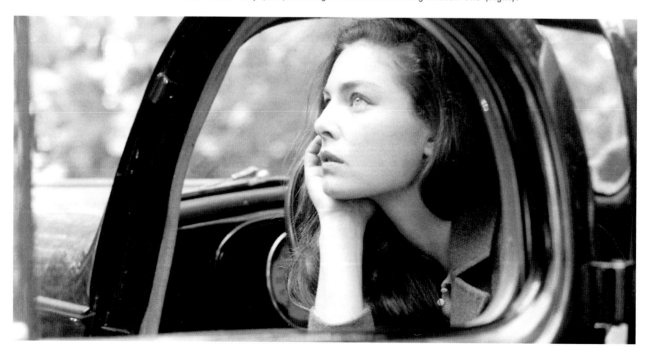

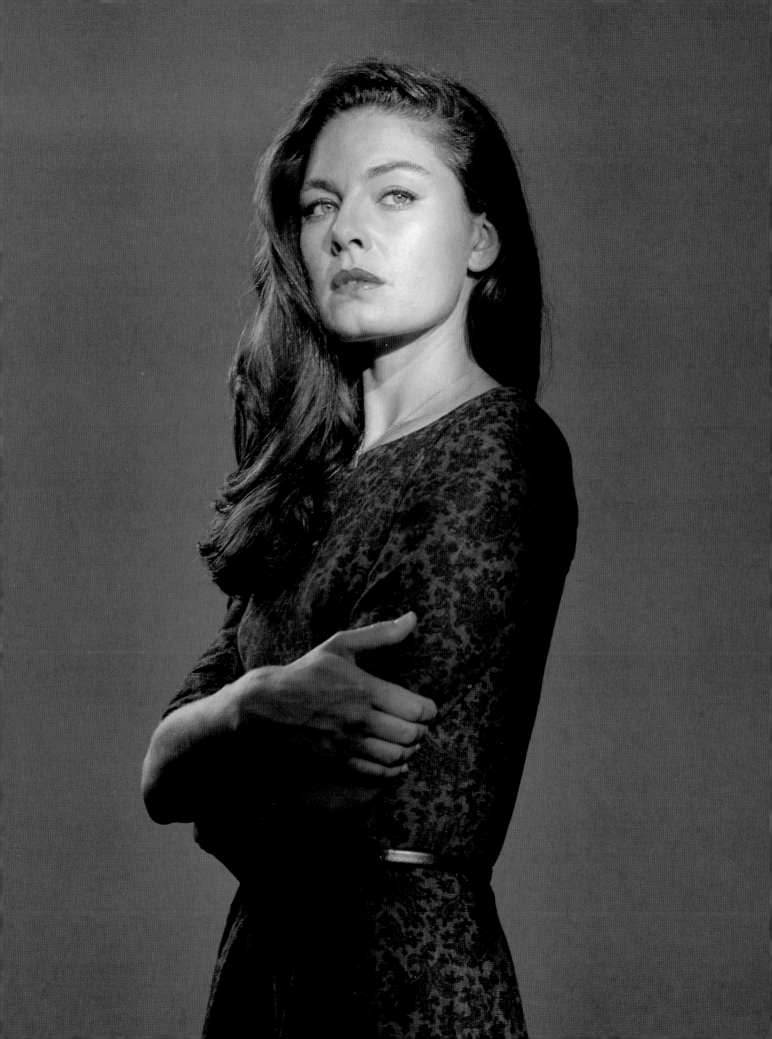

JULIANA AND FRANK'S APARTMENT

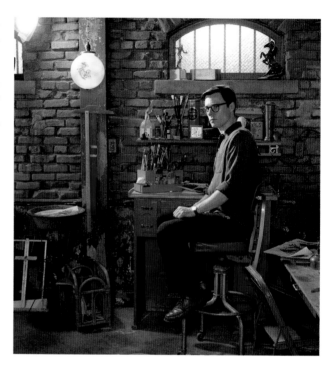

The belowground San Francisco apartment Frank Frink and Juliana Crain call home echoes the class inferiority felt by Americans in the Japanese Pacific States.

Rupert Evans found that the detail in Frank's apartment "had a lot of metaphors about his state of mind. The level of detail in the set dressing, the kitchen, the telephone, all the things in the art studio, it was a beautiful place to work in."

The apartment set was built for the pilot, shot in Seattle, and then moved to Vancouver. It would be the setting for an emotional confrontation between Frank and Juliana that both actors vividly remember. "[That scene] was such a jarring shift for the two characters and a breaking point, ultimately," says Alexa Davalos. "Nelson McCormack directed that episode, and he shot it mostly on Steadicam, which gave us full reign of the set, and it felt like a theater piece."

"That is probably one of my most special scenes and one that I will remember forever," adds Evans. "I miss that apartment."

THIS PAGE: Frank at his drawing desk (above). Juliana watching the film that would change her and her family's lives (below).

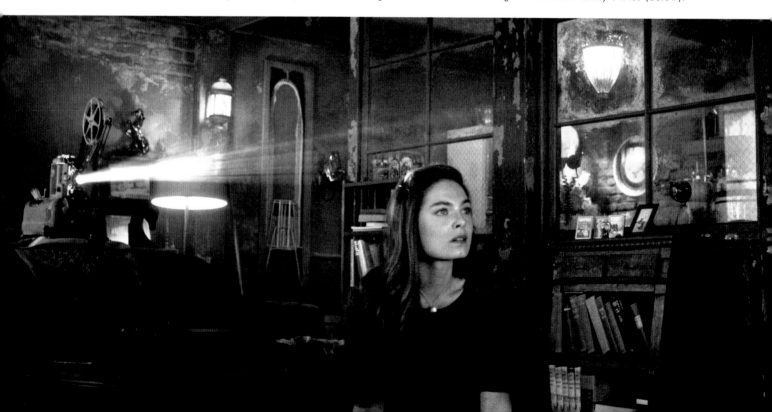

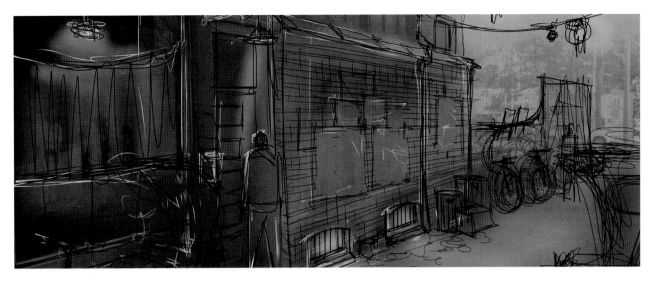

ABOVE: Concept art of the alleyway entrance to the apartment.
BELOW: The apartment was witness to many events in their lives.

FRANK FRINK

The subjugation of the Americans living on the West Coast is an undercurrent in the story of the Japanese Pacific States. The Japanese view their subjects with barely-disguised disdain. The class distinction weighs heavily on Frank, who at first seems resigned to the life he's been assigned. "He was willing to conform and be subjected to the totalitarian state that he's living in and accepting it in some way," says Rupert Evans, who portrayed Frank. "Then, it turned upside down and suddenly he finds himself."

The death of his sister and her children at the hands of Inspector Kido haunted Frank, and fundamentally changed him. The parting between Frank and Juliana only made things worse. "I think when a character experiences an extraordinary event in their life, a life-defining, life-changing event," Evans says, "you allow the character to set off on a different path for the rest of the journey of the show."

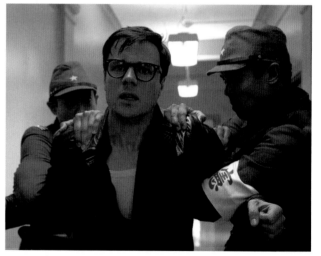

Frank's grief turned to rage, which led him to consider assassinating Japan's Crown Prince. His desire for vengeance eventually led him to take part in the bombing of the Kempeitai building, which killed numerous Japanese. Some thought he had died in the explosion, but when he turned up in season three, Frank Frink was born again. Recovering in the Neutral Zone at the Jewish settlement named Sabra, free of the suppression that suffocated him in San Francisco, he finally began to discover who he really was.

"THE CATALYST FOR ALL THAT HAD HAPPENED TO FRANK HAD BEEN JULIANA CRAIN LEAVING HIM"
RUPERT EVANS
FRANK FRINK

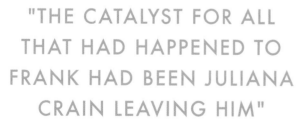

THIS SPREAD: Frank went from resigned conformist to innocent captive to a member of the revolution.

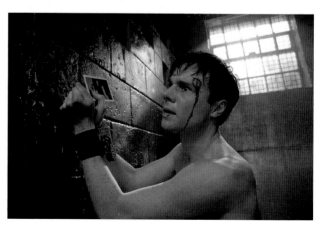

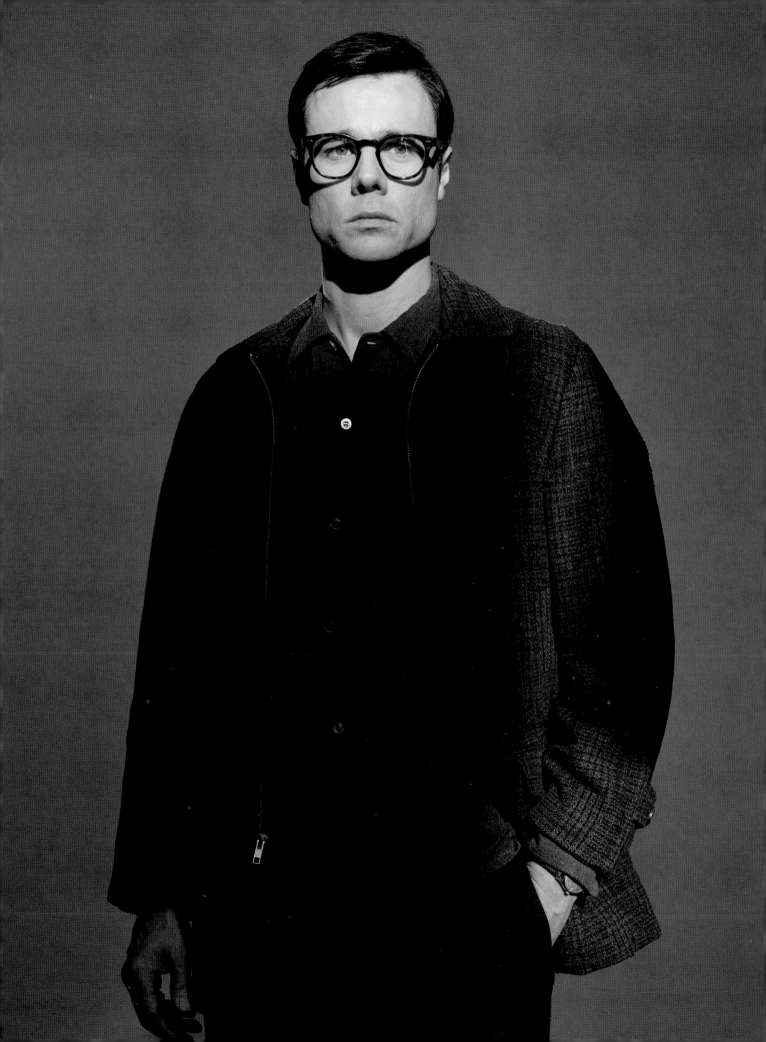

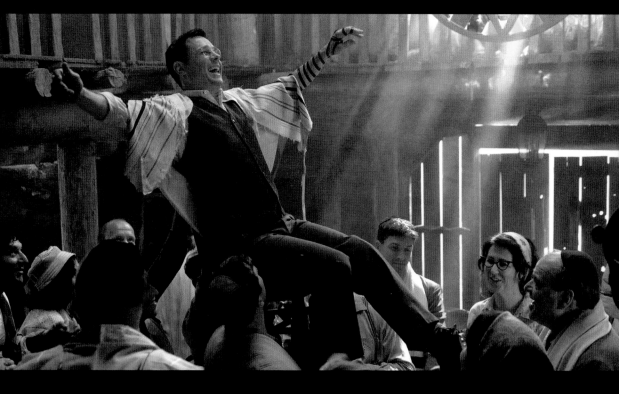

"I think for Frank, he found his faith and with that he found his identity as a human being and a citizen of the world," Evans says. "I think finding his faith was important. He wasn't scared anymore. He was unafraid of the people that had the power."

Frank's Bar Mitzvah marks a true turning point for him.

Not only is it the first time in a long time he's allowed himself to be happy, but like the tradition of the ceremony observes, it forced him to be accountable for his actions. "He had to stand up and face the mirror and take responsibility for the death of the Japanese people he blew up at the Nippon Building," Evans says.

THIS PAGE: Frank found acceptance from old friends and new within the walls of Sabra.

ABOVE: Concept art of Frank's revolutionary posters.

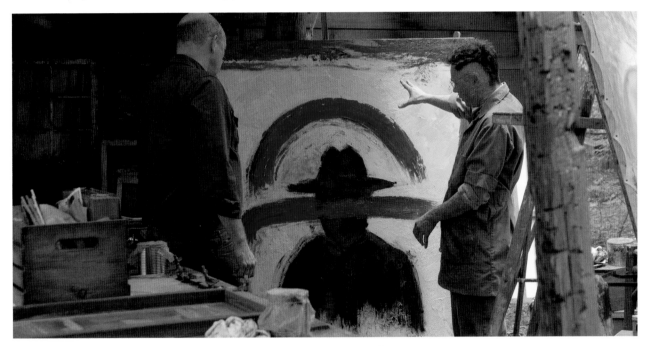

ABOVE: Frank describes the meaning behind his work to Mark at his art studio.

Instead of bombings and other acts of violence, his weapon was now his art. The sunrise posters all over the West Coast would be his lasting contributions to the resistance. Evans did not actually draw any of the designs attributed to his character, but he did weigh in on the designs. "Drew [Boughton, production designer] and I talked extensively at the beginning of season three about what he was thinking. I gave my ideas," he says. "We talked about colors a lot. The kinds of yellow, the kind of red that he wanted and what it meant. Drew was instrumental to me. He helped me understand where I felt Frank Frink was in his art, where is he going? What's behind it?"

This was Frank's true calling, expression through art. As he tells Ed when they reunite in Sabra, it was the opportunity for redemption he had longed for.

Before Frank's story concluded, he finally reconnected with Juliana as she brings the *Grasshopper Lies Heavy* film reel to show the people at the settlement. For Frank, it was a chance to rid himself of the anger and resentment he had carried for so long. "The catalyst for all that had happened to Frank had been Juliana Crain leaving him," Evans points out. "When they meet in season three, for those brief moments before she set off on her journey, it was probably the most cathartic defining moment for Frank. He realized that the path that he was on was the right path. He had forgiven himself and all the others that he had sort of… blamed for what had happened. It's such a wonderful extraordinary moment for Frank Frink, seeing Juliana after so long. It was kind of the beginning of the end when he sees her again."

THE NIPPON BUILDING

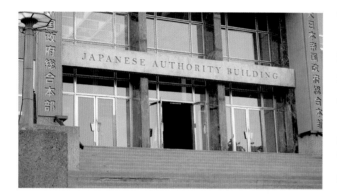

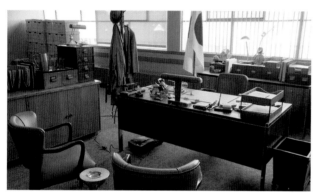

The Japanese Authority building, aka the Nippon building, is the location for the government agencies of the Japanese Pacific States. It is an unremarkable rectangular building reminiscent of the architectural design of standard early 1960s office buildings.

Many key moments in the first season occur here. This includes Trade Minister Tagomi's covert meeting with Rudolph Wegener, the Nazi officer who was attempting to smuggle plans for the Nazis' Heisenberg Device to the Empire.

In the final moments of 'The New Normal,' Juliana Crain and Tagomi met for the first time.

The lower level of the building contains the 'secure room' where telephone wiretapped surveillance is monitored. In that same room, Juliana discovers her stepfather, Arnold Walker, is aiding the Japanese to spy on fellow Americans.

Perhaps the most significant moment to involve the Nippon building comes in the first episode of the final season, when Trade Minister Tagomi is gunned down by assassins as he arrives with the Crown Princess.

BELOW: A concept sketch of the room where Juliana and Tagomi meet for the first time.

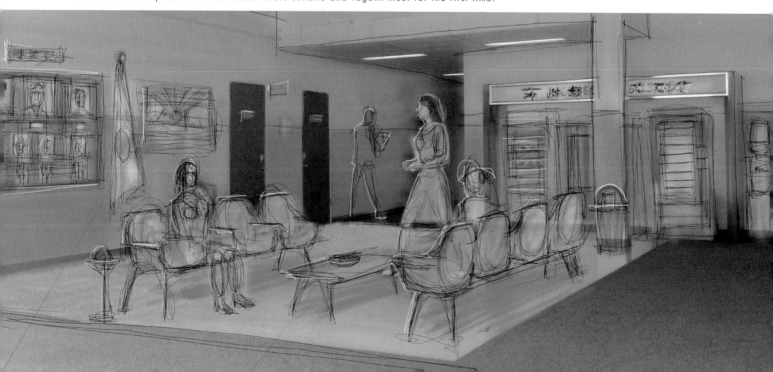

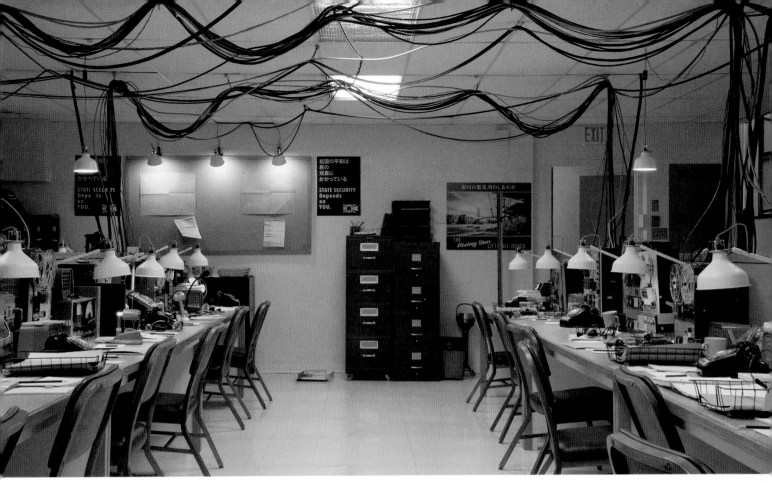

ABOVE: On set photography of the secret surveillance room inside the Nippon Building.

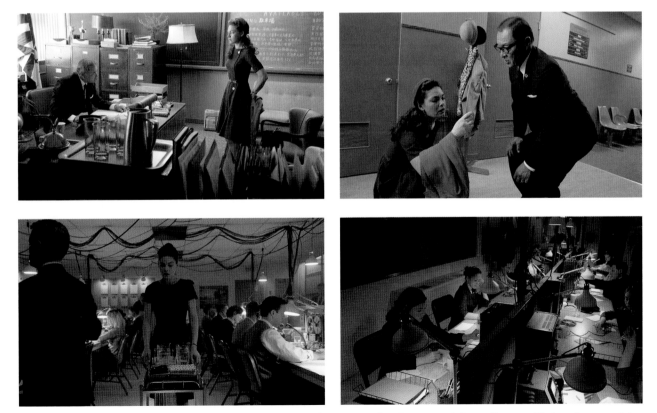

ABOVE (clockwise from top left): Juliana applying for a job, the two travelers first meet, Juliana discovers "Sakura Iwazaru," the top secret government workers.

TAGOMI'S OFFICE

The office of Trade Minister Nobusuke Tagomi, much like Inspector Kido's, reflects the personality of its main occupant. Unlike his Kempeitai counterpart, Tagomi is much more personable and engaging. Visitors to his office are likewise greeted with a much more cordial energy than those who step into Kido's office.

This office is where Tagomi and Juliana Crain first earn each other's trust and respect. Both are of utmost importance to Tagomi. When Juliana informs him during season one's 'Three Monkeys' episode that Oberführer Diels' habit of touching his throat is a sign he is hiding something, Tagomi begins to realize he can put his faith in her.

Tagomi's desk is flanked by two Samurai statues, signifying the elite status his family has enjoyed for generations. That also explains his close relationship with the Crown Prince and

Princess. The entire space is filled with softer colors, to match Tagomi's mood.

The samurai pieces were actually purchased and shipped from Japan. The artwork on the walls and interior of the doors, which depict images of the Japanese islands, signifies the contemplative demeanor of the trade minister. The mid-modern office furniture is a nod to the era and to Tagomi's assimilation with, and fondness for, Western culture.

Another sign of the series' commitment to authenticity was hiring a Japanese advisor to aid with the placement of the furniture. He helped ensure things were in the right place. "A man like Tagomi would want his office laid out in a specific way," says Jonathan Lancaster. "There were strict ways they had to face. He would have to face the door. His tea area had to be here. There were rules [we had to follow]."

BELOW AND ABOVE RIGHT: Tagomi's impressively decorated office was used to host important meetings.

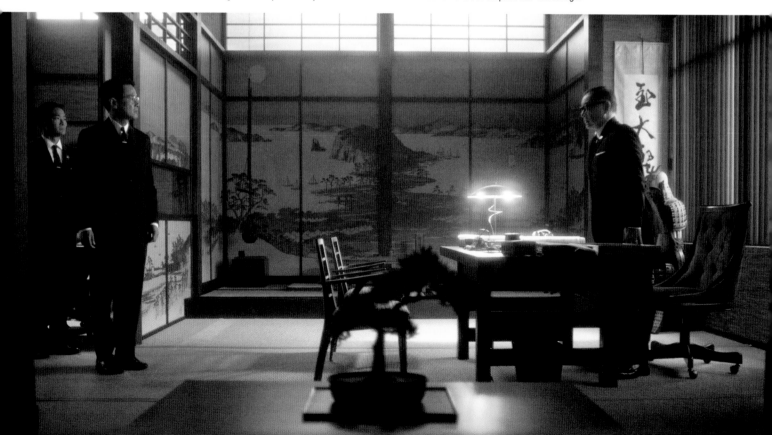

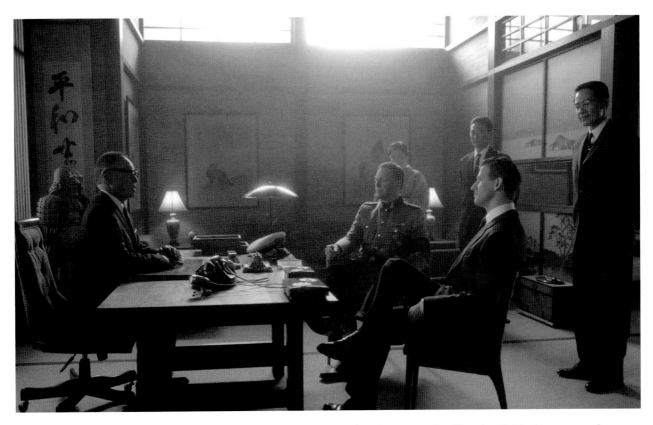

BELOW: The production design and set decoration teams added small details to Tagomi's office that fit his character, such as a modest photograph of his son, Nori.

BELOW: A sketch of Tagomi's office at concept stage.

NOBUSUKE TAGOMI

Nobusuke Tagomi (portrayed by Cary-Hiroyuki Tagawa) is the moral compass of the intricate and complex reality of the series. The trade minister of the Japanese Pacific States comes from a noble family of samurai, with close ties to the royal family. His strong sense of honor greatly influences how he approaches his post in San Francisco. Although bound by sacred duty to the emperor, he feels ashamed at the subjugation of the occupied Americans. Many of the actions he takes in the series, such as when he tells Juliana the location of the grave where her sister Trudy is buried, are motivated by his moral code.

As he does in the Philip K. Dick novel, Tagomi relies on the ancient Chinese text the I Ching for spiritual guidance on the show. It is through the divination of the I Ching that Tagomi gains the faith and wisdom to trust in Rudolph Wegener that his plan to avert war between their two nations is the right move. That balance of wisdom and tolerance for a man who holds such an influential position in the Japanese hierarchy is why Hawthorne Abendsen has his remaining films delivered to Tagomi. He believes the trade minister, due to his close relationship with Juliana, will understand the power of the films and how to use them.

BELOW: Before Juliana and Tagomi form a close bond he finds her necklace and uses it in his meditation.

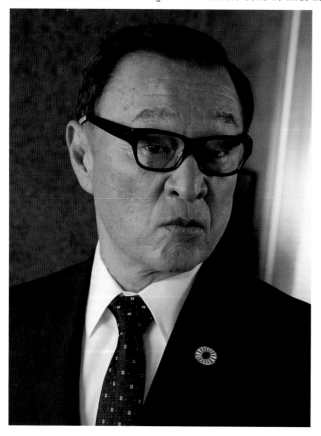

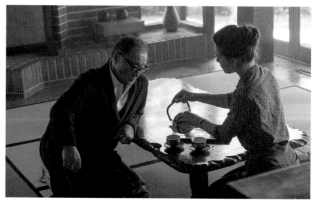

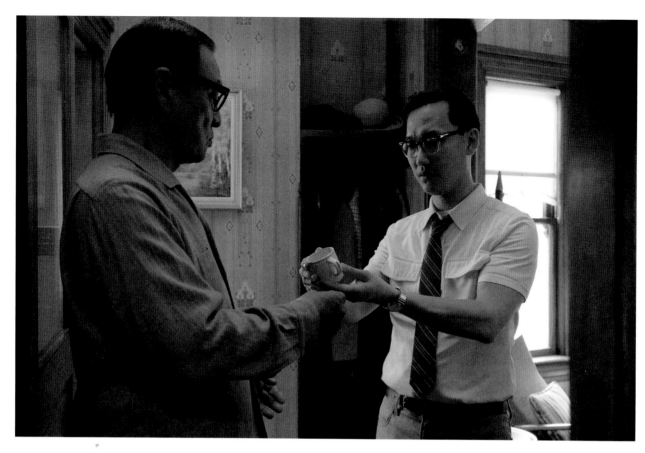

THIS PAGE: Tagomi making amends with Nori, his son from an alternate world (above). Tagomi and Juliana's bond is evident across the different realities (below).

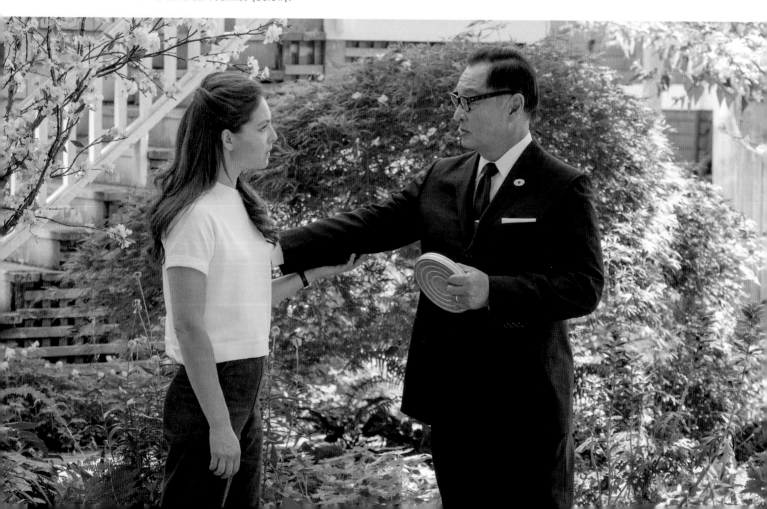

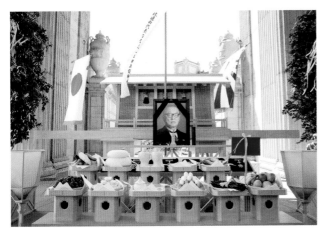

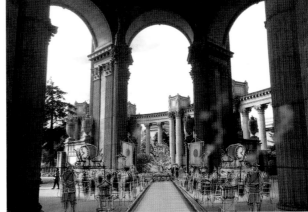

ABOVE: A full altar was created for the scene of Tagomi's funeral.

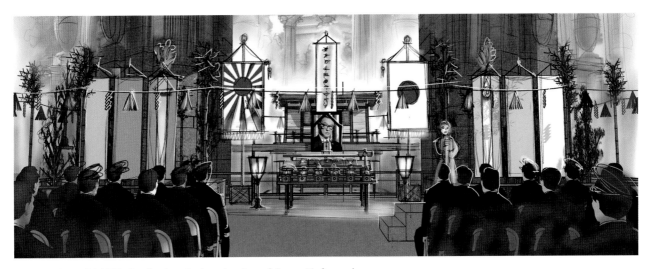

ABOVE AND TOP LEFT: Production design sketches of Tagomi's funeral scene.

"He is a good man living in a very conflicted time and he has to function within it," says Joel de la Fuente, who plays Inspector Kido, a character who often clashes with the trade minister, but with whom he shares a mutual respect. "Tagomi is not a saint. He has a position of authority in a very sort of brutal regime but he wants to do good. And he's operating within the perimeters he finds himself in."

"I always found it even more effective just to turn the camera on Cary as he looked contemplative," notes writer and executive producer Wesley Strick. "You felt a sense that he got it, that he understood there was something monstrous about the fascist regime. That's what I found to be the real strength of the Tagomi character, not so much what he said, but how he would look when he said it, or when he was listening to Juliana, for instance. It was just seeing real human compassion."

Tagomi has endured great loss in his life. Losing both his wife and son, who died in the line of duty during World War II,

greatly impacted him. The shrines to their memories at his home and office reflect the ongoing grief he still suffers from as a result.

Director John Fawcett points to the season two episode 'Duck and Cover' he directed as an example of the versatility and range Tagawa brought to the role. "That's the episode where Tagomi visits the alt-world in San Francisco for the first time," Fawcett says. "There are these wonderful scenes with him discovering Twinkies for the first time and eating them with a chopstick, and meeting his wife and his son." The visit to the alt-world establishes Tagomi as a traveler. It also provides new depth to the character, because in that world, where the Japanese had lost the war, Tagomi was a lost, tortured soul. His family had turned their back on him. The visit to the alt-world allows him to bring his parallel family back together – with the help of his daughter-in-law, Juliana – and helps provide even more perspective for Tagomi and his advocacy for peace.

KOTOMICHI

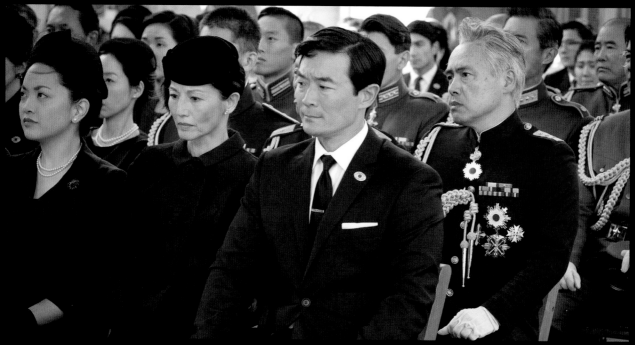

THIS PAGE: Tagomi found a loyal assistant in Kotomichi, played by Arnold Chun.

Tagomi's loyal assistant becomes even more important to the trade minister when he learns Kotomichi is a traveler. Tagomi sees the scars on Kotomichi's right hand, and then it is revealed he is from an alternate reality very similar to the viewers' world. In that existence, Japan lost WWII and the Americans dropped a nuclear weapon on Nagasaki, leveling the city and killing Kotomichi's family.

Kotomichi discovers the ability to travel between worlds while learning meditation techniques to help ease the pain from injuries suffered in the atomic blast. Kotomichi covers for Tagomi during his long absences during season two, while he traveled to an alt-world.

He is very protective of Tagomi and careful to anticipate any potential problems for him. This is one of the reasons he is so distrusting of Juliana Crain when she becomes Tagomi's assistant. Kotomichi fears she could bring trouble to his boss and mentor.

INOKUCHI

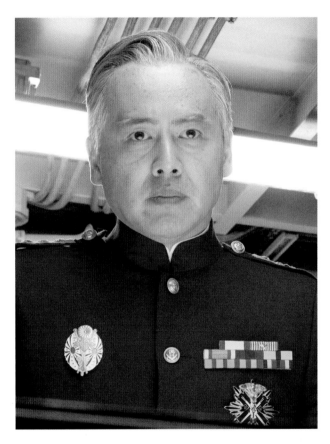

As the leader of Japan's elite naval forces, Admiral Inokuchi prides himself on being a pragmatist. It is why he knows that Trade Minister Tagomi is right when he says an arms race with the Reich is one Japan cannot win.

"What choice do we have?" Inokuchi asks Tagomi, fully aware what the answer is. The Nazis' unofficial oil embargo is putting an economic stranglehold on the Empire. Combined with the season four insurgency from the BCR, Japan's West Coast occupation is jeopardized.

The Crown Princess' request for the Admiral to meet with BCR leader Equiano Hampton and broker a peace deal goes against every militaristic instinct Inokuchi has. But his strict code of honor and sense of duty ensures he will honor the wishes of the Princess. During the meeting with Equiano, Inokuchi appears to gain a certain amount of respect for the BCR chief. Despite being on trial for treason – framed by Yamori and his loyalists – Inokuchi never reveals he met with Equiano at the request of the Crown Princess. He is ready to sacrifice himself, if need be. Just like any good soldier would.

THIS PAGE: Eijiro Ozaki as Inokuchi, meeting with Equiano (below). Before the VFX team added in the background (right).

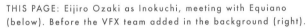

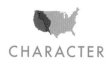
THE CROWN PRINCESS

When she auditioned for the role of the Japanese Crown Princess, Mayumi Yoshida sensed one notable characteristic: ambition.

"She was very strong and had a voice of her own," Yoshida recalls. As the series evolved, she stepped out of the Crown Prince's shadow and established herself as a key voice in the Japanese hierarchy.

"She wasn't just the prince's wife. She had her own thoughts about the political climate and as a princess in that time, that's unheard of," Yoshida observes. "Many people thought she shouldn't be involved in those kinds of conversation at all."

Trade Minister Tagomi's long relationship with the royal family explains why the Crown Princess values his judgment. "I saw him as this uncle that understood me and where I come from and who I am," Yoshida says. "Because Tagomi has known her for so long, she knows [he] will be truthful to her because being part of the royal family, people won't usually tell you the truth. Tagomi was the person she trusted most."

His murder in season four empowers her to take a pronounced stance against the power-hungry partisanship she believes has poisoned Japan's pursuit of honor. At his funeral, she decries those who ignored Tagomi's pleas for peace and tolerance. "I think more than anything the royal family wants peace and harmony. Even if it's San Francisco. They carry the blood of the Japanese Empire, so they still consider them their people."

The Crown Princess' calls for peace puts her at odds with Governor General Yamori. But she discovers a surprising ally in Inspector Kido. He is instrumental in helping her convince the Emperor to withdraw Japan from its western occupation.

Yoshida also contributed to *The Man in the High Castle* as a dialect coach. Because the show filmed in Vancouver, finding actors fluent in Japanese was difficult. "The greatest thing as a dialect coach is that nobody notices our work," jokes Yoshida. "But it also opened up many more opportunities [for me] because I got to be on set so much more and learn from all of these tremendously talented people."

BELOW: The Crown Princess shares similar beliefs with Tagomi.

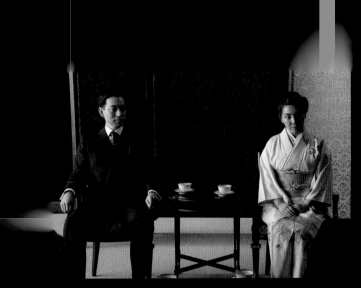

ABOVE: The Crown Princess advised on many matters.

THE CROWN PRINCE

Crown Prince Akihito is the heir apparent to Emperor Hirohito on the Japanese throne.

A young but perceptive man, the Crown Prince senses Japan's Empire is in decline, and knows the Nazis are strategizing on how to take advantage. He is also aware that Japan's military leaders view his preference for diplomacy as a sign of weakness. Akihito believes the pursuit of peace is not weakness but in actuality a measure of a nation's strength and compassion.

During his speech in San Francisco in season one the prince makes a plea for cooperation between the superpowers, despite his suspicions about the Reich. He is be shot before he concludes his speech, but survives the assassination attempt. It is later discovered a Nazi assassin was behind the shooting in an attempt to goad the Japanese into a war with the Reich they cannot win.

BELOW: Daisuke Tsuji on set filming the Crown Prince shooting scene.

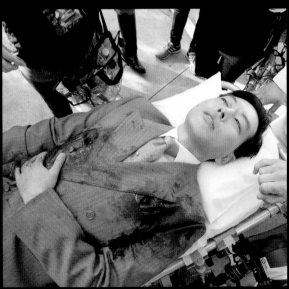
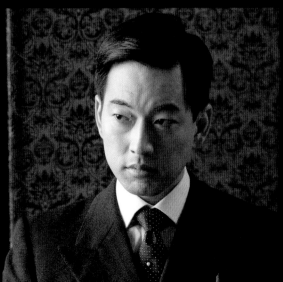

TAKESHI KIDO

Like many characters on *The Man in the High Castle*, Chief Inspector Takeshi Kido exists in the morally grey area between right and wrong.

He has done terrible things on behalf of the Japanese Empire. He has had dissidents executed, prisoners tortured. He is also directly responsible for one of the show's most horrific moments, the gas chamber murders of Frank Frink's sister Laura and her two children. On the other hand, Kido protected Tagomi when he recognized the trade minister's attempt to trade secrets with Nazi officer Rudolph Wegener was to prevent a war Japan could not win.

To Joel de la Fuente, the actor who portrays Kido, that dichotomy was crucial to understanding his character. "You could never forget it's a constant balance between this absolute brutality, which is a part of who Kido is. And then the greater complexity, which is he's behaving in the way that he does because he believes he's right."

That was shaped at the very beginning of the series, during conversations de la Fuente had with Frank Spotnitz. "Frank and I agreed it was really important that Kido not be a sadist," de la Fuente recalls. "He didn't enjoy the things he did, he did them out of his own sense of honor. It was important he had a reason for everything he did."

Over the course of four seasons, relationships with two particular characters were especially helpful in deciphering the enigmatic chief inspector.

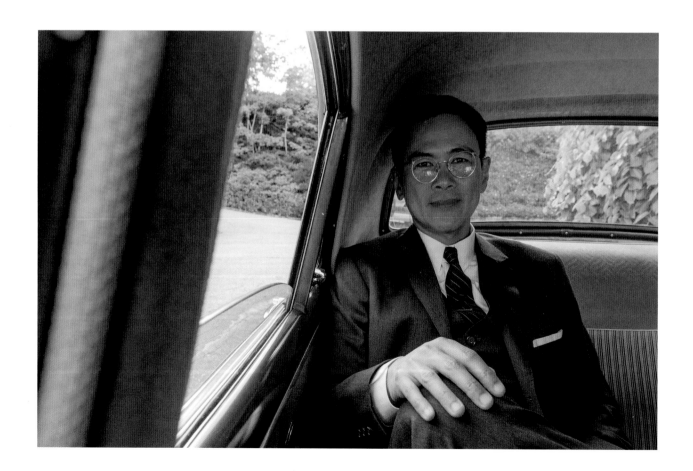

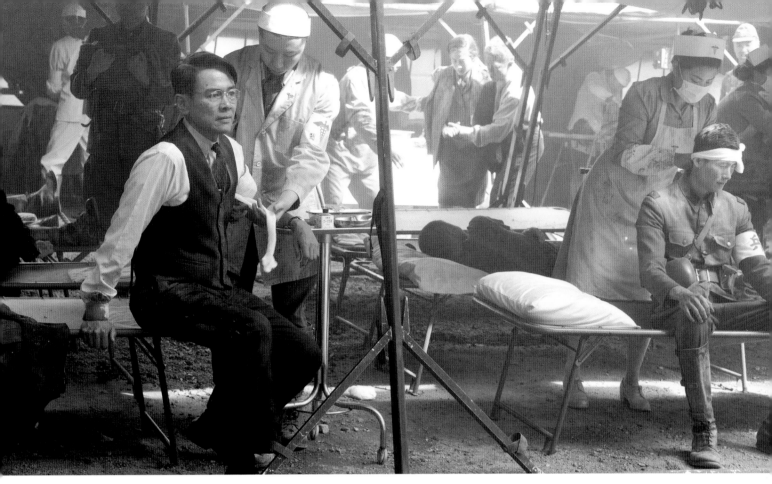

ABOVE: The aftermath of the resistance bombing.

Kido and Tagomi never truly enjoy a friendship; it is more an understanding based on mutual respect. The trade minister's death in the season four opener, however, puts Kido's honor at odds with his sense of duty. "As he investigates Tagomi's murder," de la Fuente says, "it becomes clear pretty quickly that the people that are involved are his superiors. He has to choose between his politics and his conscience." Interestingly, de la Fuente had the chance to audition for either Tagomi or Kido when the show was being cast. The actor is obviously happy he went after Kido, not just for the connection he felt to the character but also because of his admiration for co-star, Cary-Hiroyuki Tagawa. "If I had auditioned for Tagomi, I wouldn't have been on the show because Cary definitely would and should be playing Tagomi and no one could do it any better than he does. I certainly couldn't. They would have found another Kido and I would have missed out on this excellent opportunity."

LEFT: Inspector Kido's iconic glasses were a perfect addition.
RIGHT: In between takes during Frank's execution scene.

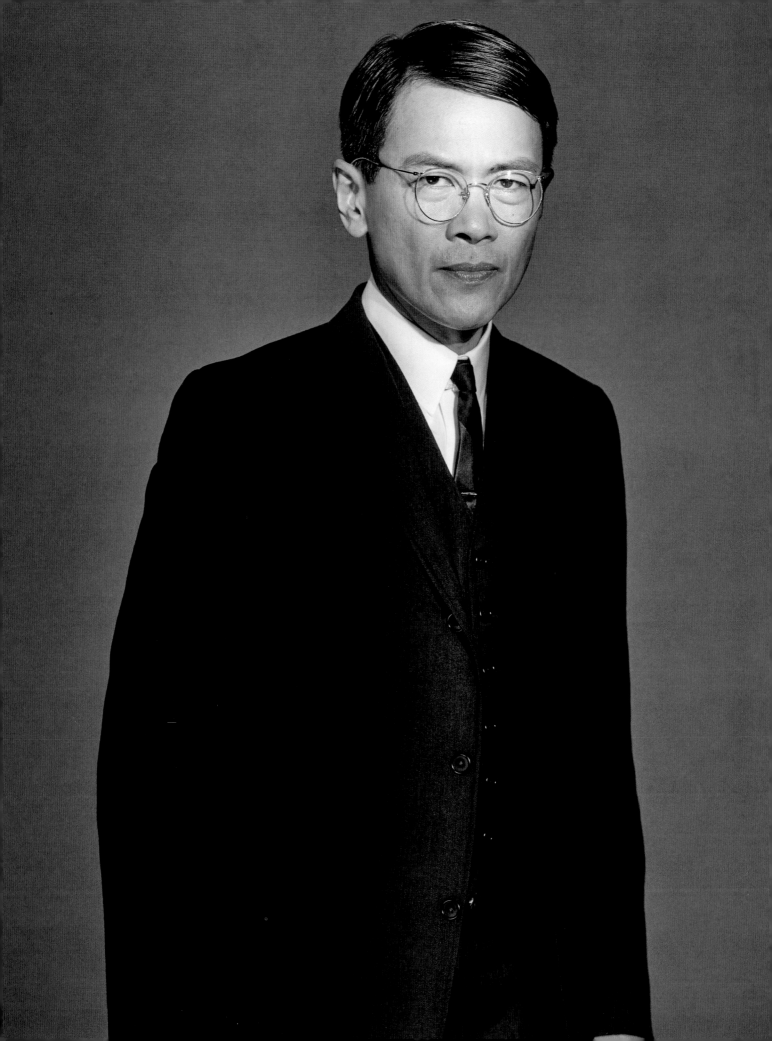

ABOVE: A still from on set of the episode 'Baku' (left). Kido's passport, a prop from the show (right).

In many ways, Frank Frink was essential to the journey Kido takes during the run of *The Man in the High Castle*. Their destinies become linked from the moment Kido arrests him. "I think they both come to define one another in a weird way," de la Fuente acknowledges. "They're both major influences on where they end up going." Kido is weighed down by the guilt not just of killing Frank's sister, but also because he let Frank go. Kido feels responsible for the Kempeitai building explosion because he realizes by letting Frank go, it led to his joining the resistance. It's why Kido tells him during the scene in the desert in the episode 'Baku,' "I know I am a part of what you did."

"That very last scene between them, they know they're connected," the actor says. "He basically gives Frank a soldier's death as a sign of respect for all of the things that they have taught one another."

During season four, Kido also struggles to help his son Toru, who is deeply troubled by his actions as a soldier. "For a guy who always seems to have an answer, suddenly he has none," de la Fuente says. "He can't help the person he cares about the most. He ends up doing the opposite, in fact, by throwing him out of the house." Kido's story comes to a fitting conclusion when he makes the choice in the series finale to stay in San Francisco and join the Yakuza in order to save his son. For this man of honor, joining the mob is almost as great a sacrifice as death.

"It's the deepest form of humiliation for him," says de la Fuente. "It's the price he has to pay to redeem himself for what he's done in service to the Empire."

BELOW: Kido with his loyal assistant, Hiroyuki Yoshida.

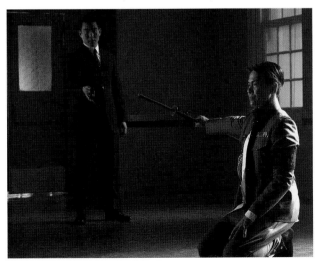

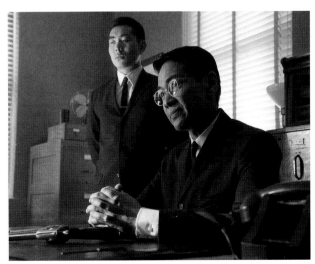

49

KIDO'S OFFICE

The office of the chief inspector of the Kempeitai befits the man who resides in it. Kido is a practical man with little patience for frivolity or distractions from his work. Much like Tagomi's office reflects his spiritual leanings, Kido's workspace affirms his Spartan sensibilities. "If you look closely, there's the steel-case furniture in the outer areas. It's much older, much more downbeat. And, other than his sword, it all went to the coldness of his character," remarks set decorator Lisa Lancaster.

The first time we enter Kido's office, water buffalo horns with the symbol of the Imperial Dragon sit atop a cabinet behind his chair. The horns are later moved to a side table to bracket Kido's Samurai sword in 'A Way Out.' Kido was contemplating Seppuku, the Japanese form of self-sacrifice, as a way to salvage honor for not capturing the Crown Prince's attempted assassin. The horns would later return to behind Kido's desk in season three.

The chief inspector's desk is always perfectly organized. It is not in his nature to tolerate disorganization from anyone, especially himself.

BELOW: Lee Shorten, Joel de la Fuente, and Dan Percival on the set of Kido's office.

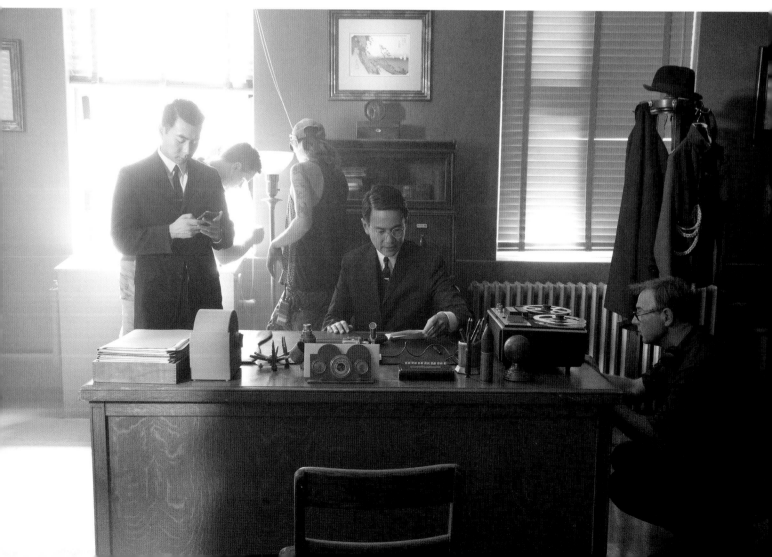

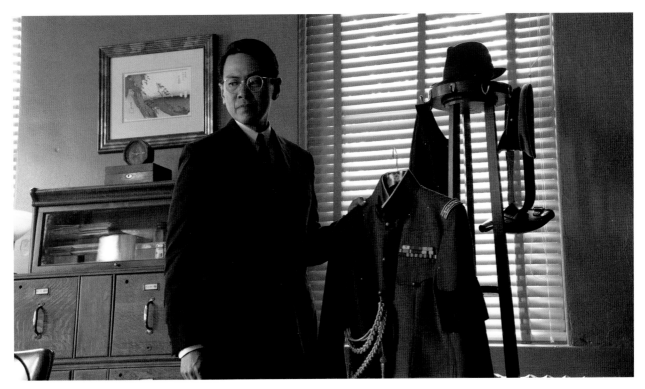

THIS PAGE: Small details were added to the set that match Kido's character.

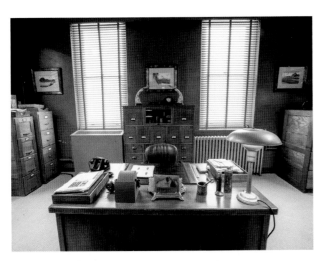

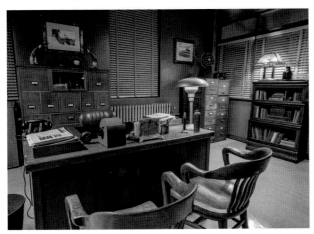

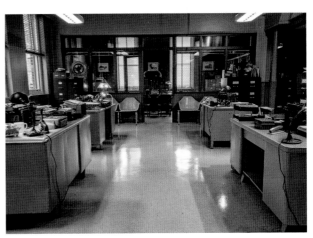

LOCATION
THE KEMPEITAI

In our reality, the Kempeitai, Japan's military police unit, was disbanded after the Empire's surrender in 1945. In the world of *The Man in the High Castle*, the Kempeitai became the iron fist of the Japanese Empire's North American occupation.

Led by Chief Inspector Kido, the Kempeitai cracked down on dissidence and rebellion swiftly and without mercy. Reprisals against resistance efforts often included mass executions on the streets of San Francisco. Prisoners were held and tortured in the Kempeitai headquarters' prison cells. That building is where Frank Frink's sister, niece, and nephew were asphyxiated in a gas chamber disguised as a waiting room.

Because there was no historical record of the Kempeitai after World War II, an entire array of medals, ribbons, and insignias had to be created for the series. A historian was brought in to help ensure consistency. "It wasn't just coming up with a pretty shiny object and pinning it on," according to the show's prop master, Dean Barker. "We always came up with a backstory… what battle, where it happened, and different degrees."

THIS PAGE: Concept art (above) and a final frame (below) of the Kempeitai building explosion.

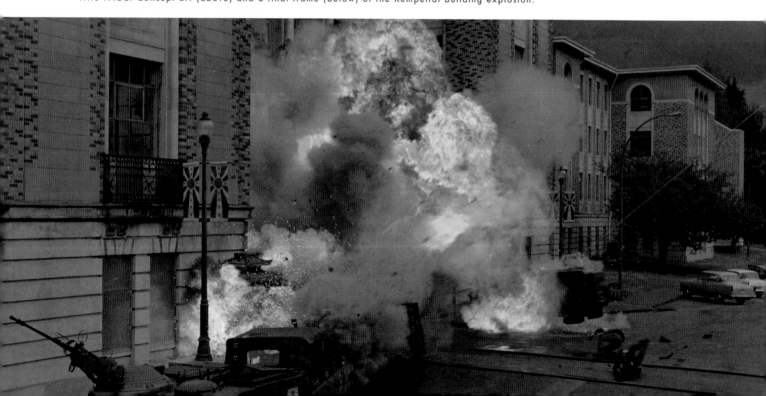

ABOVE: Concept art of the exterior of the building (top). Consistency was key when creating uniforms and medals (bottom).

That attention to detail was part of the commitment to world building so important to *The Man in the High Castle*. "It's the little details for things like medals that people who are knowledgeable of history will notice," says assistant prop master Tony Xeros.

To pull off the pivotal season two moment when the car bomb planted by Frank and Sarah levels the Kempeitai, the producers leaned heavily on practical explosions rather than CGI. "We had lots of fire elements and multiple explosions in that sequence," says stunt coordinator Maja Aro. "That was guys on cables, guys on air rams, which are like human catapults. And it all had to be perfectly timed with the special effects explosions going off, otherwise it just looks silly."

Joel de la Fuente, who plays Inspector Kido, remembers that sequence for much quieter reasons. In the aftermath seen in 'Fallout,' a wounded and clearly shaken Kido sees Tagomi surveying the bloody scene. "The script was between two and three pages of talking between Kido and Tagomi. We just went back and forth so much, Cary and I. But we felt like it wasn't capturing the spirit of what needed to be captured. The writers worked with us and restructured the scene, until eventually, all the dialog was taken out. That's why in that scene, not one word is spoken between us. I remember the writers saying [afterward], 'You know what? That conveyed exactly what we wanted to say and we were able to do it without words.' Which I think was appropriate in that moment."

CHARACTER

TORU

I n the final season, Chief Inspector Kido's personal life is explored through the lens of his troubled son, Toru. He was essentially raised by his mother in Japan, because his father's role in the Japanese Pacific States meant he rarely made it back home. Toru, like his father, served in the military. He is haunted by the horrific acts he committed in service of the Empire and is too ashamed to wear his Japanese Medal of Honor.

Kido first notices something is wrong with his son when Toru recoils at the sight of blood during an interrogation of a BCR suspect. "Kido has witnessed the things his son has witnessed and seen people struggle the way his son is struggling," says Joel de la Fuente, who plays the chief inspector.

Toru turns to drugs and alcohol to numb his pain and Kido is forced to make a deal that goes against everything he stands for – he joins the Yakuza to save his son. "I placed this burden on you from the day you were born," Kido tells Toru in the final episode. "Now it's time for me to take it from you."

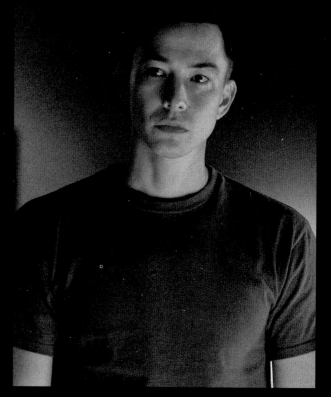

THIS PAGE: Kido's son had a tense relationship with his father.

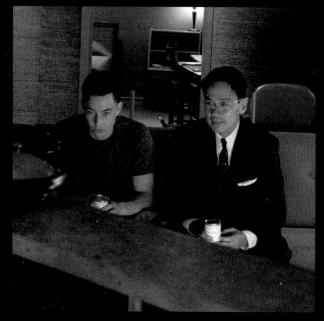

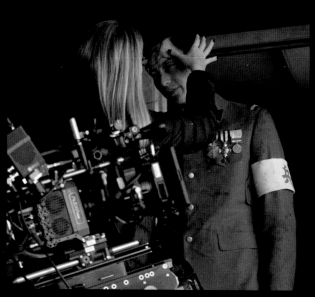

THE YAKUZA

The Yakuza, the Japanese crime syndicate that dates back to the 17th century, occupy a unique corner of the High Castle ecosystem. They are the bottom feeders of the occupied states of the West, with a hand in most illegal activities such as drug smuggling and racketeering. Inspector Kido recognizes the inevitable role the Yakuza play in any society, and allows the gangsters room to operate… up to a point.

"The notion that a fascist government would be able to stamp out a criminal organization is ridiculous. Organized crime has existed in every culture in some way, even in Nazi Germany," said executive producer Erik Oleson. "There's this symbiotic relationship between the Yakuza and the Kempeitai we see unfold in season two. And poor Childan and Ed are caught in the middle."

BELOW: Frank and Childan are held captive by Yakuza henchmen.

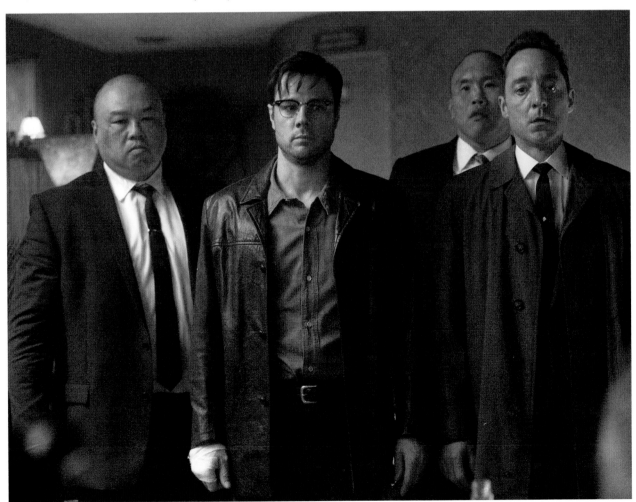

TAISHI OKAMURA

Taishi Okamura is the head of the San Francisco chapter of the Yakuza. His immaculate sense of style belies his brutal methods. Devoid of any loyalty other than his devotion to personal profit, Okamura is supremely confident in his position in the Japanese Pacific States. He tells Kido "the Yakuza cannot be destroyed any more than the sun can destroy the shade." His arrogance ultimately proves to be his undoing. When Kido discovers Okamura has been working alongside the Nazis, he goes to the Bamboo Palace and executes the crime boss. The chief inspector may accommodate the Yakuza operating opium dens, but he draws a hard line on treason.

PAUL KASOURA

The character of Paul Kasoura at first appears similar to the character in Philip K. Dick's novel. Along with his wife Betty, he is a wealthy Japanese-American with a passion for collecting American memorabilia. Like many Japanese, Kasoura looks down on Americans like Robert Childan. The realization of that disdain is what leads Childan to conspire with Frank Frink to con Kasoura into buying a phony artifact. During the unraveling of that scheme, it is learned that Kasoura is a high-powered attorney for the Yakuza.

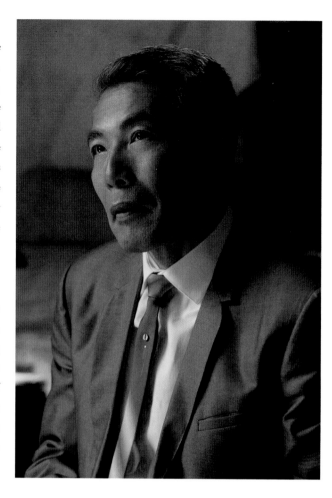

BELOW: Okamura (Hiro Kanagawa) with his lawyer, Paul Kasoura (Louis Ozawa Changchien).

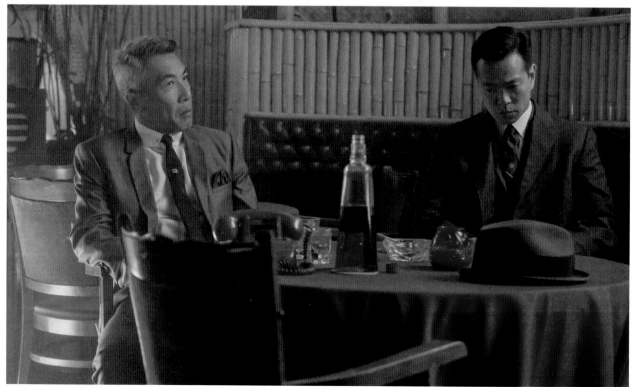

56

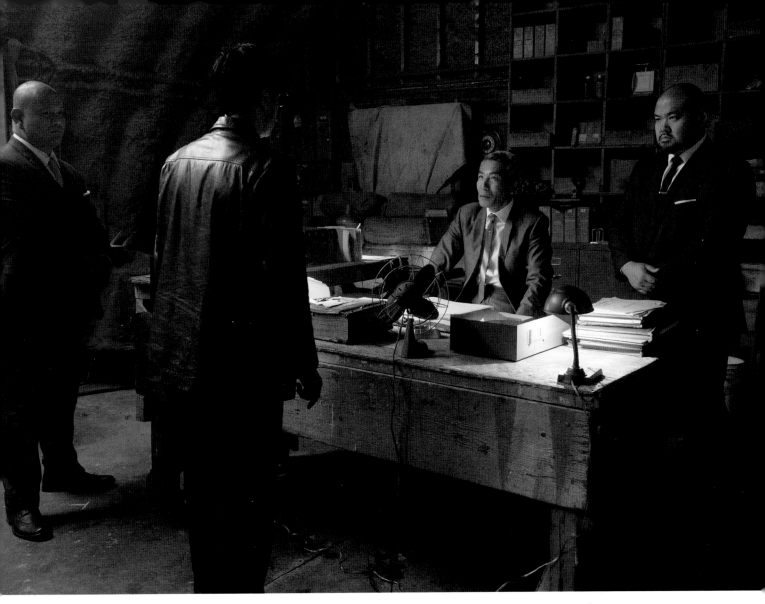

ABOVE: Frank managed to make a deal with the Yakuza.

OKAMI

The new Yakuza boss senses an opportunity.

Okami (portrayed by actor Michael Hagiwara) is aware that the unofficial oil embargo puts immense pressure on the Empire's resources in the Japanese Pacific States. "He knows there is money to be made," Kido says after meeting with Okami in season three's 'Senso Koi' episode.

Kido has always taken the pragmatic approach to the Yakuza's presence in San Francisco and their 'value' in certain sensitive matters. He strikes a bargain with Okami; find Frank Frink, and Kido will persuade Trade Minister Tagomi to allow the Yakuza to buy and sell oil on the black market.

Kido and Okami's relationship becomes more entangled in season four, when the chief inspector's son becomes indebted to the Yakuza. The Yakuza boss knows Kido will do whatever it takes to extricate his son from his dilemma. Okami is also savvy enough to understand that Kido's greatest value to the Yakuza is not government influence, but Kido himself. He knows having the most feared man in the JPS working as his Saiko Komon, his supreme adviser, would help the Yakuza maintain power during the upheaval following Japan's withdrawal. As always with Okami, it is about seizing an opportunity.

CHILDAN'S SHOP AND APARTMENT

Wealthy Japanese collectors of American artifacts flock to Robert Childan's San Francisco antiques shop. "We had a ton of fun with that set. It had character," says set decorator Jonathan Lancaster. Childan's apartment, located in back of the store, offers another, perhaps more truthful window into the character.

"The shop itself was beautifully laid out. Every item and detail we put into the shop was character driven. Then he went through a back door, through a little hall, and you're in his apartment, and it's a [mess]. The two spaces really capture both sides of the character."

Drew Boughton says the producers and writers had long discussions about how to curate Childan's shop to fit its role in the show's narrative. "I did a bunch of research at museums that collect Americana and what Americana is... and we came up with this kind of collection of movie stars, historical objects, Native American, Civil War stuff," Boughton remembers. "Things that were really iconic American objects."

That includes artifacts like Louis Armstrong's trumpet, which appears in season two's 'Travelers' episode. But historicity comes at a price. "We have to get permission from the estates of these actors and also permission from the studios for the artifacts we're going to present on film. For example, the Gone with the Wind poster. Getting permission to use the poster. Getting permission from the Gable estate to have a fake signature written on it by us and so on. There's this whole massive sort of legal process that we go through just to put that poster on the wall and have Childan sell it. And there were plenty of times where people denied us permission."

BELOW: The entryway to Childan's shop.

ABOVE: Filming the season two sequences between Childan and Ed.

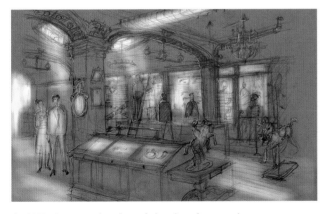

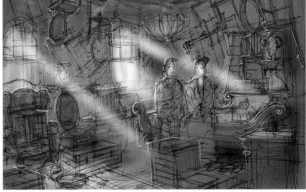

ABOVE: Concept sketches of the shop front and apartment.
BELOW: Final production design stills of the sets.

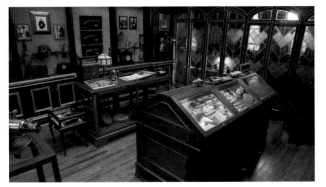

ROBERT CHILDAN

Americana is a valuable commodity in *The Man in the High Castle*. No one is more aware of its intrinsic value than Robert Childan. His antiques shop in San Francisco is a popular destination for wealthy Japanese collectors with a taste for nostalgia. Brennan Brown, who portrays Childan, says his character's pragmatism is his defining characteristic. "He's one of the only characters that has fully bought into the world," notes Brown. "'This is the way it is. I'm going to make this work for me and I'm going to use this situation to my advantage in some way.' He's adapted himself to the world in which he found himself."

While Childan's sardonic demeanor provided some carefully curated levity, he's also the representation of the devastating effects of colonialism in the High Castle world. "In the book, it seems clear to me that [Childan] is schizophrenic and that's what I think one of the points of the book was," Brown says. "How damaging psychologically the act of colonizing and taking over a culture is."

That complexity is what Brown enjoyed most. "Frequently when you get scripts, it's like, okay, I'm playing the nice cop, or the mean lawyer or this guy or that guy," he says. "With Childan it was like, I've never seen this guy. Who the hell is this person?"

Brown has always advocated for his character to keep evolving. "What I told the writers was, he's like a shark. You've got to keep moving forward with him." The unlikely friendship between Childan and Ed McCarthy is one example. When Childan joins Ed and Jack to unfurl a giant Sunrise banner in Frank's memory, it marks a turning point for the character. "That moment," Brown says, "was the culmination [of season three]. He was just going with Ed purely out of friendship, to do this thing that has no reward for Childan."

In the final season, Childan finds himself in a romance with Yukiko, a Japanese woman with her own talent for survival. "In season four, he is finally faced with a situation where, 'here's something that I care about more than just my own personal advancement.' It's genuine, so all is not lost with him."

THIS SPREAD: Childan worked hard to collect rare and expensive curiosities but would give everything up for Yukiko.

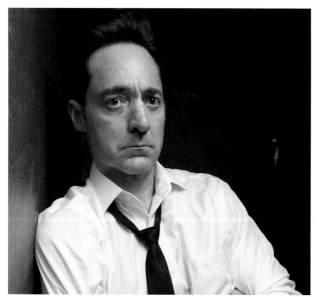
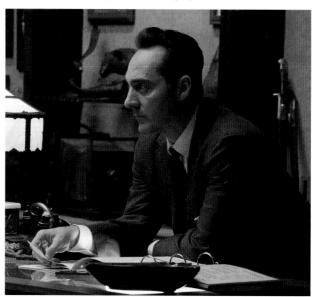

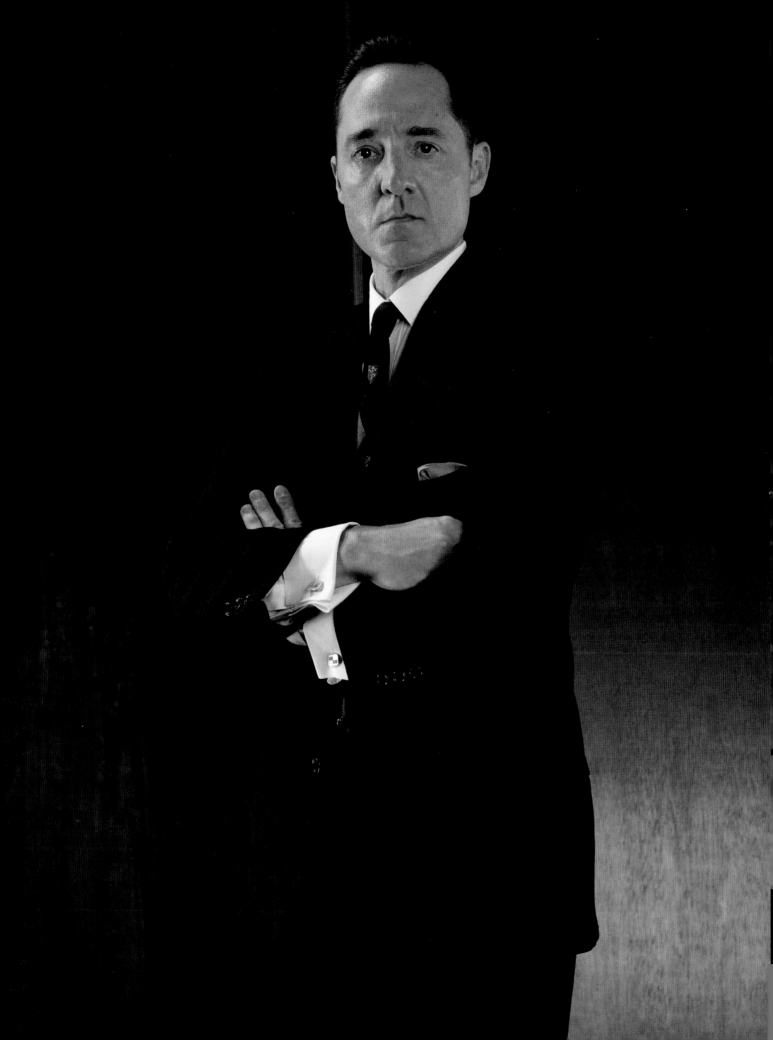

YUKIKO

Robert Childan's assistant (played by Chika Kanamoto) always knows exactly what to say to calm the easily agitated antiquities dealer. When the Crown Princess drops by the shop to preview the items to be auctioned at the gala, Childan momentarily panics. It is Yukiko who calms him. Her devotion touches Childan but his colonial shame makes it difficult for him, at first, to accept that a Japanese woman could care for him.

Yukiko is a widow from a pre-arranged marriage, and like Childan, a survivor. "I think Yukiko is a great character, and in many ways, she's much tougher than Childan," says Brennan Brown, who believes their relationship is a sign of Childan's growth and maturation.

Chika Kanamoto did not have much acting experience when she was cast as Yukiko. "She did a nice job at the audition," remembers casting director Jeanie Bacharach. "After she did her scene, my associate said, 'Let's give her one more shot because I think she can do it better.' So we ran out outside, brought her back in and talked it through with her a bit more and she got it. To [cast] someone in their first major job, it's such an awesome feeling."

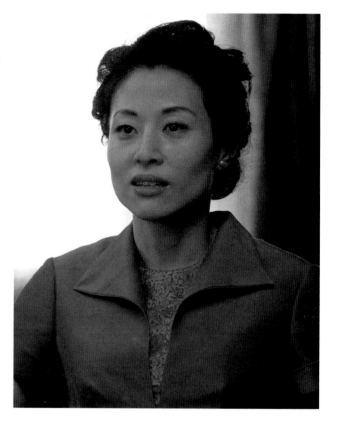

THIS PAGE: Yukiko described Childan and herself as survivors, a quality they had in common.

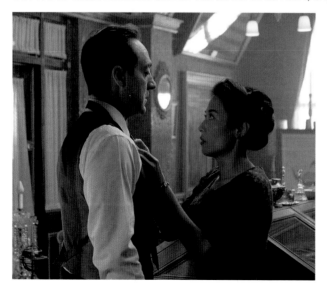

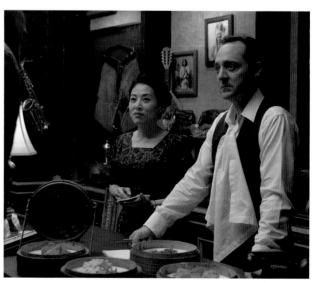

ALTERNATE TELEVISION PROGRAMMING

Building the immersive environment of *The Man in the High Castle* meant no detail was too minor. "We obsessed about things as many hours as we were awake," jokes executive producer Richard Heus. "If you were tired of obsessing over some tiny detail, someone else would do it for you."

Several 'shows-within-a-show,' such as *Guess My Game*, were created to underscore how important television was in the Greater Nazi Reich as a source of propaganda and entertainment. The absurdity of well-dressed Nazis answering benign questions before a live studio audience underscored how a Nazi victory in WWII would have permeated all aspects of American society.

Perhaps the most popular TV show in the Reich is *American Reich*. An obvious take on the classic cop series *Dragnet*, the series stars two Aryan detectives who solve crimes and push the propagandist message of state before family.

In the final season, television is used in retaliatory fashion as a captured Hawthorne Abendsen is forced to host a *Twilight Zone*-esque series entitled, *Tales from the High Castle*.

THIS PAGE: Sketches of in-world television shows (RIGHT). The in-world set, including camera, of *Hausfrau with Gabriela*.

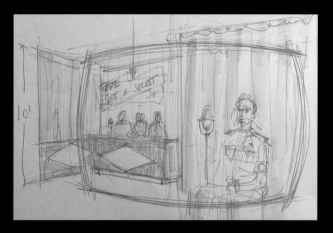

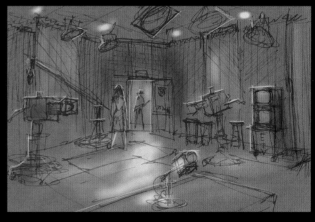

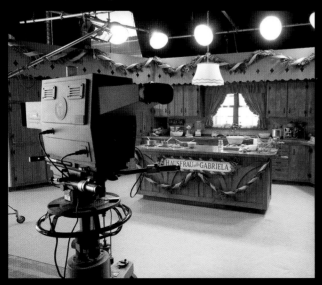

ED MCCARTHY

Ed McCarthy is first introduced in the pilot as he's discussing conspiracy theories about Hitler hiding his Parkinson's disease. Except, Ed is right. "When we meet Ed, he's just see this sort of meek, really loyal, honest guy," says actor DJ Qualls. "But he is actually a very smart guy."

Like many Americans living out West under Japanese rule, Ed suffers from a sort of metastasized PTSD. "We live under occupation. We are marginalized, but we know the formula," Qualls says. "If we keep our head down and we go to work and we shut our mouths, we survive."

His friendship with Frank is incredibly important to Ed's journey. When Frank begins to get radicalized and joins the resistance, part of Ed's concern is fear of waking up to an uncertain future. "When Frank starts having all of these ideas and the anger that results from his sister being killed, Ed wants to stop him, not just because he's worried about his friend but also, what's next? If [the JPS] destabilizes, we don't know what's to come."

The trip to the Neutral Zone marks a radical shift for Ed. Not only does it cement the offbeat friendship between him and Robert Childan but also it's the first time he is able to embrace his homosexuality, and meets his boyfriend, Jack (James Neate). In many ways, it is a liberation for him. "What's interesting to me is when I look back on the character, and where he was and where he wound up... Ed needed to get away from Frank," Qualls says. "It was a completely co-dependent relationship, that was largely one-sided."

Leaving San Francisco helps Ed see that keeping his head down and not making trouble is no longer an option. "There's a great book called *Alone in Berlin* that's about a couple who, during WWII, wrote anti-Nazi slogans on postcards and dropped them all over Berlin," Qualls says. "What wound up happening was when people found these postcards, it made them think this, 'I'm not alone.' That's how rebellion can really spread, much faster than acts of violence. I think Ed would've gone and sought out like-minded people like him. There's no way he could've gone back to the way things were."

THIS SPREAD: Ed was a quiet conformist who eventually learned there was more to life.

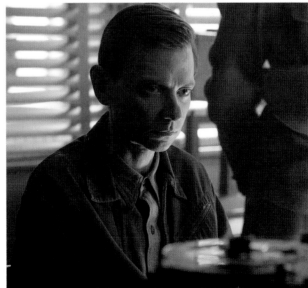

THE FILM STORAGE

Hawthorne Abendsen's makeshift film library resides inside a massive barn in the Neutral Zone. It is here where the Man in the High Castle first meets Juliana Crain.

Floor to ceiling, there are massive shelves with hundreds, even thousands of film reel canisters of various sizes, organized by year. It is a library full of 'What If' tales, and Abendsen is the librarian. "We shot that on location in an empty barn in Vancouver," says Drew Boughton. "We built the racks and the dressing pieces to hold the film canisters and moved all of it into the barn."

All those film reels on the shelves in Abendsen's barn are real. It required a colossal effort to procure them. "We tried lots of ideas because we needed like 2,000 film reels that aren't CG, to be up on shelving," admits Jonathan Lancaster. "It was the one time that Drew [Boughton] came in and his jaw dropped and he was actually speechless for a few minutes."

"We basically bought them from everywhere we could… eBay, local universities," says Boughton, but it was not nearly enough.

"We bought every film reel we could find around the country," adds Lisa Lancaster. "We were still a thousand short. We went to CBC (Canadian Broadcasting Corp.), and what happened is the curator there… actually had the last four-foot bins left in all of Vancouver that were CBC's old films. So we paid an archivist to come in and digitize these films and then in turn, we were able to get the film canisters."

The props department filled in the rest by creating duplicates of the two reels used in the pilot, only to be hampered by the fact that those particular reels happened to be quite obscure. "I'm almost willing to reach my neck out and say one-of-a-kind, because we, in all of our years, could never find an exact duplicate," says Dean Barker.

BELOW: Stephen Root and Alexa Davalos behind the scenes at Abendsen's film storage.

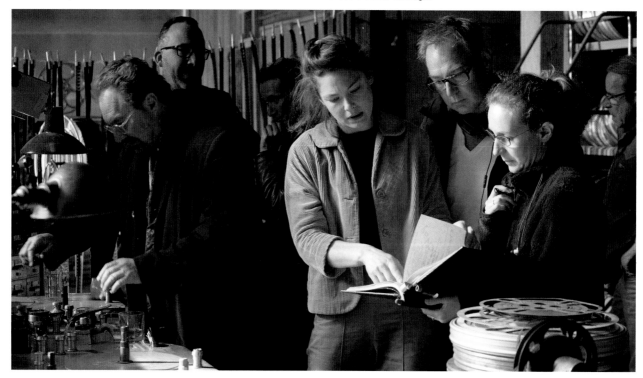

ABOVE: Sketches of the film storage before (top) and after (bottom) it's destroyed.

ABOVE: John Smith discovers the hiding place too late.

BELOW: Production still of Abendsen's workshop.

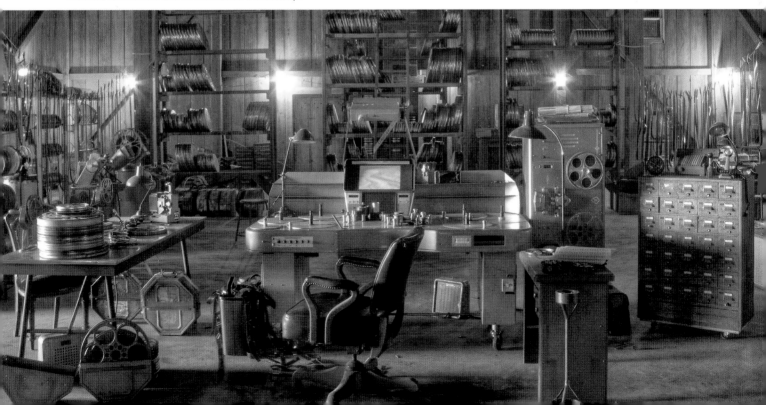

PROPAGANDA FILMS

On February 15, 1933, in our reality, a man named Giuseppe Zangara tried but failed to assassinate then-President Elect Franklin Delano Roosevelt. In the reality of *The Man in the High Castle*, Zangara succeeds in killing FDR, and creates a divergent point in history, where the Axis powers win the war. The propaganda films are essential to understanding the multiverse of the series.

When he originally developed the adaptation, Frank Spotnitz decided one change was crucial.

"In the novel, Hawthorne Abendsen has written a book where the Nazis didn't win the war," Spotnitz recalls. "I changed it to films, because television is a visual medium. And I thought it would be much more viscerally affecting than a book."

Dan Percival, producing director for seasons one to three and showrunner for the final season, created an in-depth 'show bible' that detailed the reasoning behind the films and the alternate realities they depict. The films function as a gravitational pull, attempting to bring the High Castle world back into balance. This particular reality is wildly unbalanced by tyranny, despair, and terror. The idea is based on essential theories of Quantum Mechanics, which suggest that events in one universe may influence a parallel universe. The spiritual principals of the thousands year-old I Ching are also based on universal balance, and thus help inform the High Castle concept.

BELOW: Hitler obsessively searched for the propaganda films.

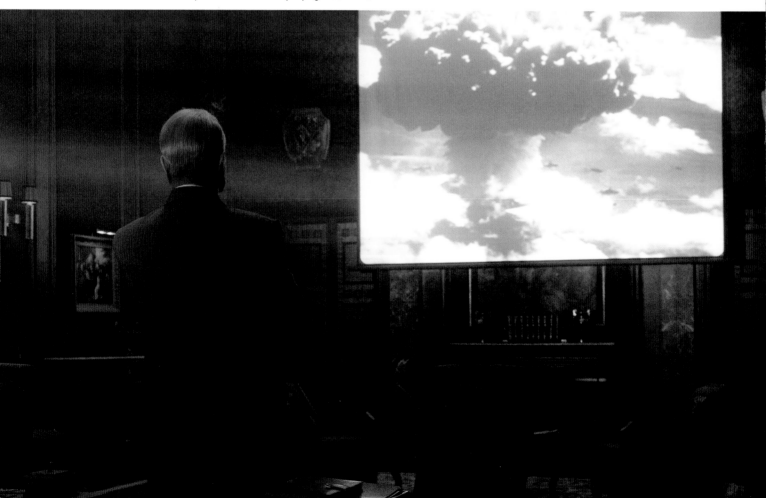

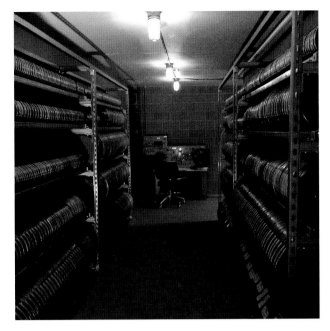

Collecting and analyzing the films becomes Abendsen's quest and his curse. He uses the films to analyze potential outcomes. That's how he learns of Juliana's importance in the bigger picture. "Abendsen existed in a world where history played out one way," says Percival, "And he desperately wanted to imagine a world where history played out a different way." Before he burns his collection, Abendsen has roughly 3,000 film reels dating between 1900 and 1962.

By comparison, Hitler has less than a thousand films at his Austrian retreat.

The production team of *The Man in the High Castle* used actual newsreel footage from World War II to create the scenes we glimpse from the films. Scenes created for it, such as Frank Frink and George Dixon being executed by Joe Blake, were shot on film stock, and then digitally degraded to make it consistent with the archival footage.

THIS PAGE: A still and sketch of the Nazi collection (above). Hitler and Wegener's stand off in sketch (below left) Juliana shows Frank why the films matter (below right).

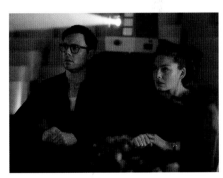

CHARACTER
SARAH

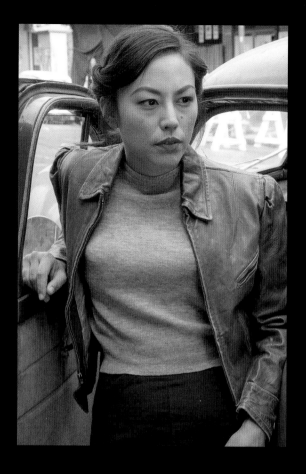

Born in America to Japanese parents, Sarah (played by Cara Mitsuko) is one of many Japanese-Americans who feel uniquely disenfranchised in the High Castle world. Her family was interned during the war at the Manzanar concentration camp in California's Owens Valley, a real-life internment center for thousands of Japanese-Americans during WWII. To her fellow Americans, she was an enemy. To the Japanese, Sarah was viewed as a traitor.

She is part of the resistance and won't hesitate to kill if it helps their cause or protects innocent lives. However, she is not as cold-blooded as Gary. They may be on the same side, but Sarah does not disregard civilian casualties as easily as he does.

A shared sense of persecution is one of several reasons why Sarah and Frank grow closer. Their affection for each other is apparent as they argue over Sarah being part of the Kempeitai bombing plot. Frank doesn't want her there to protect her. Sarah isn't about to let Frank stop her from contributing to a key mission. In the end, Sarah dies in the bomb blast, a good soldier seeing her mission through to the end.

CHARACTER
GARY

Gary Connell is a particularly militant member of the West Coast resistance. He believes in instilling fear in the Japanese with insurgent attacks that will lead them to be reactive and prone to mistakes. Gary understands that these actions will lead to Japanese reprisals against innocent civilians. A member of the resistance since 1957, he sees this as acceptable collateral damage.

That puts him at odds with other resistance members, including Lemuel Washington. "Lem and Gary did not see eye-to-eye in terms of what they were supposed to be doing," says Rick Worthy, who portrayed Lem. "Gary is a wild card who will shoot first and ask questions later."

He disregards an order from Hawthorne Abendsen and tries to kill Juliana. It leads to a shootout that costs resistance member Karen Vecchione her life. Gary is later found and executed for his role in the Kempeitai bombing.

THE BAMBOO PALACE

The Bamboo Palace is a San Francisco nightclub operated by the Yakuza. The club is the setting for the aborted sale of a propaganda film involving Joe Blake and the resistance in season one. "The Bamboo Palace was supposed to feel like a depressing Yakuza hangout at first," says Karyn Kusama, director of the 'End of the World' episode. "We decided to create a boozy, cocktail lounge atmosphere, and give it a kind of decrepit glamour."

Kusama felt having a lounge singer who was distinctly American singing in Japanese was an excellent way to create a tone of dislocation and alienation. "It immediately made me think of how David Lynch uses music in his films for that purpose," she says. Canadian singer Lini Evans portrayed the singer. She actually wrote the Japanese version of 'End of the World' heard in the episode. In our reality, the song was an early 60s hit for Skeeter Davis.

In season four, his troubled son Toru's problems with the Yakuza ensnare Chief Inspector Kido. He learns that no one is immune to the moral compromises that are part of the fee one pays when they step foot inside the Bamboo Palace.

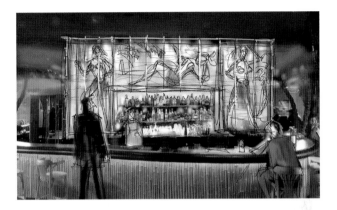

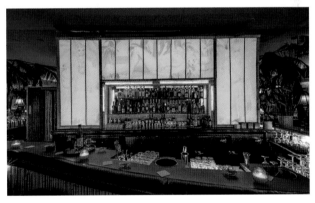

THIS PAGE: Concept art of the Bamboo Palace (top). Production stills of the bar (above and below).

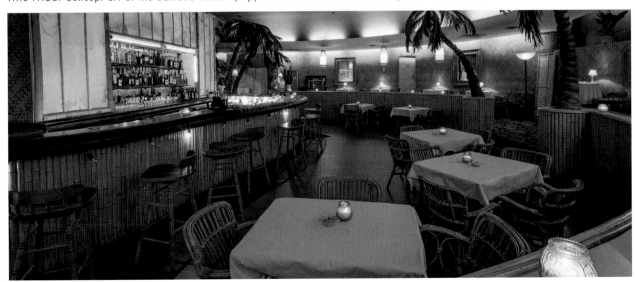

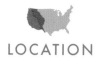

THE GOVERNOR GENERAL'S OFFICE

General Yamori is a man who values strength more than anything. Which is why it is not surprising at all that the most identifiable item in his office at the Imperial civic building was a giant Samurai statue. The office gave the general home-field advantage over anyone who stepped through the doors.

It was inside that space where he barked commands at Inspector Kido, or browbeat Admiral Inokuchi over his deference to the Crown Princess. Yamori's office is spacious and imposing. It has an anteroom outside the office suite. There is a large round table inside his office, as well as large windows to allow the general the opportunity for that rare moment of reflection as he gazes upon the city.

During the BCR's decisive bombing campaign that brings the Japanese to their knees, Yamori's office becomes the focal point of the Japanese Pacific States' strategic decision-making. With the general confined to a cell after his treasonous activities are exposed, it is Kido who takes over the space as the Japanese scrambles to hold off the rebellion.

THIS PAGE: Concept art of the entrance to the general's office (top). Final still, including soldiers (bottom).

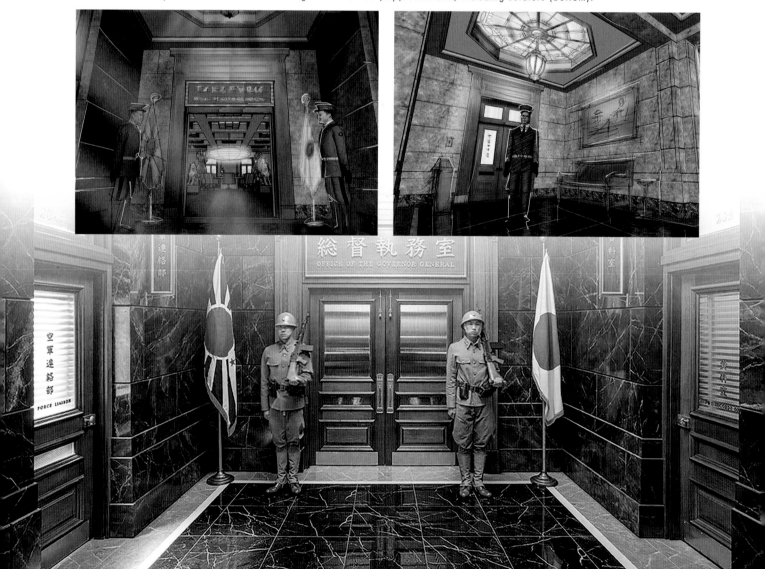

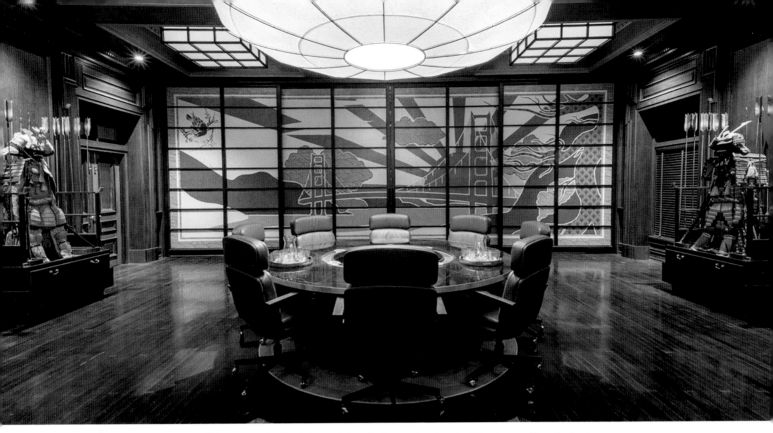

THIS PAGE: A production still featuring the final decor (above). Concept artwork of the inner office (below).

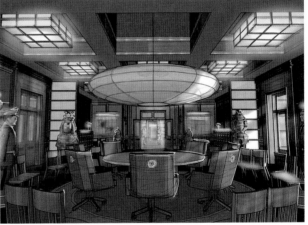

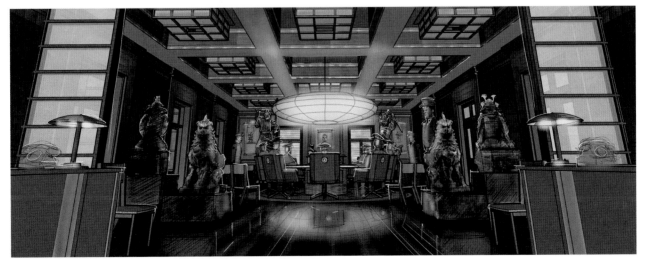

YAMORI

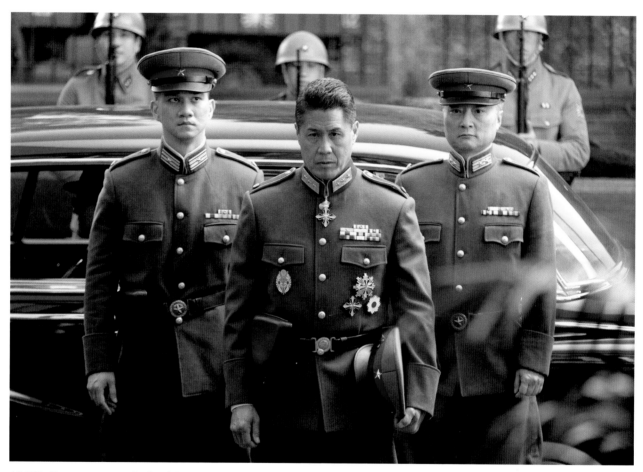

ABOVE: Yamori entering the fateful auction soon to be attacked by the BCR.

In a militarized colonial state such as the Japanese Pacific States, the Imperial Governor General holds the top position. As the BCR's campaign gains momentum, Governor General Yamori believes too many in the leadership structure of the JPS are weak. This puts him at odds with Admiral Inokuchi.

Yamori's dislike of Inokuchi has its roots in the natural rivalry between Japan's army and naval branches. The hardened military veteran also resents Inokuchi's close relationship with the Crown Princess and the Emperor. Yamori dismisses the admiral as an appeaser who carries the tone of surrender in his

voice. He has similar disdain for the Crown Princess and her calls for peace and tolerance in the JPS. In Yamori's worldview, even entertaining the idea of peace talks with 'terrorists' such as the BCR is failure. His two sons gave their lives in service to the Empire. In some twisted way, Yamori believes giving up the western states would be a disservice to their memory.

Yamori's frustration with the BCR's attacks, and refusal to accept the reality of Japan's weakening grip on the western states, leads him to concoct a treasonous plan. He orders the assassination of Tagomi and blames it on the BCR. He then uses

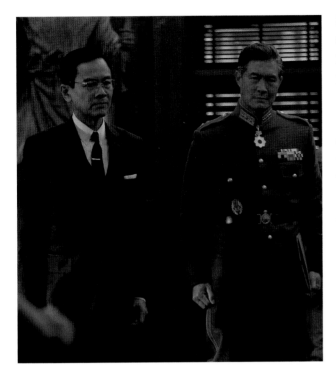

Inokuchi's secret peace talks with Equiano to frame the admiral for conspiring against the Empire. Yamori even has General Masuda, a man Yamori says he owed his life to, killed as part of his plan. Collateral damage is perfectly acceptable to him.

Yamori's scheme to remove Inokuchi as an obstacle puts Kempeitai Chief Inspector Kido in an impossible position; does he choose duty to the Empire, or personal honor? "Kido is a smart investigator. As he investigates Tagomi's murder it becomes clear who is really involved in his death," says Joel de la Fuente, who portrays Kido. "He has to choose between his politics and the Empire, and his conscience."

In the end, Kido's honor wins out and he arrests Yamori. Defiant almost to the end, the general refuses to sign his confession. Instead, he takes his own life in his cell, alone with the photos of his two sons by his lifeless body.

BELOW: A still from on-set of season four.

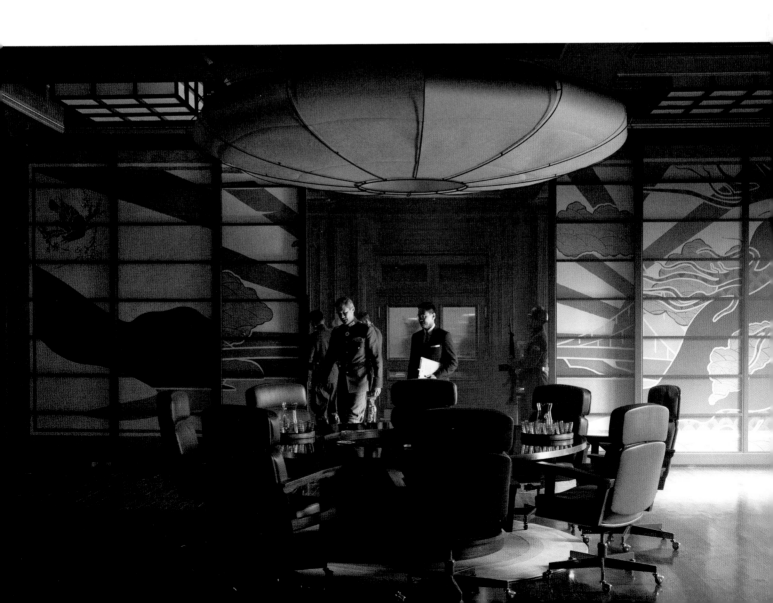

THE BLACK COMMUNIST REBELLION

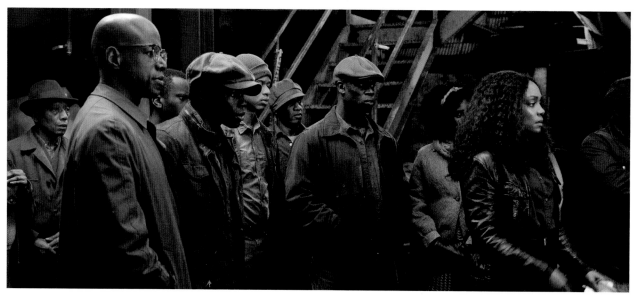

ABOVE: The Black Communist Rebellion gathered to discuss their next plan.

The point of view of the African-American community in America during the Reich/Japanese occupation was something the show's producers had wanted to address for some time. The emergence of the Black Communist Rebellion network provided that opportunity.

"The BCR wants their own homeland. They want to be free from the oppression of the Japanese by any means necessary," according to Frances Turner, who plays key BCR operative Bell Turner. "The world changed when the Allies lost, and they don't want to be a part of this world. They're fighting for their own freedom."

The BCR were modeled after the Black Panther movement of the 60s, according to season four co-executive producer/writer Julie Hebert. One aspect the writers wanted to explore was the role of women in such a group. "They might have been as smart and as driven and as committed as the men, but they were not the leaders," Hebert says. "So they had to fight their way up."

The BCR's objective is different from the resistance, according to executive producer Isa Dick Hackett. "There wasn't freedom and justice in the old America [for black people]," Hackett says. There was no civil rights era in the United States, because they lost the war."

The BCR is well armed due to its partnership with the Chinese. Both are fighting the Japanese for their own liberation. The various West Coast cells of the BCR are loosely linked, with the leader of the movement a man named Equiano Hampton. When he is killed, it's Bell who helps keep the BCR organized and focused on its objective. In fact, the group's plan works almost too well.

After a daring multi-pronged attack on key Japanese installations, the Empire announces its withdrawal. The BCR wanted its own parcel of territory to provide safe haven for African-Americans; it wins half of North America, instead. "I think it dawns on Bell pretty quickly then, that things are about to get harder before they get easier," says Turner. "It's one thing to get your own homeland; it's another thing to now have to manage, essentially, half of the country. And oh yeah, the Nazis are coming for you."

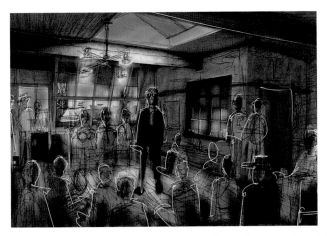

ABOVE: Concept art of Equiano's speech (left). A production still from one of the BCR's meeting places.

BELOW: Bell is a leading voice in the plan to work with the resistance at the auction attack.

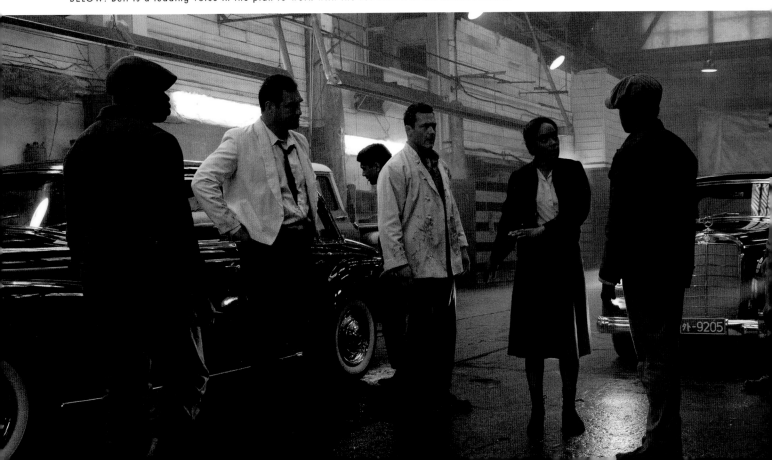

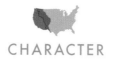

BELL MALLORY

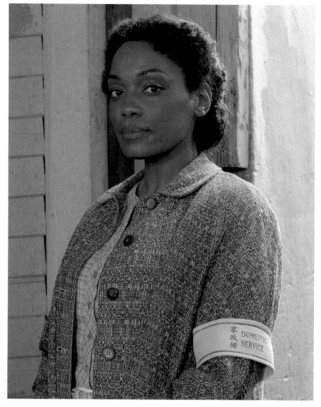

With the Black Communist Rebellion, a major storyline in season four, the role of Bell Mallory was key. "You had to believe this woman has the capability of leading and who had the gravitas and the weight of her character's history," says casting director Jeanie Bacharach. "Once everyone saw Frances' tape, they saw everything they were looking for in Bell."

"What I love about Bell and her journey is that she doesn't set out to be a leader. You literally watch a leader emerge through the course of the season," says Frances Turner, the actress who portrays Bell.

Bell's journey began in Alabama. After the occupation, she and other African-Americans were placed in labor camps. She managed to escape and wound up in the Japanese Pacific States. She eventually joined the Oakland BCR cell.

"Bell is a believer in Equiano's mission. She's smart, she's strategic, she's a care-taker, and also a nurturer," Turner says. "She has a fierce compassion for those who mean something to her and what she believes in."

She's also a woman of her word. After a planned assault at the Presidio Mansion goes awry, Bell is the one who prevents Elijah from reneging on a deal to provide guns to Wyatt Price. "I think that when Bell stands her ground with Elijah about the guns," notes Turner, "You see that she has real integrity."

> ## "SHE DOESN'T SET OUT TO BE A LEADER"
> ### FRANCES TURNER
> #### *BELL MALLORY*

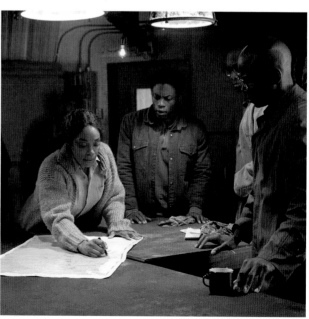

THIS PAGE: Bell finds her voice and takes control of the BCR's plan to overthrow the government.

ELIJAH ROBINSON

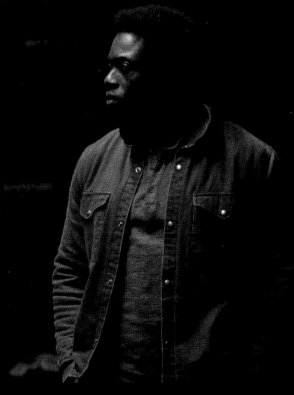

Elijah Robinson (Clé Bennett) is a high-ranking member of the San Francisco cell of the Black Communist Rebellion. On the very first day they met in 1962 at an underground gathering of Black activists, Elijah introduced Bell Mallory to Equiano Hampton. Two years later, they are partners and lovers.

Bell and Elijah love each other, but they don't always see eye to eye. They disagree on working with Wyatt Price's resistance group for the attack on Childan's auction. When Elijah wants to back out of their agreement to give Wyatt his stash of weapons, it is Bell who insists they honor the deal.

Elijah has no interest in returning to the pre-war America. That country had no more use for black people than the version they are living in. A separate state for African-Americans is the goal he strives for because he doesn't believe an integrated nation is possible. "Elijah is a soldier who grew up in the fight. He has been an activist all his life," says Frances Turner, who plays Bell. "For him the fight never stops."

THIS PAGE: Elijah and Bell wouldn't always agree on methods but both were committed to the BCR and each other.

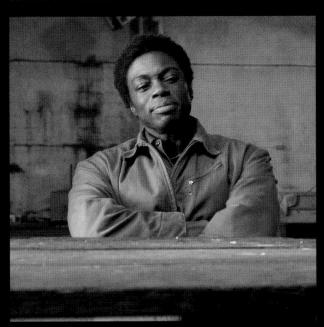

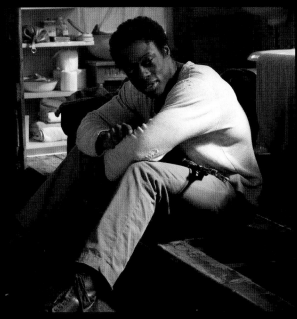

EQUIANO HAMPTON

Equiano Hampton was the leader of the Black Communist Rebellion. He had lost his wife and daughter when the Reich sent them to an extermination camp in Saginaw, Michigan. Over time, he became an influential figure in the black underground that was worshipped by some, feared and distrusted by those in power.

Equiano is a revolutionary, but he can envision a time when the rifles would have to be put down and governing would start. When he meets Bell Mallory at a meeting of San Francisco's black underground, he senses she is someone special. "Bell rises to the top because she is the most committed to what the BCR is fighting for," says season four executive producer Julie Hebert. "Equiano recognizes that."

The BCR chief agrees to meet with Admiral Inokuchi because he understans the significance. This is the first time anyone has entered negotiations with a black person as an equal. That alone makes the meeting worth it. Both men leave their meeting with grudging respect for the other. Equiano views Inokuchi "as a man of war, trying to learn to make peace." Moments later, a sniper's bullet ends Equiano's life.

But Equiano Hampton knows his death isn't an end. It is just an opening, a new path to victory.

BELOW: David Harewood as Equiano Hampton.

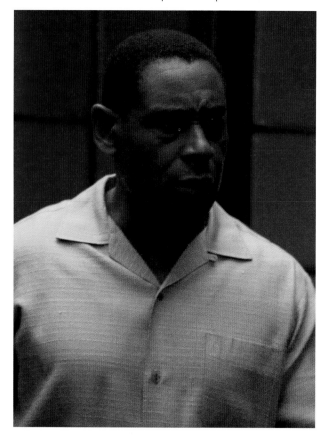

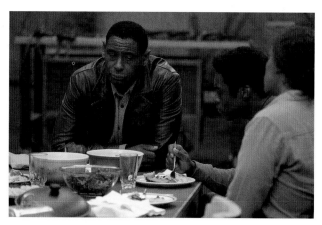

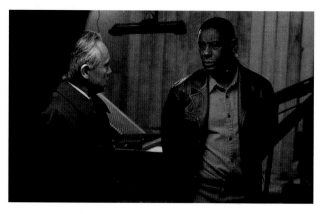

OSCAR AND BENJY

Revolutions are formed on the back of the young and idealistic. Benjy (Bzhaun Lorenzo Rhoden) is an eighteen year-old member of the BCR on a rapid learning curve. Oscar (Alex Barima) lost his parents, John and Alva Watson, when they were shipped off to a Nazi concentration camp in the Midwest.

Oscar and Benjy play key roles in the BCR's plan to take out General Masuda, "The Butcher of Manchuria," and the bombings of San Francisco that ultimately lead to the withdrawal of the Japanese. Oscar is the dutiful soldier, adept with a rifle and willing to do any task, such as driving a truck rigged with explosives.

Benjy is part of the new generation of African-Americans inspired by Equiano's teachings. While he's killed in service of the BCR, Benjy is not a cold-blooded killer. Proof of that comes when he disobeys a direct order from Leon to kill Childan. Instead, the young rebel simply lets him go.

THIS PAGE: Benjy (above) and Oscar (below) were younger members of the BCR.

THE NEUTRAL ZONE

POPULATION: 7 MILLION

AREA OF INTEREST: CANON CITY

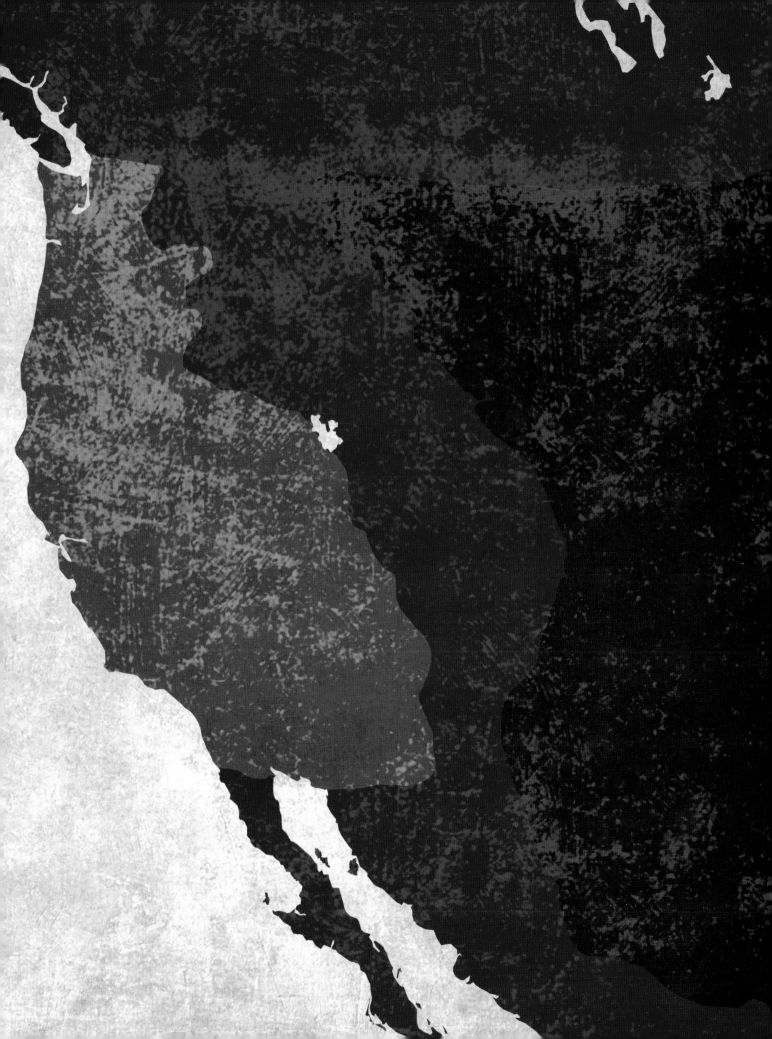

CANON CITY

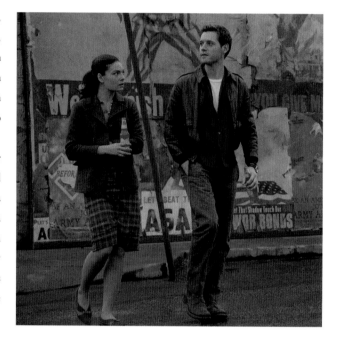

anon City, our first introduction to the Neutral Zone, resembles a frontier town in the Old West. Appropriate, since Canon City exists in our reality, having been founded in 1890. In *The Man in the High Castle* world, it is a reflection of the slow death of the American spirit. "The idea for [Canon City] was, this is the space that America has been allowed to go to rot," says writer and co-executive producer Kalen Egan.

Because it is in the Neutral Zone, Canon City offers shelter for minorities, homosexuals, and outlaws. "Everything is faded in Canon City. It's a consciously nostalgic place of old propaganda posters and old American automobiles that people are holding on to," says production designer Drew Boughton. While the location offers a sliver of hope to the people who end up there, Canon City is also a place the production team was fond of, because it allows for creative expression that doesn't fit with the Japanese Pacific States or the American Reich.

THIS PAGE: Juliana and Joe in Canon City (above). Concept art of the main Canon City crossroads (below).

ABOVE: Concept art and a behind-the-scenes still of the Canon City Hotel.

"As a designer, I loved it having an empty set, and I would turn it over to the paint department and tell them to make [everything] look like it's fifty years old, moldering and rusting. And then they would just go to town on it, and it was so satisfying."

We learn in the season three premiere that Hawthorne Abendsen was the projectionist at the theater in 1948 when he created the very first propaganda film (from spliced news footage) showing the Allies winning the war. Hence, the Canon City Theater is the birthplace of the mythical Man in the High Castle.

The exterior scenes from the pilot were shot in Roslyn, Washington. The Canon City set used for the rest of the series was built on the same back lot in Burnaby, British Columbia used for the 2009 film, *Watchmen*.

BELOW: The theatre where Joe watched his stolen propaganda film in concepts and final sets.

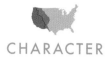

LEMUEL WASHINGTON

ABOVE: Lem is Juliana's first introduction to the resistance.

Like many fans of the show, actor Rick Worthy knew little about the character of Lemuel Washington when he scored the role. "My first question when I was cast was whether Lem was the Man in the High Castle," recalls Worthy.

Lem turned out be one of the leaders in the resistance in the Neutral Zone. He also maintains close ties to the elusive Man in the High Castle. "Lem and [Hawthorne Abendsen] have known each other a long time. They go way back," says Worthy. "There's a reason Abendsen trusts Lem and chooses him as his lieutenant."

His relationship with Juliana Crain is more complicated. They met in the pilot at the Sunrise Diner. After slowly getting to trust Juliana, Lem feels betrayed when she helps Nazi spy Joe Blake escape. That put her in the crosshairs of the resistance, who tries to kill her. "It's a big messy situation that we're a part of," Worthy says. "I always like to believe Lem cared for Juliana, but in the situation they're in, he can't really trust anybody."

The conflict he feels over Juliana came to a head in 'The Road Less Traveled.' Lem and fellow resistance member Gary track Juliana back to San Francisco. They chase her down and shoot at her, although Worthy remembers taking another approach while filming that sequence. "Lem is rightfully pissed off at Juliana, but in that scene where they're chasing her through the tunnel... it just didn't feel right to be shooting at her. It was written that way, but I didn't play it that way. If you watch the footage, I didn't even aim the gun that high."

Lem and Juliana eventually bury the hatchet and Lem delivers Abendsen's remaining alt-world films to her old friend Tagomi. He then joins Wyatt's rebellion in Denver, because he still believes a better tomorrow awaits America. Worthy points out a crucial moment with BCR member Elijah as proof. "Lem is an older guy, he was a soldier in World War II, and he sees the bigger picture. There was once an America we could believe in. But we lost the war. Lem still believes the stars and stripes mean something."

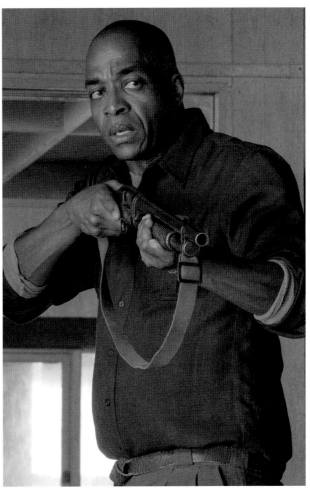

THIS PAGE: Lem's links to the resistance help him form an alliance with the BCR.

THE MUSIC OF
MAN IN THE HIGH CASTLE

Using classical orchestration as the foundation, composer Dominic Lewis used specific musical elements to serve as identifiers for certain characters and locations.

"The way I approached it was to create something familiar but offset it so that it felt very strange," says Lewis. "I used the tent poles of the western orchestra, elements like woodwinds, brass and strings and percussion. From that point, those sounds become associated with the different people and locations in the America we see on the show."

Lewis incorporated woodwinds for scenes in the Japanese Pacific States, and brass sounds for the American Reich. The Neutral Zone allowed Lewis wide berth to experiment.

"The Neutral Zone became this mishmash of everything, including some American folk instrumentation I threw in there, thanks to this hundred year-old Banjolin I have," Lewis says. "I'm never going to be able to tune it in my life but it makes this really amazing noise and I used it for some of the scenes with The Marshal in the first season."

While the Voice of the Reich blares hourly propaganda on AM dial 1030, Resistance Radio broadcasts its defiant message out of the Neutral Zone. Those who find the frequency get to hear DJ Evangeline play African-American music banned by the Nazis. During her time living in the Zone, exposure to this music has a profound impact on Jennifer Smith. Playing these outlawed songs of rockabilly and blues, as the disc jockey says, keeps the spirit of America alive on the airwaves. Music was considered such a key component of *The Man in the High Castle* that Amazon created a promo Resistance Radio station to extend the immersive experience of the television series.

THIS PAGE: George Dixon introduces Juliana to Resistance Radio (top). Street instruments in the Neutral Zone (middle). Bell takes over the airwaves (bottom).

THE MARSHAL

Bounty hunters are hired by the Reich to track down escapees from concentration camps and other fugitives who have retreated to the Neutral Zone. The most feared of these hired guns is Mr. Kahler, who calls himself 'The Marshal.'

The Marshal (played by actor Burn Gorman) carries playing cards with information and photos of fugitives. In our reality, soldiers often carried a deck of cards with their intended targets. The Marshal cuts a finger off his victims as a way to track and confirm his kills, to collect his bounty. He works hard to maintain his fearsome reputation, which is why he hangs the body of Carl the bookstore owner in plain sight. Like the black-hat villain from a classic western, he is relentless, and prefers to let his shotgun and icy glare get his message across.

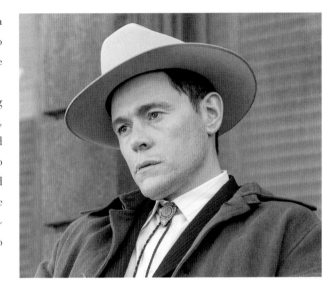

THIS PAGE: The Marshal on the hunt for his bounty.

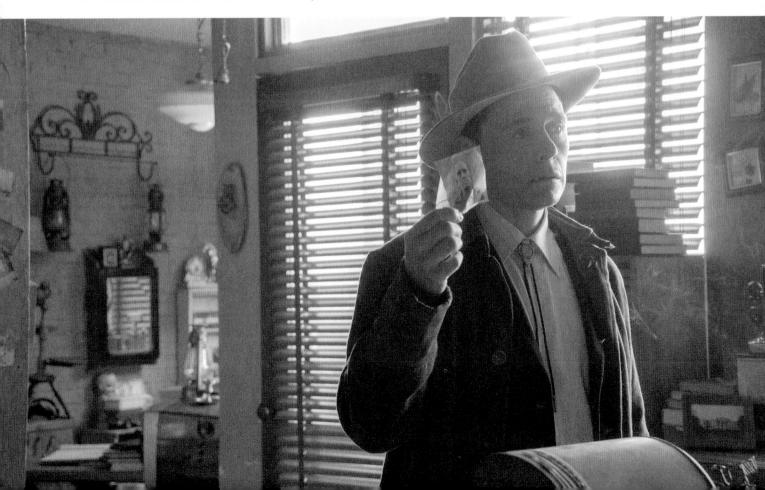

THE ABENDSEN FARM

The Abendsens don't stay very long in any one place. As things began to escalate in season two, Hawthorne Abendsen made the decision to 'lighten his load' and burn all but nine essential film reels and have Lem take them to Tagomi.

They relocate to a secluded farmhouse in the Neutral Zone in Jamestown, Colorado around the time they make contact with alt-Trudy. Juliana joins them after returning from New York, and the four form a close bond. The Abendsen farmhouse scenes were shot on location at the Blieberger Farm in Langley, B.C., which has been used on shows like The X-Files (where it served as Agent Mulder's house). The two-story home is an original homestead with no running electricity, which meant bringing in portable generators and having to find creative ways to hide cables and wires. "There is no bathroom," according to Lisa Lancaster. "Just a water closet."

"We wanted to dress that location to make it feel like Caroline and Hawthorne had lived there and spent a lot of time there, but not too cozy," Lancaster says. "We added touches like wind chimes for when they're looking out the window at Trudy, to help convey that sense of comfort."

The remote location provides what the couple believes is an ideal place to hide out from their enemies. But after the unsuccessful kidnapping attempt by three Nazi Lebensborn agents, the Abendsens realize they have once again run out of time.

BELOW: A small group of the resistance form to watch a new film at the Abendsens' farm.

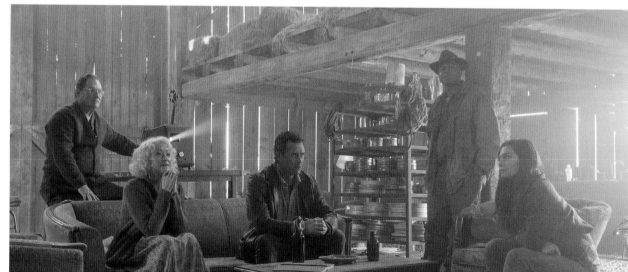

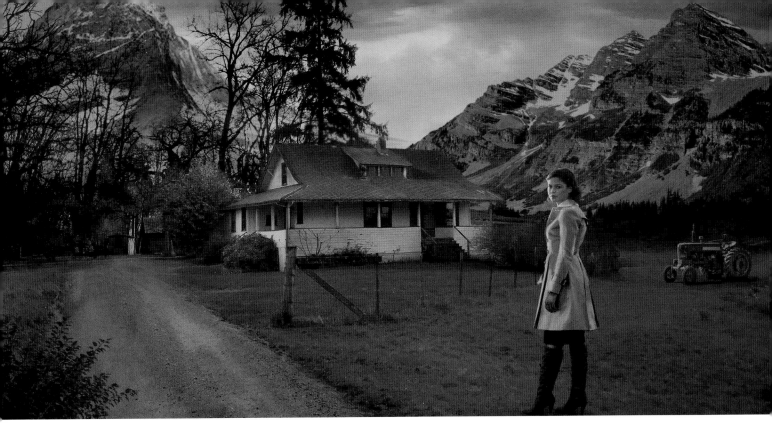

ABOVE: Concept art, featuring Trudy Walker, of the farmhouse. BELOW: Production design stills of the interiors of the farmhouse.

BELOW: Photos on set showing how closely the final exteriors matched the concepts.

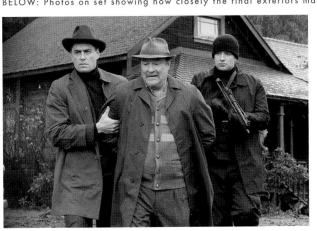

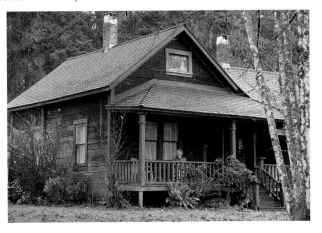

HAWTHORNE ABENDSEN

The identity of the Man in the High Castle was a well-kept secret at the start of production, for good reason: They wouldn't cast the role until late in the first season. "None of the actors knew because... I think I was hired after the first season or very late in the process," recalls Stephen Root, who played the titular character. "We had to keep it under wraps for a heck of a long time.

Hawthorne Abendsen is as much a legend as he is a man in the series. Most people have heard of him, very few have actually seen him. His first appearance on the show even plays into the mystique for dramatic effect. "I love my very first

entrance, when we start in that small trailer, then he steps out into that huge barn filled with films. It was very cinematic," says Root.

Abendsen's journey began as a projectionist at a Canon City movie theater shortly after America's crushing defeat in the war. It was there he created the first of the films. Using wartime newsreel footage, he edited a movie showing the allies winning WWII to boost the morale of the locals. Word quickly spread, and then almost like a magnet, travelers and couriers began arriving from the alt-worlds, carrying real films. In that incidental manner began the legend of the Man in the High Castle.

BELOW: A miserable Hawthorne is forced to record a new kind of propaganda film, this time for the Nazis.

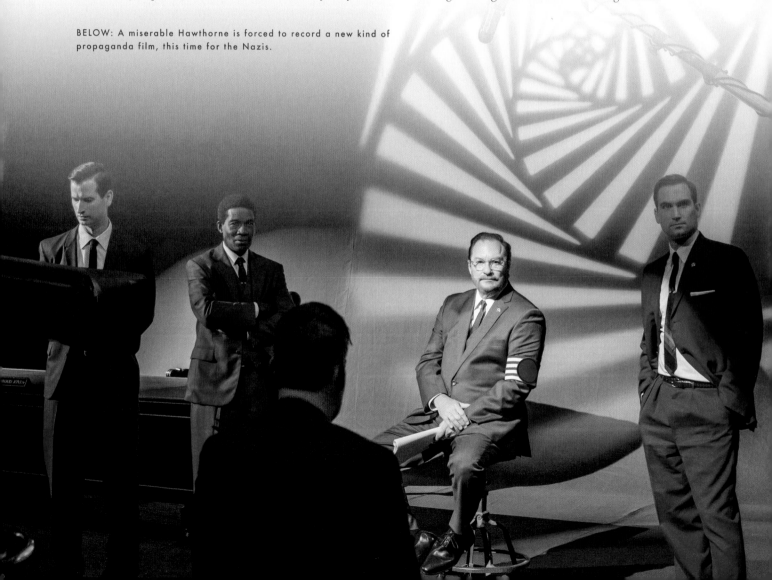

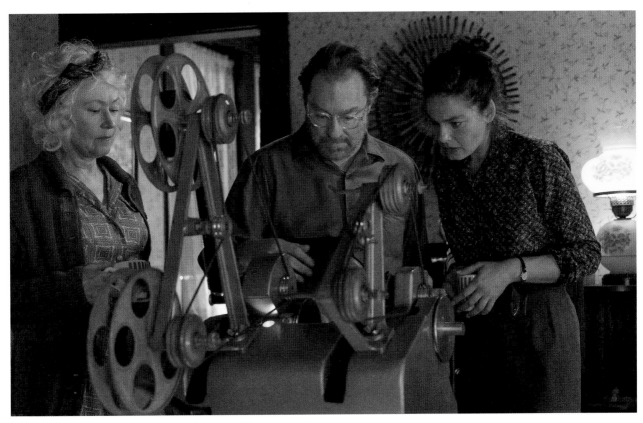

ABOVE: Hawthorne shows Juliana his first ever film.

BELOW: On the in-world set shooting a Nazi propaganda film (left). A sketch of Hawthorne filming his *Tales from the High Castle*. shorts (right).

 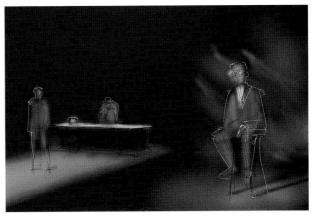

LEFT: Hawthorne with his wife, Caroline, at the farmhouse.

ABOVE: Hawthorne is forced to work for the Nazis.

For Root, the in-depth show bibles executive producer/director Dan Percival created helped provide context for his performance. "It certainly did help, because it was really extensive and a great starting place," Root says. The actor particularly enjoyed the show's exploration of its more otherworldly elements. "It was a pleasant surprise to find out that the show was going in the direction of the multiverse because I'm a huge sci-fi guy myself," he says. "They planted all the seeds. They did their job, writing-wise, to make it a viable and real world."

Percival sees Abendsen as a man under immense pressure because of the knowledge he is burdened with. "He is the only person who understands about other worlds because he's the only one who has met travelers," Percival notes. "And yet, Abendsen, in his own way, is trapped by his own limited understanding of what the films are."

As curator of some 3,000 films, Abendsen picks up on many patterns and familiar faces, including Juliana Crain. Their relationship gets off to a bad start, but Abendsen eventually comes to care for her and to understand that, ultimately, his role in the bigger picture is to help Juliana figure out hers. "It's like in life. You can tell when you've been around people whether they're good people or not," says Root. "Abendsen

grew to know that she was a good person."

Abendsen's capture puts him at the mercy of John Smith in season four. In order to see his beloved wife Caroline, he's forced to be a Nazi propaganda puppet as host of *Tales from The High Castle*. "Being a huge Twilight Zone fan, getting to be in a version of that was a great surprise and joy to act in that," Root says of yet another of the show's clever twists on 1960s TV programs. "Even if it was detrimental to my character!"

Smith and Abendsen's history goes back to the war, when they both fought on the same side. Root was happy the writers gave him the chance to share screen time with Rufus Sewell. "It was fantastic that it happened," he says. "As an actor it gives me a chance to work with a great actor like Rufus that you wouldn't think you'd get to work with, but they found a way to put us together."

In the series' final moments, Abendsen is there as a wave of travelers enters his world through the portal. He smiles and he cries, knowing that this will change his world. His burden has been lifted. "I think that's exactly right," Root says. "He was saying, it's not me anymore. It's time to give it to somebody else."

And with that, the Man in the High Castle stepped into the portal and exited this world for another.

CAROLINE ABENDSEN

Caroline Abendsen (actress Ann Magnuson) i the wife and partner of the mythical Man in the High Castle. She grows close with Juliana Crain and her half-sister, alt-Trudy, during their stay with them at their farmhouse in Jamestown, Colorado.

Caroline notices Trudy is unable to sit still and is growing increasingly agitated. It is her observation that uncovers a problem all travelers encounter: Spending too much time in another reality can lead to great physical and emotional damage. It is why she is relieved to hear that Trudy eventually returns to her own parallel timeline.

A lifetime in hiding hardened Caroline. She trained herself to be a deadly accurate shot with a pistol. She also teaches Juliana how to become an expert marksman, which comes in handy when Juliana saves Caroline and Hawthorne from the Lebensborn assassins.

Above all else, Caroline is devoted to Hawthorne. Their relationship is unique to the High Castle reality. They are not together in any of the thousands of films Hawthorne has seen from the couriers, a fact Caroline sees as confirmation of the uniqueness of their love.

BELOW: Caroline worked with her husband, Hawthorne, to fight the Nazis.

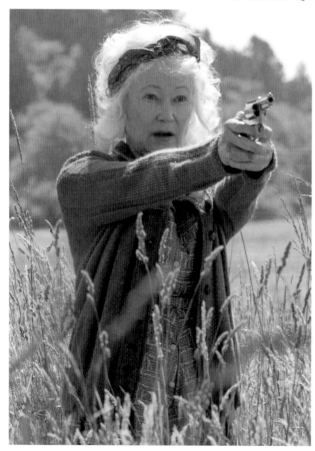

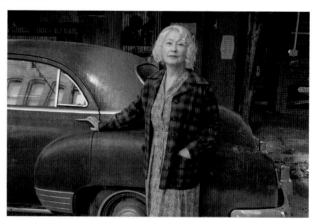

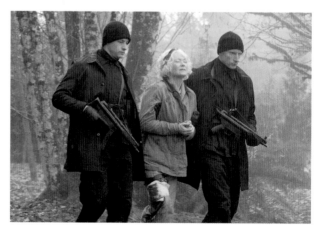

WYATT PRICE

The first time the audience lays eyes on Wyatt Price, he's just another guy on the hustle in the Neutral Zone, an Irish fixer peddling black market medicine. It won't be long before he becomes a key figure in the American uprising. Jason O'Mara very much enjoyed playing Wyatt, especially since it afforded the actor the rare opportunity to use his authentic Irish brogue.

"It had been a while since I was able to be Irish and I quite enjoyed it," O'Mara says. "After I went to meet David Zucker and Isa and the rest of the team initially for the role, I assumed I would be [playing an] American. I got the call afterwards that they want Wyatt to be Irish. At first, I thought they were joking, and once I realized they were serious, the whole concept of the character opened up to me."

BELOW: Wyatt and Juliana hiding out in the safe house while they form their next plan.

Ireland's complicated political history informs some underlying elements in *The Man in the High Castle*. "Especially when you consider the history of Ireland and the neutrality, with particular regard to World War II," he says. "It allowed the writers and producers to create quite a rich and unexpected back story."

In the show, Ireland does join the effort against the Nazis. Liam (his real name) fought against the Reich in Europe, and like many others, fled to America when the war was lost, and disappeared into the Neutral Zone. But while his motives seem self-serving at first, his innate sense of justice eventually wins out.

"What we tried to achieve with Wyatt was this sense that he had compromised himself morally," notes O'Mara. "That he was playing both sides against the middle for his own personal gains. But if push came to shove, he would probably choose the right side."

Those wheels go in motion once Wyatt meets Juliana at the Grand Palace in Denver. Their connection is immediate and impactful. "They both carry around such a deep sense of loss and grief, that even if things did improve, it would never change what they have lost." No longer content to sit on the sidelines, Wyatt in the final season becomes one of the leaders of the reborn resistance, returning to New York with Juliana to take down Reichsmarschall Smith.

In the show's final scene, as people from the alt-world start coming through the portal, Wyatt finds himself side-by-side with Juliana. As it should be, according to O'Mara. "Wyatt is right there, with Juliana by his side, right until the end, which I love. I think they've both earned that. It suggests hope. And like all the best endings of any television series, it leaves something up to the imagination."

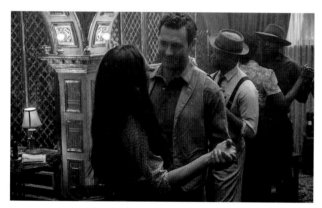

THIS PAGE: Wyatt's links to the underground serves him well as a leader of the resistance.

THE GRAND PALACE

The idea behind the Grand Palace Hotel was to create the Neutral Zone version of Rick's Café in Casablanca, a place soaked in booze, bad intentions, and regret. The actual design aesthetic was modeled after a real-life landmark in Denver, the 127 year-old Brown Palace Hotel. "It was a real place. One of the first large hotels in Denver," says Jonathan Lancaster. "That's where [our] inspiration came from. All the archways and moldings, they all were inspired by that place. That was a great set."

"We picked out all the old electrical parts and had them glued together. We had to find velvet drapery – who gets to do that on television anymore? And then we had our guys paint them to make them look much older," adds Lisa Lancaster. Other times, the Lancasters went digging around every antiques shop they could locate in search of the items they needed to bring the set to life. One treasure they unearthed was the vintage 1938 Seeburg jukebox, in working condition, seen in the background of the debut episode of season three.

The slavish attention to the tiniest detail can help draw the viewer into the story. A perfect example is a vintage beer brand that prop master Dean Barker felt was perfect for The Grand Palace. "It was called the People's Beer. I just thought it was a nice tie-in to this outlaw resistance depot. So we tracked it down and we were allowed to use it," says Barker. "We got a lot of comments on Instagram from people remembering that brewery from that area in that time period. Those small details sitting way in the background, for a viewer to notice that was pretty amazing."

THIS SPREAD: Concept artwork of the hotel bar (below) and a final still (top right).

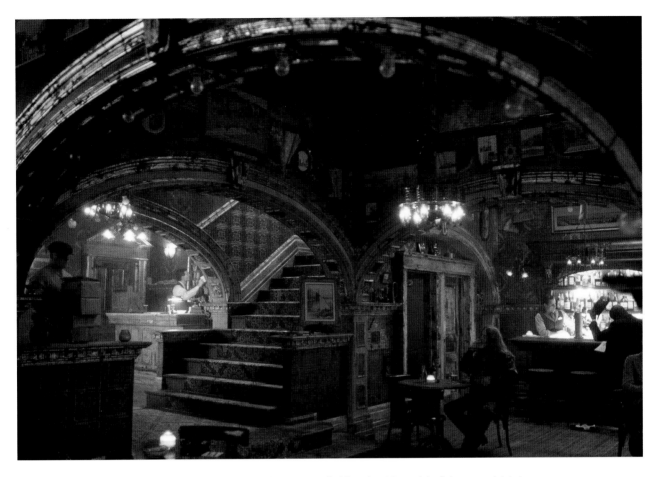

BELOW: A sketch of the bar from the point of view of the stage (left) and a 3D model of the room (right).

BELOW: Concept art (left) and a final production still (right) demonstrate how detailed the early stages are.

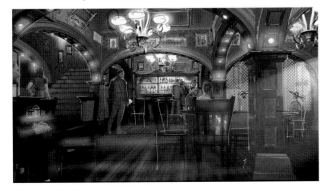

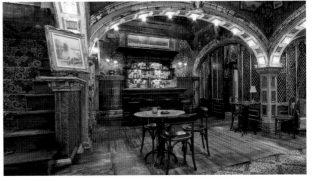

THE BORDER WALL

The Nazis have strict security measures along the eastern border of the Neutral Zone. Armed soldiers guard the entry point to prevent unauthorized entry to the American Reich. In season three, Juliana and Wyatt engage in a shootout with patrols at the border wall as they snuck back in to the Eastern section of the country.

The location used for the border wall sequence was the Cleveland Dam in northern Vancouver, and it led to some unavoidable logistical challenges. "The location itself was under construction at the time which proved to be a very tough obstacle to overcome," recalls location manager Nicole Chartrand.

If this location seems familiar to sharp-eyed viewers, that's because it's where Juliana throws the German agent off the bridge. The production team used the location and staged the border wall sequence in a different manner, to create a whole new look for the dam.

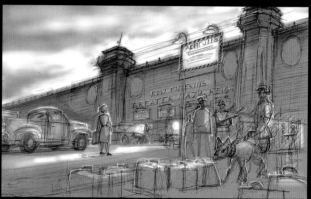

THIS PAGE: Sketches of the border walls at both sides of the Neutral Zone.

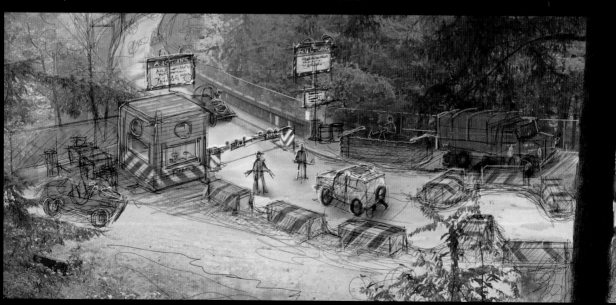

ST. THERESA'S

The Jewish people in the Neutral Zone hide in plain sight within St. Theresa's.

The moment one enters the gated community, large crosses provide the appearance of an appropriately Christian environment. Since the extinction of the Jewish faith is a longstanding priority for the Nazis, St. Theresa's offers refuge for those who want to practice their Jewish heritage. But it must be done under the guise of Catholic worship. When Griggs the bounty hunter forces his way into St. Theresa's, Father Finn begins to hold a traditional Catholic mass.

The uniform whiteness of the buildings was an intentional design choice by the production.

"We decided to paint all the buildings white to give it a little uniqueness," says producer Erin Smith. The whitewash also provided a biblical sensibility that supported the community masquerading as a Christian outpost.

"With that one move we really transformed it," adds location manager Nicole Chartrand. "It really looks and feels like a small western town."

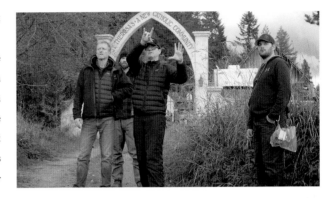

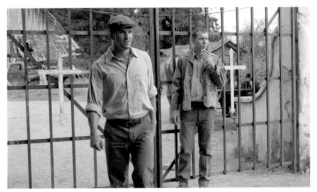

ABOVE: Behind-the-scenes photo of the set (top). The community are cautious and keep guards at the gate (bottom).

BELOW: Concept art of the gated arch entrance.

LOCATION

SABRA

S abra is a community of Jews in the Neutral Zone, nestled in the mountains outside of Denver. It masquerades as the Catholic enclave St. Theresa's, to avoid detection by the Nazis and the bounty hunters they use to hunt down Jewish people. 'Sabra' is the Hebrew name for a cactus that can grow and thrive in the Holy Land.

For the people at Sabra, resistance means survival and the preservation of their Jewish heritage. The written word is extremely important within Judaism, and the Torah is the foundational text. Writing a Torah scroll by hand is considered a religious act, and only a trained Jewish sofer (scribe) can do it. There is at least one such scholar hiding in Sabra.

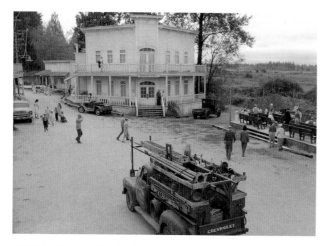
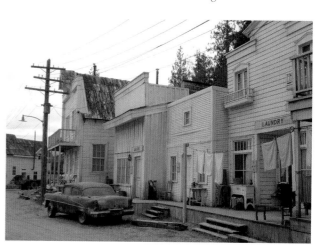

ABOVE: The people who live behind these walls formed a community to look out for one another.
BELOW: The main road of Sabra, in concept art.

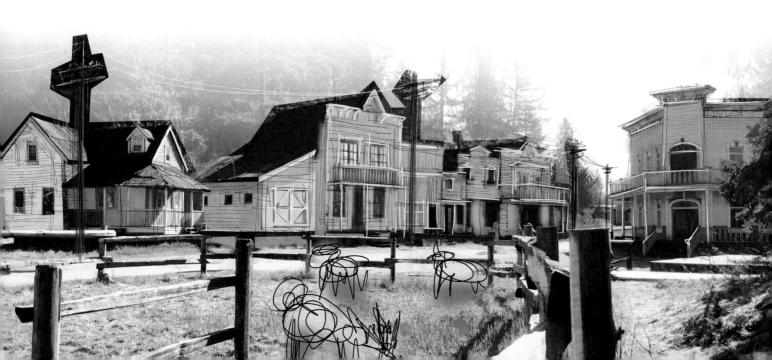

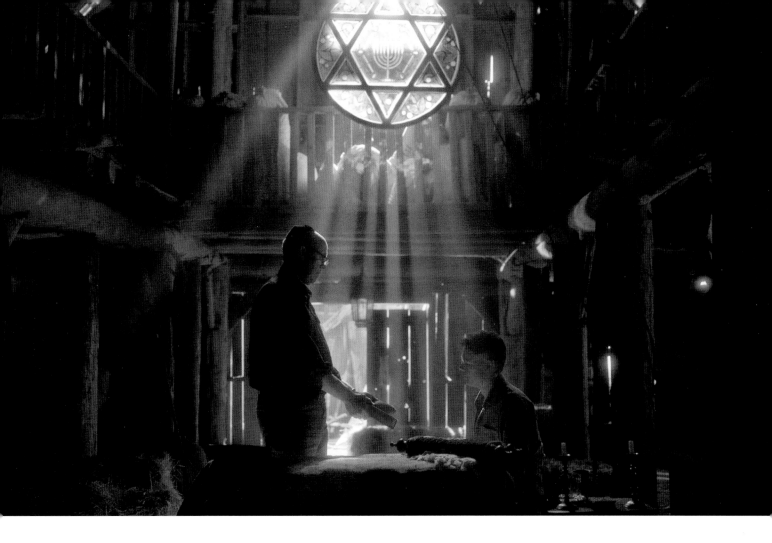

A remote back lot named Bordertown was used for the Sabra scenes. According to location manager Nicole Chartrand, the aged appearance of the thousand-acre ranch provided the perfect complement to the aged aesthetic that defined the Neutral Zone. "We went out to the property, and it just provided all those elements we were looking for. It looked like this town in the Old West with some level of decay, and everybody really responded to the imagery," Chartrand says. "It was very turn of the century, very nostalgic."

The Bordertown set was rather secluded, which meant a long drive each day for the cast and crew. Michael Gaston, who plays Mark Sampson, says it was worth it. "It's crazy that Drew Boughton and his team were able to create this great period location. It was a wonderful place to go to work. A little far from the hotel, but it was good."

TOP: Mark teaches Frank to read the Torah.
RIGHT: Concept art of Frank's studio and the temple at Sabra.

MARK SAMPSON

The first time Mark Sampson meets Frank Frink, he whispers "to life," a translation of the Hebrew phrase "l'chaim," to let Frank know he was Jewish. From that point on, Sampson becomes instrumental in helping Frank rediscover his Jewish heritage.

"He was there to provide some spiritual paternity, and brotherhood for Frank to support him through all that he was going through," says actor Michael Gaston, who played Sampson in seasons one to three. "I think he probably had, and I don't mean this pejoratively at all, an ulterior motive too in helping to bring Frank in. Which was to keep the Jewish faith alive for as long as possible."

Sampson himself had only truly become committed to Judaism after the Nazis and Japanese won the war, and the Reich began systematically eliminating American Jews and all signs of their religion.

"My understanding when Frank Spotnitz and I first talked about the character was that he was not a religious person," Gaston explains. "It wasn't a part of [Sampson's] life until it got taken away and then he suffered so many personal losses."

Guiding Frank to truly connect with his faith enabled Sampson to better understand the importance of Jewish traditions, as he describes during the Bar Mitzvah ceremony in 'Sabra' from season three. Gaston, who is not Jewish, dove into the study of the Torah and Judaism to prepare for the role, with a bit of help of modern technology. "There is actually an app

for that, if you can believe that," Gaston said with a laugh. "I also consulted with three or four different rabbis. It's one of the great gifts of [acting]. It sends me down these paths of inquiry that you never would have necessarily thought to otherwise."

The veteran character actor was grateful for a role that was a departure from the villains he's often played in his long career. "If you're a man and you want to have a consistent career and you aren't particularly handsome, you better be good at playing the bad guy. And that's sort of what I've had to do," Gaston says. "So it's been a thrill to play a positive character."

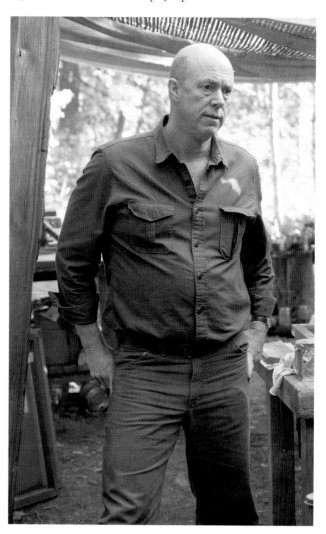

"IT'S BEEN A THRILL TO PLAY A POSITIVE CHARACTER"
MICHAEL GASTON
MARK SAMPSON

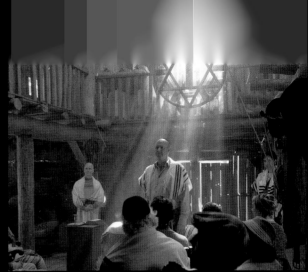

ABOVE: Mark introduced Frank to Judaism and helped him find redemption.

LILA JACOBS

Before she ever utters a single word, Lila Jacobs introduces herself by putting a bullet through the head of a bounty hunter. Tough as nails and gifted with a pragmatic nature, Lila (portrayed by Janet Kidder) is the perfect leader for the Sabra community. "Janet is an incredible actress and we just really connected right from the start," says Michael Gaston, who plays Lila's husband Mark Sampson.

Lila and Mark's relationship gave the actors a chance to flip the dynamic on typical television romances. "When we kissed for the first time, it was originally scripted so I was the one who made the quote unquote first move," Gaston recalls. "But it was important to me that Lila be the one to do that and that it be sort of shocking and a little scary, and I successfully convinced the writers [to change it]. That's one of my favorite moments on the show.

BELOW: Lila will do anything to protect her community.

RICHIE

In the shadow of the Brooklyn Bridge, Richie keeps his "finger on the pulse," as he says.

He traffics in pornography for his influential clients, who value his discretion. As Richie points out, he's like a madam. He's protected by his client list.

There is history between Richie and Liam going back to the war. When Wyatt (Liam's alias) returns to New York City, he determines that shady operators like Richie are his best bet. "Some of these guys Wyatt contacts are old friends, but 'Raunchy Richie' is just a business relationship and there's a bit of, 'you scratch my back, I'll scratch yours' thing happening," Jason O'Mara says.

Richie helps make hundreds of copies of *The Grasshopper Lies Heavy* to distribute across the country. And he happens to hold on to a copy of the film reel that becomes especially crucial after the resistance's crushing defeat in Denver. 'Raunchy Richie' turns out to be a very useful ally.

THIS PAGE: Richie (played by Peter Kelamis) helps the resistance create and distribute films.

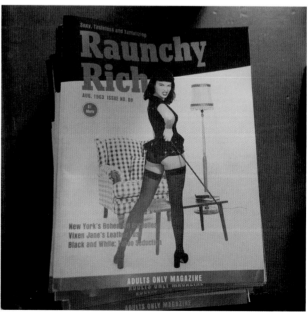

JEREMY JOHNSON

Jeremy Johnson (Glenn Ennis) is a member of the East Coast resistance who becomes Wyatt's most trusted lieutenant. They meet when Jeremy agrees to help with the plan to sneak into the No. 9 Lackawanna coalmine and blow up the Nazis' Die Nebenwelt portal. When the plan goes awry, Wyatt and Jeremy escape and return to New York City.

After watching the Statue of Liberty be destroyed, Wyatt and Jeremy target the Nazi leader. From a high vantage point in a nearby office building, Jeremy fires the rifle shot that severely wounds, but does not kill, the reichsführer. They quickly exit the building and blend into the crowd to escape detection.

Jeremy was with Wyatt when the resistance suffered devastating losses in the Battle of Denver. After aiding the BCR in the bold assassination plot at Childan's mansion auction, Jeremy and Wyatt return east with renewed purpose. Jeremy is one of the key figures in the takedown of John Smith in the Poconos train assault

THIS PAGE: Although he's a new face to the series, Jeremy is a significant member of the resistance.

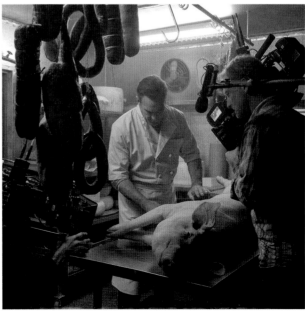

THE BATTLE OF DENVER

The city of Denver is the setting for one of the most ambitious sequences in the history of *The Man in the High Castle*. The Battle of Denver happens at the onset of season four between the resistance network led by Wyatt Price, and a Nazi battalion that enters the Neutral Zone. Wyatt's forces are decimated, and the setback in Denver sends him underground to regroup and rethink his approach to fighting the Nazis.

Shot on a railway yard in Squamish, British Columbia, the set piece took nearly two months of preproduction planning and involved several days of filming utilizing tanks, eighteen-wheeler trucks, and even fifty cows! "[The Battle of Denver] was probably the biggest set-up we've done on the show," says stunt coordinator Maja Aro. "We had almost fifty stunt performers for that."

Some carefully placed VFX were added, says VFX supervisor Lawson Deming, to include German military vehicles that show the Nazis' technological edge. "It was great to be able to use visual effects for world building in that sequence," he says.

"I think it started out like *Saving Private Ryan*," jokes Jason O'Mara. "We had lots of extras, stuntmen, and well-placed pyrotechnics and... there was this machine gun with blanks that was so loud you could actually see the pulses of sound coming out of the weapon. The kind of sound you could feel inside your body. We woke up the next morning with cuts and bruises, but nobody got seriously hurt."

O'Mara has seen his fair share of highly-stylized action scenes thanks to roles on series like *Marvel's Agents of S.H.I.E.L.D.* and *Terra Nova*, and says *The Man in the High Castle* crew takes a back seat to no one. "Show me a show that looks better than *The Man In The High Castle*," he says. "Everybody's got to come together and complement each other. When you see teamwork like that, that's when you know you've got a great crew, above and below the line. I can't say enough about those guys."

BELOW: Taking direction for the battle scene.

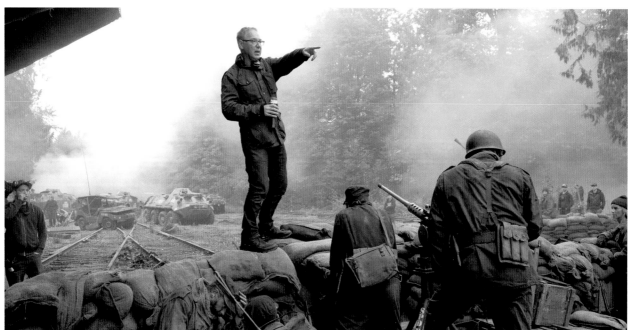

ABOVE: A brief pause between takes to discuss the scene (top). Wyatt narrowly misses an injury (bottom).

ABOVE AND BELOW: Concept art of the action-packed Denver battle scene.

GREATER NAZI REICH

POPULATION: 80 MILLION

AREA OF INTEREST:
NEW YORK, NEW BERLIN

NEW YORK CITY

In the High Castle world, the Reich has weaponized propaganda and turned the swastika into a symbolic WMD. Nowhere is the power of the Nazi machine on bigger display than among the bright lights and big buildings of New York City, the capital of the American Reich.

Frank Spotnitz is no stranger to world creation, thanks to his years on *The X-Files*. The 'lightbulb moment,' as Spotnitz calls it, in understanding this world came when he saw an early piece of concept art of Times Square under Nazi rule. It showed billboards with images like beer, sausages, and girls in traditional German dress. "It completely missed the point," he says. "It's not about America being forced [to adopt] German culture. It's about America being forced to take fascist values as their own."

New images were created with Nazi slogans proclaiming the virtues of work and the agricultural industry. "We got rid of all the optimism of the American architecture and design we actually had in the 50s and 60s," Spotnitz says, "And replaced it with much more functional stuff. That is a lesson I learned from *The X-Files*. What we always used to say on that show was, 'It's only as scary as it seems believable.'"

Production designer Drew Boughton was the architect of the world within the show. Boughton dug into research to try and reasonably predict what an Americanized fascist society would look like. "There's much more limited access into the fascist and totalitarian societies of the 60s than there is about fascism in the 1930s," Boughton notes. "But that's where we found some of our most interesting images because they were sort of like modernized Nazism."

Creating a fully realized New York City under Reich rule involved digital layering. Visual effects blended with actual

BELOW: An iconic New York City streetscape in concept art.

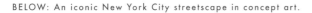

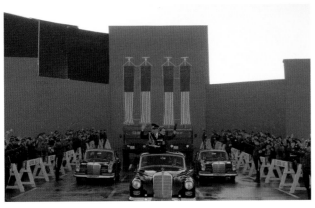
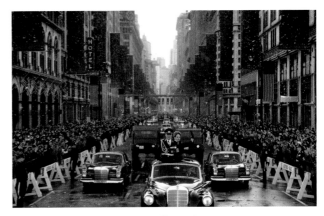

ABOVE: Before (left) and after (right) the backgrounds and buildings were added by the visual effects department.

ABOVE: A full artistic concept of the New York City skyline.

locations and sets to create the sprawling skyscrapers and infrastructure on the show.

"We worked very closely with Drew's artwork and illustrations and what the art department created," says VFX supervisor Lawton Deming. "Because visual effects have a tendency to automatically come across as more fanciful, you're fighting this uphill battle against believability. It was extra important to me to be able to have very real-world references – like, this is what a building made out of this kind of concrete looked like – for everything that we did. So we worked extra hard to make them mundane. To make them match what we believe real life looks like."

Boughton and David Semel, who directed the pilot, created a backstory about the industrial design of this alt-world. They took inspiration from German designer Dieter Rams, a mid-century industrial designer who worked for the Braun products company and whose 'less is better' design approach had a strong influence on Apple's products. "Rams kind of influenced the sober plainness of the kind of product design in our thinking about everything in the show," Boughton says.

"I think a huge part of the success of the show was Drew Boughton's incredible attention to detail, and his full embrace of this idea that it must be authentic and have an internal logic," Spotnitz adds.

That includes the incredibly detailed props that fill most every scene in Nazi New York, which carried the omnipresent symbol that drove home the message. "We put swastikas on everything. Notebooks, pocketbooks, briefcases, coffee cups," says prop master Dean Barker. In real life, the swastika was ubiquitous in Nazi Germany, something that surprised Boughton during his research. "And the more we studied it, we found out that the Nazis with the swastika had basically invented what we call a branding campaign," he says.

EVERYDAY EAST COAST AMERICA WARDROBE

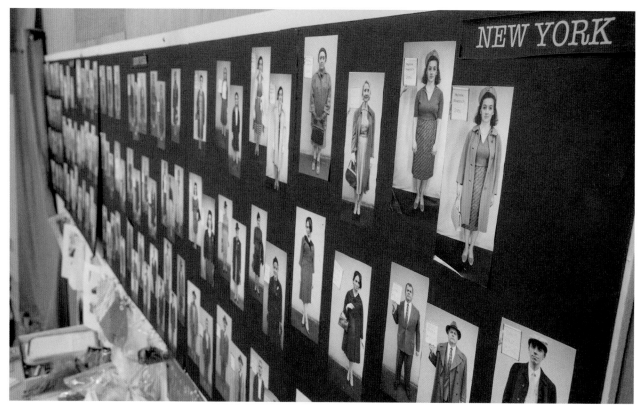

ABOVE: The costume department's visual list of all the different looks created for the West Coast background characters.

The fashions of the Greater Nazi Reich reflect the stunted nature of the reality of the series. The postwar optimism that appeared in European and American fashions of the 60s never came to be in this world. Often, the clothes seen in scenes set in New York City appear to be a blend of *Mad Men* influences and *The Winds of War*.

"In our alternate world, many of the historical events that happened in terms of fashion and history didn't happen in our world," says Audrey Fisher, the costume designer for the show's first season. "There was no Elvis, no JFK; so fashion is different and not as far forward as it would have been in our 1962.

"We created a very strict vocabulary [at the beginning]," she continues. "It was important to us to maintain the rules and make sure we didn't deviate in a way, like referencing designers who couldn't have existed past the end of the war, because that would upend the whole effort."

The clothes worn by John Smith when he is at home on Long Island in the first two seasons reflects the idea of culture and fashion being somewhat frozen in time, specifically the 50s. "When John Smith was home, he had this almost creepy casual dad look with his Mr. Rogers type sweater," Fisher says. The stylish exceptions to these choices would be high-ranking officials like Minister of Propaganda Billy Turner.

German filmmaker Nicole Dormer in particular exuded a sense of fashion that mirrored her status in the Reich. "Nicole's attitude is, 'I want to wear a dress that's almost backless because I can, because I am the elite.' Her attitude reflects how the Germans are, in a sense, more loose," notes season three costume designer Catharine Adair.

In Helen Smith's case, her classic American housewife fashion sensibilities are part of her façade to hide her fragile mental state after the death of her son, Thomas. "It's those values of femininity, domesticity, and being beautiful and impeccable and sort of always looking a certain way," says Fisher. "That's the Nazi idealism of womanhood for a woman in that environment, and Helen exemplified it."

JOE BLAKE

Joe Blake could never truly escape his destiny.

Originally sent to the Neutral Zone by John Smith to infiltrate the resistance, Joe winds up questioning his purpose after meeting Juliana Crain. "She changed him. She helped him discover a sense of humanity rather beyond his mission," says actor Luke Kleintank. "For me personally, I always thought that he was against the Nazi party. I think the audience probably believed that, too. At least that's how I played him."

Joe's relationship with Smith was complicated by the fact that the obergruppenführer was the father figure Joe had never had. Kleintank notes that one un-filmed scene in a season one episode was to have a flashback where a young Joe Blake is caught by John Smith trying to steal a car. That marks the beginning of a relationship where Smith would groom Blake for the Reich. The actor says he used that untold backstory to inform his approach to the character.

"Joe's kind of an outsider and doesn't really have anybody, until Smith," Kleintank says. "Yeah, he was helping him and teaching him, but ultimately he used [Joe]."

Joe's journey to Berlin changes him in many ways. He discovers he was part of the Reich's Lebensborn program. He meets his father Martin Heusmann, soon to be named acting chancellor after Hitler's death, and learns the truth about why Joe's mother raised him alone. After Heusmann is arrested

for poisoning Hitler, Joe is imprisoned and re-educated. He is forced to execute his own father.

"The emotional aspect of that scene, because [Joe] was so brainwashed, you would think that he would just stand there and shoot his father without any problem, right?" Kleintank says. "But I didn't want to make him a robot. If you were going to shoot your father in the head, how would that feel? You can't really control how you feel. It'll just come out."

Kleintank says the re-education Joe undergoes in Berlin saps any rebellious streak left in Joe. "He is a broken man in season three," the actor says. "But there is some truth to what he's saying to Juliana, that the Japanese won't last because the Nazis are so much stronger. I don't think he's saying that in the way that you would think of a Nazi."

"JOE'S KIND OF AN OUTSIDER AND DOESN'T REALLY HAVE ANYBODY, UNTIL SMITH,"
LUKE KLEINTANK
JOE BLAKE

THIS PAGE: Joe served as an introduction to the Nazi world.

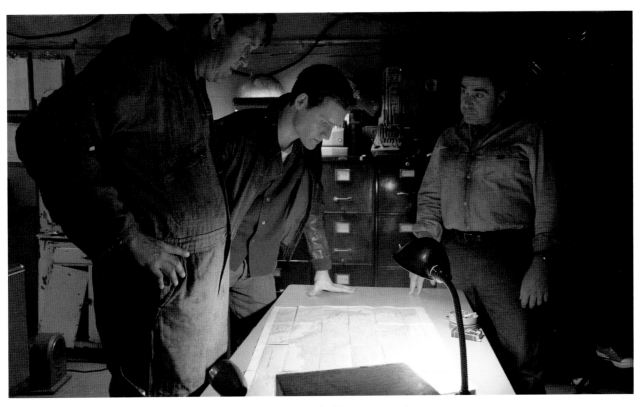

THIS PAGE: Joe's work with the resistance in season one is in aid of Nazi reconnaissance.

Juliana and Joe's 'reunion' in the third season confirms just how far apart they have grown. Juliana is discovering her true purpose in the grand scheme of the High Castle world, while Joe commits to his new role as Nazi assassin. His memorable death at Juliana's hands closely mirrors the death of Joe Cinnadella (the character Joe Blake is based on) in Philip K. Dick's original novel. Kleintank remembers it well, because it was his final day on set. At least, it was supposed to be.

"I had a prosthetic around my neck and a tube attached that would shoot out blood. For some reason, the blood wouldn't work. We had to cut the scene and had to stop," Kleintank says. "I was prepared this was going to be my last day, and all my emotions were there. This is my last scene, and I'm like, 'oh man. I've got to do my death scene twice.'" Three weeks later,

Kleintank returned to reshoot the scene and brought along his sister and brother-in-law, who is a surgeon. "They were on set watching us do this scene, and thank God he was there," notes the actor, "because he was telling them exactly what it would really look like. He was like, 'Oh, that gaping, there wouldn't be that much blood.' He was like, 'Instantly you should make him pale because his face would go pale.' And they did."

Kleintank left with another memory from his final days of shooting that was a bit more painful. "When I fall back against the wall, I really slipped. I hit one of those little towel holders in the bathroom," he recalls. "That wasn't fake. It wasn't me pretending. I think there was blood on the ground because I think it was one of the many takes we did. But yeah, I fell really hard. It looked great, though."

BELOW: After his torture and brainwashing, Joe becomes a hitman for the Nazis.

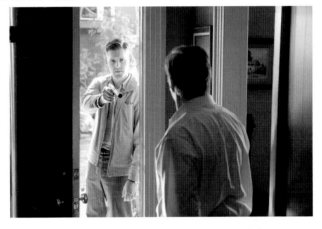

BELOW: Filming Joe's death scene involved prosthetics and a large amount of fake blood.

TIMES SQUARE

Times Square is an important touchstone for establishing the dystopian environment of the Greater Nazi Reich. The towing neon swastika billboard was part of the Germans' strategy to institutionalize Nazi ideology in America. "It reveals this icon of American consumerism distorted into a vessel for Nazi propaganda," says executive producer/director Dan Percival.

The Times Square sequence from the pilot episode was filmed in an empty lot surrounded by green screens in Seattle, Washington. Plate photography of Times Square from the early 1960s provided the background, while details such as billboards, cars, and even some people were digital layers added in postproduction. "We didn't design the entire shot in 3D because we didn't need to," Percival notes. "The shot was designed to work with the plate photography. "

As the show evolved, so did the show's idea of what 'crossroads of the world' would look like in the High Castle reality. "It's not just about placing swastikas on everything,"

says visual effects supervisor Lawson Deming. "It's about creating a variation of that world that represents fascism, in a less overt way."

Part of the process involved figuring out the elements of this Nazi-occupied New York. That meant more conservative clothing, duller color palettes, and less adventurously designed cars.

"We would constantly ask ourselves, 'what is this image supposed to do?' The more we built out our world, things like the advertisements evolved," Percival says. "The CGI also became more sophisticated when we revisited Times Square in later seasons."

Deming credits the art department for creating the compelling background imagery that helped firm up the show's immersive environment. "They did a really good job creating advertisements and world-building things, like the phone booth, versions of cigarettes and alcohol," he says, "And the type of advertisements that you would see in a place that is as dense with advertising as Times Square."

BELOW: A horrifying reimagining of the landmark New York City attraction.

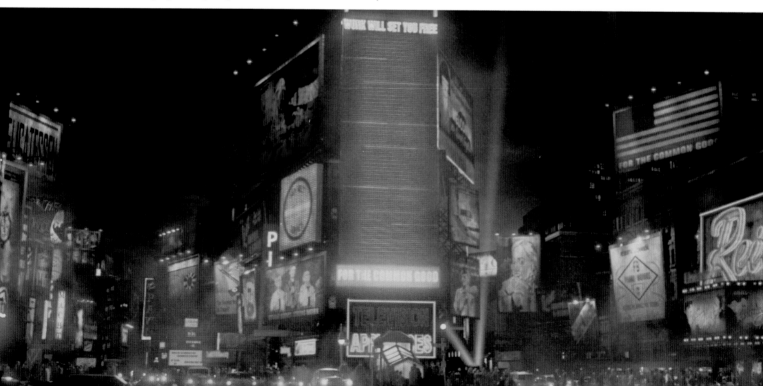

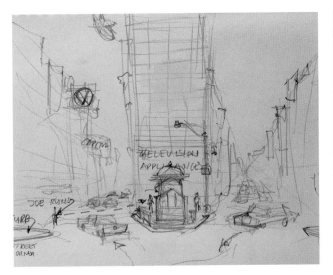

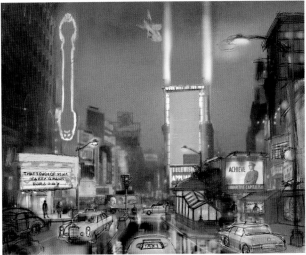

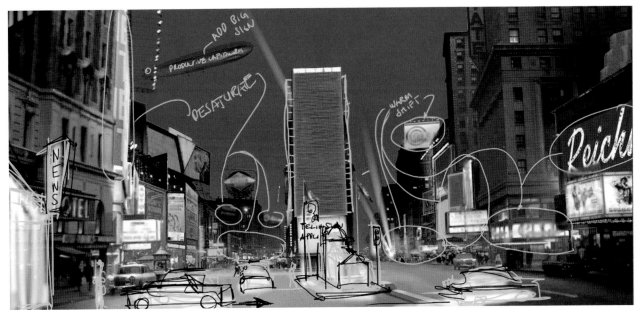

THIS PAGE: Sketches and concepts of the location (above). The final set and concept design of a news stand (below).

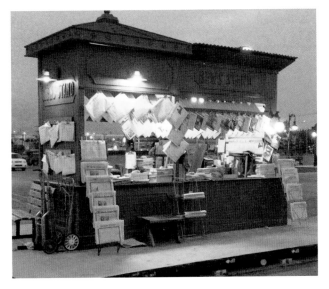

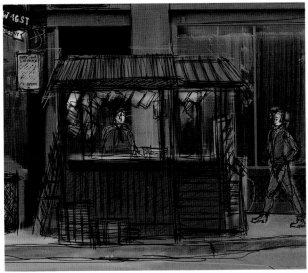

NEW YORK SS HEADQUARTERS

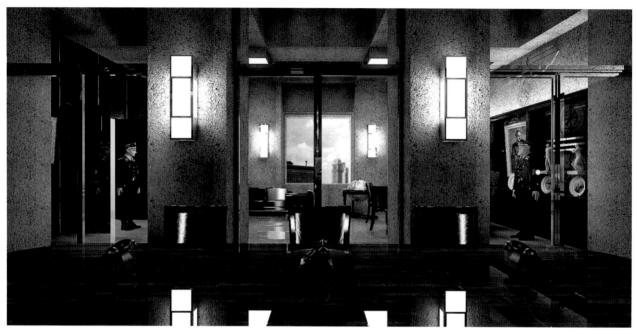

ABOVE: A 3D composition of the SS war room looking out onto Smith's office.

The first time we see the American Reich's New York City headquarters, its towering presence is immediately noticed. The grey stone design evokes images of Cold War-era buildings in eastern bloc nations under fascist rule. It is an imposing structure, by intention. "Nazi architecture was always designed to make people feel small," says Frank Spotnitz. "I heard a story once that Walt Disney designed Main Street in Disneyland at a smaller scale, because he wanted people to feel big. It was a direct response to Nazism and the architecture of the Nazi regime."

Production designer Drew Boughton incorporated the straight lines and dull concrete aesthetic common in Nazi Germany into his design of Nazi New York. "Drew is really the guy who built the base that we went off of," according to set decorator Jonathan Lancaster.

John Smith's office inside SS HQ has the atmosphere of a Wall Street power broker's workspace. It's a long, dark office that casts an intimidating shadow over most visitors, an effect that surely is not lost on Smith. "We had a lot of discussions about the type of furniture to put in his office. We decided to go with the smoking couch and chair and the heavier, darker desk," says Jonathan Lancaster.

The placement of key Nazi paraphernalia around Smith's office reinforces the importance of symbolism in the Reich, an element the art department team found from historical research. Hanging on the wall behind Smith's desk, above a painting of the führer, is the parteiadler (Party's Eagle). In 1935 Hitler had the Eagle and swastika combined to create the emblem for the Nazi party. Mythology also mattered greatly to the führer. Hitler wrote in *Mein Kampf* that Germans, Greeks, and Romans were linked together in racial unity. "The Nazis idolized Roman and Greek sculptures. That's why you'll see evidence of that influence across the Reich offices," noted Lisa Lancaster.

BELOW: A sketch of the interiors of the headquarters (left) and a floorplan of Smith's office and war room (right).

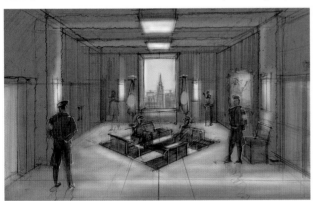

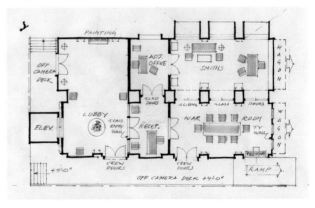

BELOW: A 3D composition (left) and final production still (right) of Smith's office.

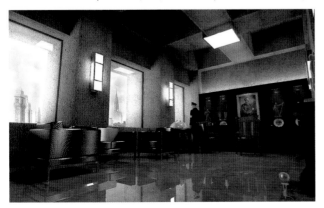

AMERICAN NAZIS

Instead of the postwar optimism that permeated fashion in our world, caution and conformism are key style markers in the American Reich. "A bunch of Nazis running around in Hawaiian shirts doesn't really cut the mustard," notes Catherine Adair, costume designer for seasons three and four.

"You have to consider that the Americans would try harder than Germans to fit in [to the Reich]," says Adair, "And that's something you see historically in colonialism all over the world." Non-military officials such as TV executive Billy Turner and J. Edgar Hoover wear functional suits that match the colder, more muted color palette of the American Reich.

Audrey Fisher was the costume designer for the first season of *The Man in the High Castle*. She helped create the fashion template for the show. "My goal during the pilot was to establish and work with familiar silhouettes from the 1940s and 50s," Fisher says. "We wanted to present an alternate reality that looked and felt authentic."

BELOW: A selection of the different uniforms featured in the series.

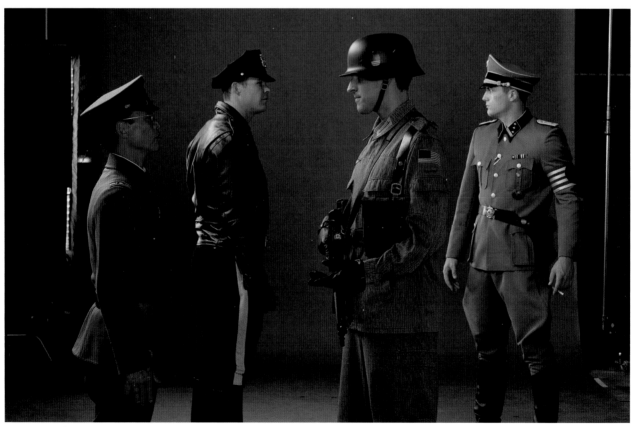

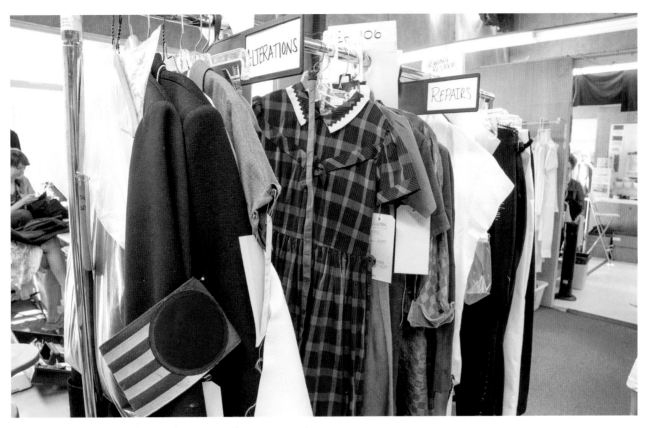

THIS PAGE: The black uniform in the costume department and on set.

Even the hairstyles for the men in the Reich required gargantuan efforts. Hair designer Caroline Dehner estimates they did more than 2,000 haircuts each season of the show.

Fisher decided to incorporate into the High Castle reality the black SS uniforms that the Nazis had stopped using by the start of World War II. "The black uniform had been phased out by Hitler [in our world] because it was too similar to the Mussolini black shirts," Fisher notes. "I pitched that our Nazis would want to embrace that look because it was dark, masculine, and they were in charge."

"I know it sounds a bit perverse, but the uniform does so much work on its own," says Rufus Sewell about wearing the Nazi clothing. "My job [playing John Smith] was to try to forget it, and just think of it as his clothes. Incrementally, we just get used to anything. And I became swastika blind."

Nazi officers are mandated to wear fitted suits. Shirt collars were sharp, ties always done with the proper Windsor knot. And instead of slacks, the men wear jodhpurs. Maintaining that impeccably tailored look throughout a twelve-fifteen hour shooting day required extra effort from the wardrobe department to ensure the clothes remained up to the standards set within the show.

JOHN SMITH

At first, the role of Reichsmarschall John Smith did not hold much interest for Rufus Sewell. The actor's memorable turns as the antagonist in films like *The Illusionist*, *A Knight's Tale*, and *Macbeth* had him anxious to avoid playing one-dimensional villains, and the pilot script did little to convince him that Smith was anything but a Nazi sadist.

"It was something I was going to turn down," admits Sewell. "I read the first episode, and there were quite a few parts I felt I could have played. The one part I wasn't particularly interested in was this relatively one-dimensional bad guy. And I knew the character didn't exist in the book. Normally when they add a character like this, it's a mechanical function, an anchor of evil to hold the narrative together."

Then he met with Frank Spotnitz, who developed the series. "Frank told me about the plan for this character having a lot of conflicts, that he's going in surprising directions, and that, in some way he would represent someone who, in our timeline of events, would not have been a bad man," he says. "That was going to be fully explored."

"Often, [this sales pitch] is just some bullshit they're throwing at you to bait and switch you in," Sewell points out. "But then I read this scene in episode two with Smith and his family where, aside from the fact that he was wearing an SS uniform, it was a relatively functional family. It suddenly occurred to me that he might be telling the truth."

John Smith has proven to be anything but one-dimensional over the four seasons of *The Man in the High Castle*. He is an inscrutable figure whose soul has been wholly corrupted by choices made long ago. "I would have been less interested in it as a concept if it had been sold to me as a *Red Dawn* thing," Sewell says. "[Smith] was someone with a pretty even mix of good and bad in him, like most people."

THIS PAGE: The many sides of John Smith.

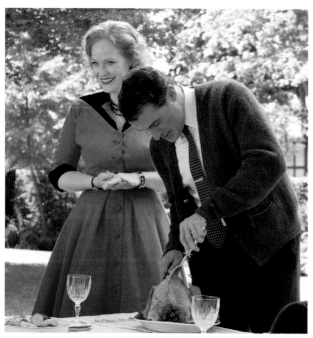

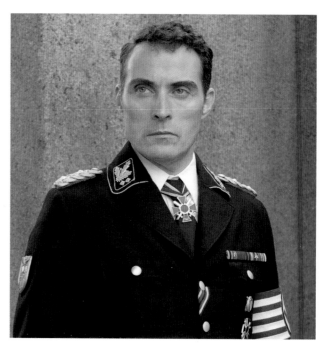

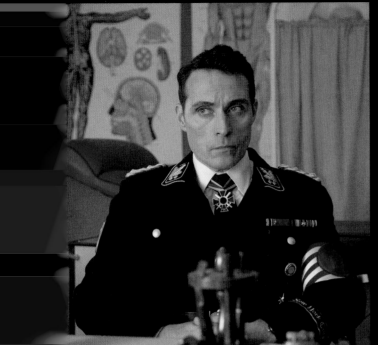

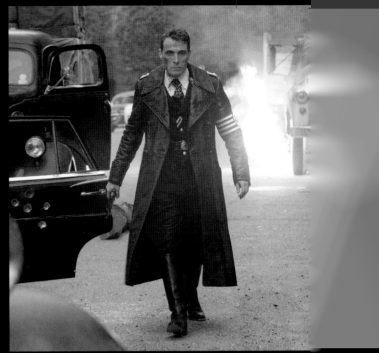

ABOVE: The attempt on John Smith's life was made to look like it was organized by the resistance.

ERICH RAEDER

Trust is an asset John Smith offers with great caution.

But SS Major Erich Raeder earned it during an assassination attempt on the obergruppenführer. Badly wounded, Raeder gave his gun to Smith, an act that saved his life. Months later, Raeder was the sharpshooter who helped Smith capture the rogue Nazi leader Heydrich and stop a coup against Hitler.

While he was a dedicated member of the American Reich, Raeder's true loyalty was to Smith. "I have much to learn from you, Obergruppenführer," Raeder told him in the pilot episode. A man like Smith can instantly sniff out self-serving fawning, but it was clear he had genuine respect and even a fondness for his protégé. When he learns, in season three, that Raeder was killed by Joe Blake (on Himmler's orders), the normally impassive Smith's sadness is palpable.

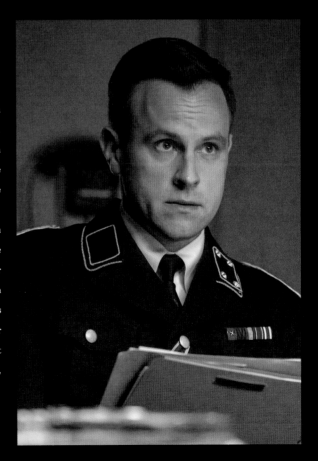

ABOVE: Raedar was a loyal assistant to John Smith.

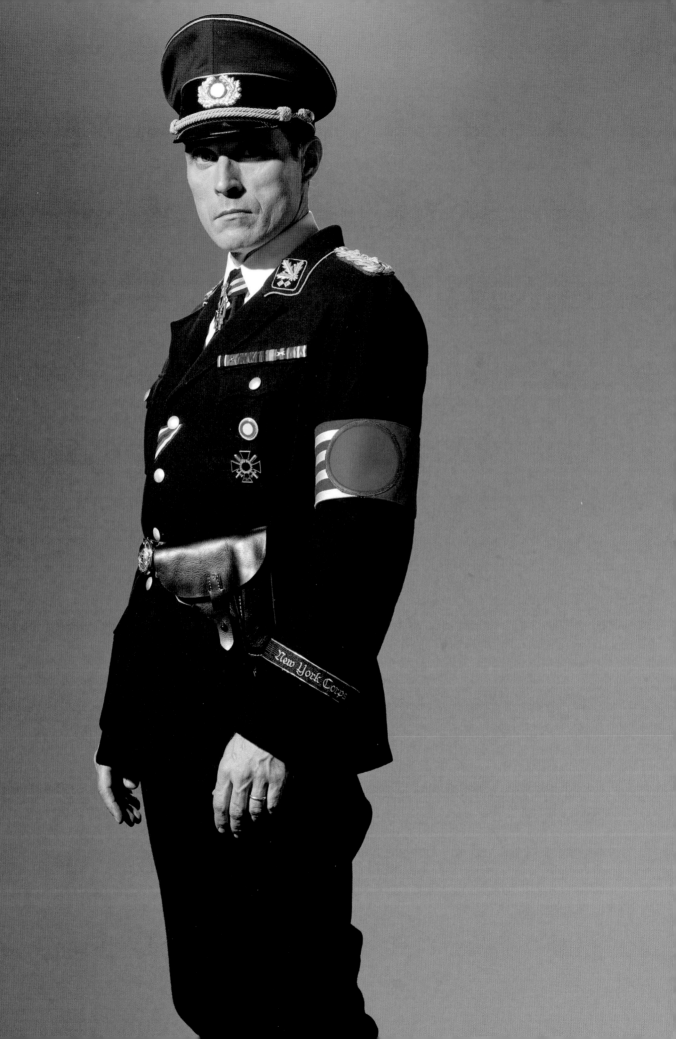

Smith is also exceptionally cunning, which explains how he manages to survive numerous attempts by adversaries such as J. Edgar Hoover to remove him from power. "He's someone who is incredibly good at reading people. He can work out what someone's motivations are, what they have to lose, what they have to gain," Sewell says.

Smith uses his family to rationalize many of the horrific acts he takes part in, but his love for them is unquestionable. Thomas Smith's death has a major impact on John Smith that Sewell doesn't believe he ever truly recovers from. "I think from the moment he discovers his son has this disease, he is immediately aware of the terrible irony," he says. "From that moment, his internal battle with the resentment of the regime started then and there. But what's key is that the reason that Thomas died is because they raised a perfect Nazi. He knows it's his fault."

The visits to the alt-world during season four allowed Sewell to show a different side of John Smith, albeit one from another reality. The actor wishes he had more time to play in that alt-playground. "I was disappointed I never got the chance to do a sale as alt-Smith the salesman, because it would have been interesting," Sewell notes. "It was something I'd been really looking forward to doing."

When alt-Smith is killed and John Smith of the High Castle world goes through the portal and impersonates him, he is confronted by a ghost from his past. Seeing the alternate version of a friend who he turned his back on after the war revives a memory Smith had suppressed long ago. It triggers something in the once-unflappable Nazi leader. "He realized that it was a choice he made out of cowardice to let one of his best friends die," Sewell says.

Thomas' death, Amy's blind allegiance to the Reich, Helen's desire to escape him… it could all be traced directly back to the decisions and actions made by Smith. In the series finale, after his emotional confrontation with Helen, he takes his own life. To Sewell, that moment is Smith facing an undeniable truth.

"I think he comes to an acceptance of the truth, that he is a bad man," he says. "He finally accepted the fact that he had a chance to be a different person, and he told himself that he had no choice, but he did have a choice. And he can't escape that."

BELOW: John Smith in his office, overlooked by the late and current führer.

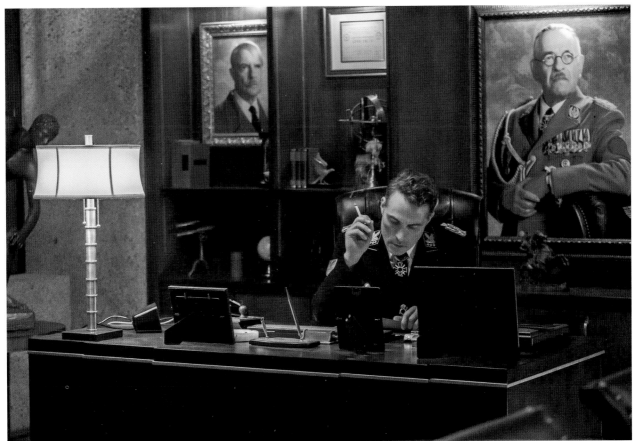

THE SMITHS' HOME

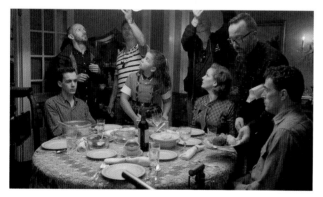

There is a moment in 'Three Monkeys,' the sixth episode of season one of *The Man in the High Castle*, that encapsulates the chilling atmosphere that permeates the entire series. Obergruppenführer John Smith opens the door to his picturesque suburban home and greets a neighbor with a casual "Heil Hitler" and a friendly wave. Writer and co-executive producer Wesley Strick, who joined the series in season two, was fascinated by the idea of this ruthless Nazi leader living in the 'burbs. "I thought it made a great scathing satirical point about the nature of homegrown American fascism," Strick says.

Homes on TV shows are typically exterior establishing shots and the interiors are normally filmed on a set. But Emmy-nominated set decorators Lisa and Jonathan Lancaster explain that, after discussions with Drew Boughton, the show's production designer, it was decided to use a house as a primary shooting location for the Smith's Long Island-set home. "It was a beautiful house in Shaughnessy here in Vancouver. It was a lot of fun for us just to get the character moments," says Jonathan Lancaster.

THIS PAGE: A sketch (top) and behind-the-scenes still (above) of the dining room. The grand house from the outside (below).

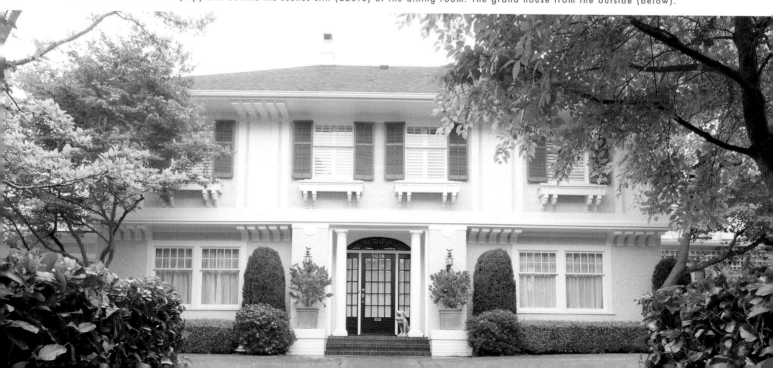

ABOVE: All the decor was chosen to match a wealthy American family from this alternate period.

ABOVE: Stills from within the Smith family house.

All those little details that help create the mood on a period show like *The Man in the High Castle*, such as the vintage dining room table and china cabinet, take months to track down. Other times, it was left up to crafty ingenuity. "The zebrawood TVs in both Smith's home office and his living room, we actually did LED screens that are in behind [the set]," Lisa Lancaster says. "Our guys built the TV from scratch, right down to the antennas and knobs."

Chelah Horsdal, who plays Helen Smith, says shooting the Smith family scenes in an actual house lent authenticity to those moments, but it also meant extra work for the crew. "My understanding was that… every time we would go in [to shoot], they would have to paint the color the set department had picked for the house, and then when we wrapped the set on that episode, they would paint it back to the original color of the house," Horsdal recalls. "I was like, 'Why does it always smell like paint in here?' And they would say, 'because we have to paint this place every single time.' I would guess the rooms got smaller over the course of two years because there's so much paint on the walls!"

The Smith family home is also noteworthy because it marked the start of a four-season journey for the Vancouver-based cast and crew. "On day one, we shot that breakfast scene. So, for me, it kind of set the tone," observes Horsdal.

HELEN SMITH

When Chelah Horsdal auditioned for the role of Helen Smith, the perfectly proper Stepford Wife of the Reich, she didn't have much to work with. Not only could she not refer to Philip K. Dick's novel for reference – Helen did not exist in the book – she was given just three lines.

"I think [the lines] were 'Good Morning,' 'Coffee,' and 'your father is a very wise man' or something," Horsdal recalls. "It was really simple." Helen Smith would turn out to be anything but, emerging as one of the series' most complex characters.

The relationship between Helen and John Smith is amplified by the onscreen chemistry between Horsdal and Rufus Sewell. "I think much of what happened with Helen in season one and beyond was the direct result of Rufus Sewell, and the relationship that the two of us had," Horsdal explains. "I think the two of us had a rhythm together instantly, and a comfort that made us a lot easier to write for."

In season three Helen struggles to cope with Thomas' death, while the final season sees her take control of her own destiny. We also learn Helen is the one who pushed John to join the Nazis after the war, a storytelling choice Horsdal was all for. "If it could be her who instigated it, there's something just so rich in that, and for Rufus as well, for the John character as well to not be the person who was in charge necessarily," she notes. "It was very important to me that she not be just a bystander, or a victim of her circumstance, because that's boring."

In the final episode, Helen is forced to face the consequences of her past decisions by her oldest daughter and it comes to a head in a final confrontation between Helen and John that Horsdal says was the highlight of her time on *The Man in the High Castle*. "It's the two of them confronting each other about everything, and for me it was so satisfying because from a storytelling perspective, it's not that it wraps it all up, it's that they say everything that needs to be said between them, and it was some of the best work that I've ever witnessed from Rufus. It was something completely different from anything that I'd seen him do on the show before."

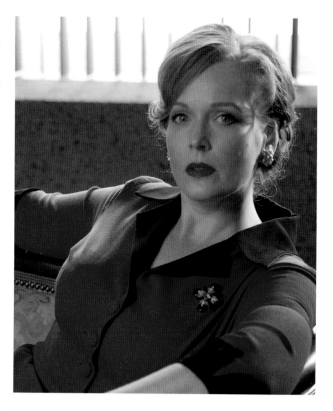

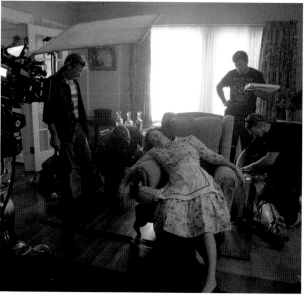

ABOVE: Behind-the-scenes still of the fight that ended in Sarah's death at Helen's hands.

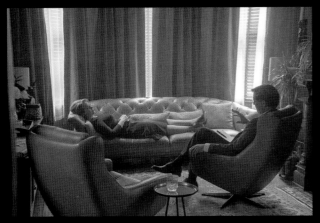

ABOVE: Thomas' death had a different impact on Helen and John.

THE WOMEN OF THE REICH

The appearance of suburban bliss is the overpowering illusion of the American Reich. We see it in season two when Helen Smith gathers with Alice Adler and Lucy Collins in the kitchen for small talk. No one dares share anything too personal, at least not initially. After the Smiths move to a Manhattan penthouse, Helen's resentment for the Reich can barely be contained in a cocktail conversation with Lucy and Mary Dawson.

Because pop culture had been stillborn in the High Castle world, fashion in the American Reich follows the architectural style of Berlin. Everything is very angular, sharp, crisp, and cold with a distinctive German influence. "Chanel would have been maybe the only French designer who had survived," according to costume designer Audrey Fisher. "The capital of fashion would not have been Paris, it would have moved to Berlin."

Even a recurring character like Lucy offered a unique challenge for the show's hair department. "A big part of her story was her struggle to get pregnant, so we kept her look more demure," says hair designer Caroline Dehner. "By the way, the first time we saw Emily Holmes (who plays Lucy), she had a pixie cut! It was a scramble to get her ready for shooting."

BELOW: On screen still of Helen's friends (left) and behind-the-scenes photo from on set (right).

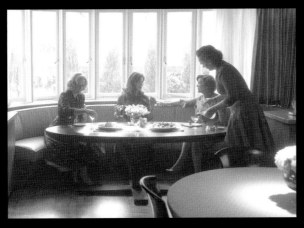

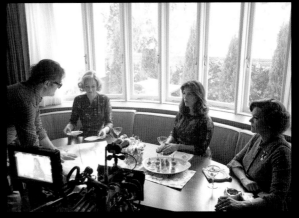

THOMAS SMITH

The eldest child of John and Helen Smith is a dedicated acolyte of Nazi ideology. He worshipps his father and his position within the Reich. When Thomas is diagnosed with the congenital disease Facioscapulohumeral muscular dystrophy, he voluntarily turns himself in to be euthanized, as per the Reich's policy regarding ill citizens.

That decision highlights the depths to which Thomas has bought in to the Nazi way of life, putting state before self. "I think he was overwhelmed by all this information about being sick, and also the brainwashing," says Quinn Lord, the actor who played Thomas. "He was brought up to be the ideal little Nazi, and then went out and proved he was."

Thomas' 'selfless act' is transformed by Nazi propaganda into a symbol of Aryan courage and selflessness, thanks to Nicole Dormer's documentary, An American Hero. His high school is named after him. But Thomas' death irrevocably damages the Smith family. Helen never really recovers. His sisters react in vastly different ways, with Jennifer ultimately learning to reject the Reich, while Amy fully embraces Nazism. John Smith never can move past losing his son, which leads him to travel to the alt-worlds in hopes of bringing another Thomas back to the High Castle reality.

"I think one of the main characteristics of Thomas is that he really does believe in a higher power," Lord points out. "When he's in the [High Castle] world, he really believes in the Reich.

But in the alt-world, he's all about believing in his country, America, and believing in the war in Vietnam. He's the same person with the same beliefs, but... in different circumstances. There's no telling him 'no.'"

The actor was particularly excited to get to return to play the alt-world Thomas in the final season. "It was very interesting. I got the call right before production began, saying they need an alternate Thomas Smith," Lord recalls. "I was like, 'Yes! I love alternate timelines!'"

THIS PAGE: A posthumous painting was created for Thomas' memorial.

ABOVE: Quinn Lord taking direction on set (left). Thomas made a devastating decision against his parents' wishes (right).

JENNIFER AND AMY SMITH

Being raised as the children of American Nazi elites has enormous consequences for the Smith children. Amy (played by Gracyn Shinyei) is completely indoctrinated by the Reich's propaganda machine. When she does the Nazi salute at the tribute ceremony for her brother Thomas, Helen Smith knows that her youngest daughter now belongs to the Reich.

Jennifer turns out differently. Actress Genea Charpentier says her character at first, like most kids, believes what her family tells her and she embraces the Nazi way of life. "But as time went on," Charpentier says, "Jennifer discovered more and more about what the real truth was."

The time she spends living in the Neutral Zone changes Jennifer. Hearing the BCR's message in the hijacked TV transmission confirms what she already suspects. "That's when she finally realized what the people around her really were," Charpentier says.

It leads to a searing exchange between mother and daughter in which Helen confirms what her and John Smith had done in the name of the Reich. "That confrontation was a breaking point for Jennifer. It was the proof she had been hunting the whole time that she was speculating [about her parents]," she says.

Charpentier praised her onscreen mom, Chelah Horsdal, for helping her work through the emotions of that scene. "We did it a couple of times. But I knew that we were going to use this one take just because everyone on the set, they were crying. And when they yelled 'cut,' I just started crying. And so did Chelah. We all just did a big fat group hug, which really felt good after a scene like that."

BELOW: The Smith daughters before Thomas' death changed their lives.

SMITH APARTMENT

The Smith family's penthouse apartment in Manhattan is emblematic of John Smith's growing stature within the Reich. Moving the Smiths from Long Island to an elegant high-rise in the city was a move suggested by writer/co-executive producer Wesley Strick for practical and symbolic reasons.

"I felt that it was unsustainable, really. It just felt hard to support the idea that this incredibly powerful dictator was living in suburbia," Strick says. "We never even saw much, if anything, in the way of security around his home. I also think it made a point about the way ruling classes in a totalitarian government inevitably live. They don't live among the common people in any sense."

The apartment is also the scene of the gradual collapse of the Smith marriage. Set decorators Lisa and Jonathan Lancaster created the décor of the apartment set to reflect the darkness gripping the Smith family. "A lot of the warm colors and bright fabrics were removed," she says. "We went to colder, cooler, darker colors. We tried to bring a richness to the look, but we wanted it cold and dark."

According to Jonathan Lancaster, "The carpets we selected were a little grayer. The wallpaper was a darker blue. All the comfort that we saw in the old home was pulled out. Because it wasn't so much a happy place anymore."

BELOW: The Reichsmarschall could afford an incredible skyine view of Manhattan.

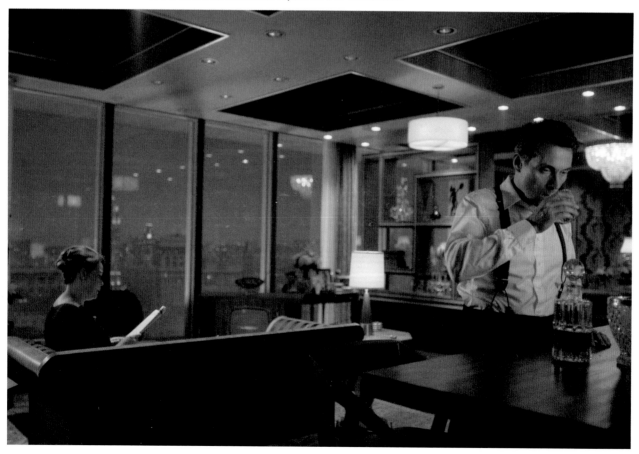

ABOVE AND BELOW: The production design and set decoration teams created an aesthetic that harmonized the apartment with the previous Smith family home.

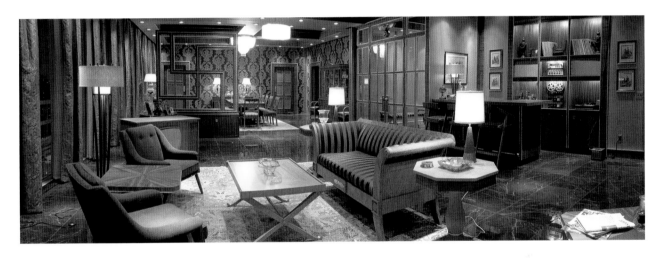

BELOW: Production still of the entranceway to the apartment (left) and concept sketches of the interiors (right).

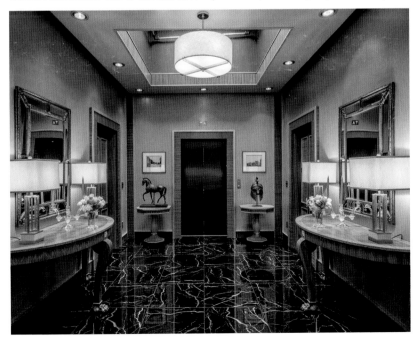

MARTHA STROUD

ABOVE: Concept sketch of Martha's death scene in the hospital basement.

The Staatspolizei, the secret police unit of the Reich, has certain agents with specific skill sets. Agent Martha Stroud (Rachel Nichols) is Helen Smith's personal bodyguard, although she describes herself as a 'wife-companion.' Reichsmarschall Smith orders the security detail to keep tabs on Helen and make sure she doesn't run away with the children again.

Helen resents Agent Stroud's presence, but Amy Smith takes an immediate liking to her. It makes sense, given Amy's devotion to the Nazi ideal, that she would admire somebody who seems the personification of a woman of the Reich.

Martha is also lethal with a knife. She nearly kills Wyatt Price with a switchblade during their bloody encounter in the basement of the Davenport Clinic. With Juliana's help, Price manages to get the upper hand and kills Agent Stroud with her own weapon. Her body is then tossed in the incinerator.

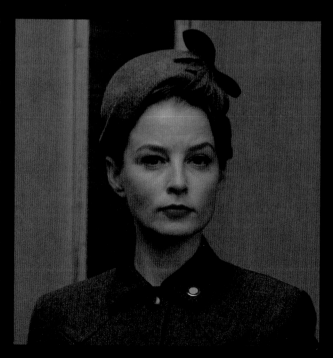

BILL WHITCROFT

Bill Whitcroft is perhaps John Smith's oldest and most trusted friend. That familiarity is no doubt why Whitcroft suggests to Smith in season four, episode eight, that he seize control of the American Reich army and the 103 nuclear warheads on the continent, and take back their country. "You could be shot for what you're saying," Smith says.

"I'm willing to take that chance," Whitcroft replies.

Whitcroft and Smith fought together in WWII. They joined the Reich together in February 1946, after the US had surrendered. Colonel Bolden had shown up at Fort Monmouth and given them a choice: Join the Reich, or die. For nearly two decades, Whitcroft wears the swastika without hesitation. But now, the crumbling Japanese occupation on the west has stirred patriotic emotions that Whitcroft thought had died years ago.

"In his heart of hearts, [Whitcroft] really wants America to be America again," says executive producer David Scarpa. "He fought all his life under the stars and stripes, and he wants that back. Many Americans under occupation would yearn for a return to the stars and stripes, a return to being their own country. He sort of represents that."

Unfortunately, John Smith has no desire for an American rebirth. When Smith's death makes him the new führer of North America, Whitcroft's first decision is his most impactful. He calls off the attack on the West Coast, and takes a key step toward the long process of healing a broken nation.

THIS PAGE: Bill was a loyal friend to John Smith.

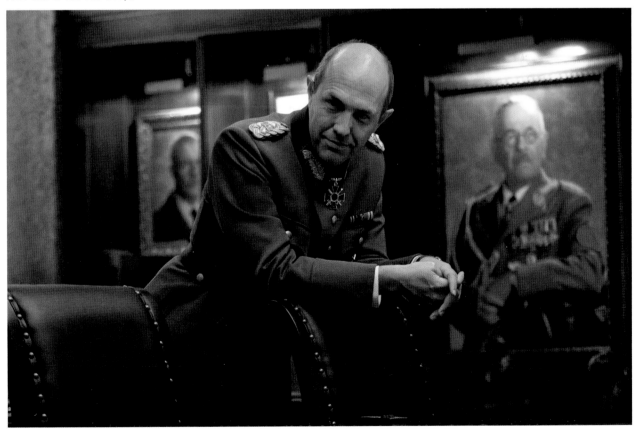

RESISTANCE BAR

The American resistance maintains a discreet presence in Manhattan. One location used for information drops is an underground bar located off an alley in the Bowery, at Spring and Willets Streets. It's where Juliana meets George Dixon and resistance leader Susan to tip them off that Hitler is near death.

The speakeasy is inside an abandoned subway station. A live band on stage entertains the sparse crowd that kills time drinking beer on tap, and smoking cigarettes. When the band takes a break, a jukebox plays outlawed blues music. The attention to period-accurate detail for the props and set decor is essential to immersing the audience in the High Castle world.

"We really tried to be period correct and historically accurate for the time," says Lisa Lancaster. "We had to be really careful that we didn't go past, say, 1962 with the items we pick, whether it's a phone or a piece of furniture."

BELOW: Sketches (top) and final stills (bottom) of the resistance bar.

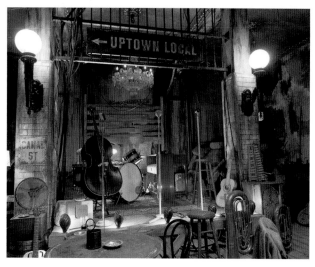
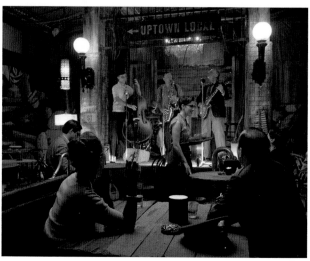

GEORGE DIXON

George Dixon is the biological father of Trudy Walker, and the mystery man who appears in several alt-world films. He is also part of the resistance. Hawthorne Abendsen believes Dixon is the key to preventing nuclear war between the Nazis and the Japanese. Juliana finds him in New York City, working undercover for the Nazis installing wiretap devices.

Dixon appears to care for Juliana, but she starts to doubt his honesty after fellow resistance member Susan tries to kill her for helping Joe Blake escape. Juliana kills Susan instead, and outside the bar she sees Dixon, in disguise in a Nazi uniform. He plans to take an audio recording that reveals Thomas Smith's illness. Juliana tells him not to do it, and when Dixon calls her bluff, she shoots and kills him. It is the exact moment played out that Juliana saw in Abendsen's film. By killing Dixon and protecting Thomas, Juliana indirectly prevents the actions that would lead to the atomic destruction of San Francisco.

THIS PAGE: George and Juliana's first meeting in New York.

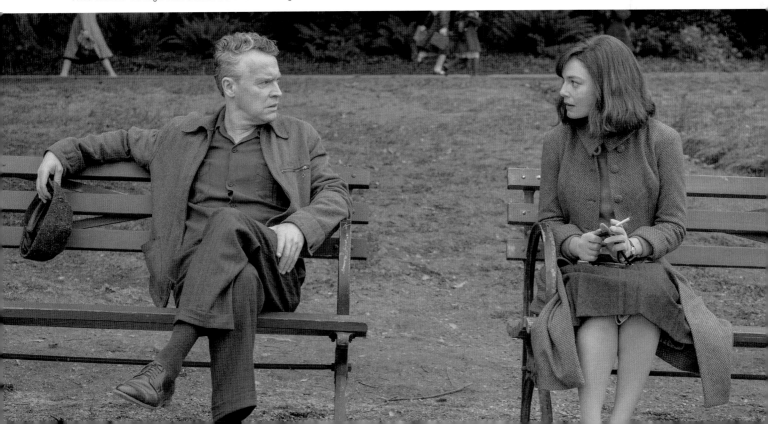

BERLIN

Berlin in the High Castle reality serves as the commerce and cultural capital of the world. To bring this version of Berlin to life onscreen, producers referred to actual plans drawn up by Nazi architect Albert Speer for 'Germania,' the grand rebirth of Berlin that Hitler envisioned for the Third Reich.

When it came time to shoot actual footage, producers ran into a problem. "Because it was bombed so badly during WWII in real life, Berlin was largely rebuilt," says producer Erin Smith. "It doesn't have as much surviving historical architecture as other European cities of the same age."

A combination of plate photography shot on location in Germany and computer generated visuals created a sprawling metropolis. In the final episode of season one, Grosser Stern Square and the Victory Column, two well-known Berlin landmarks, are seen as Wegener returns to the city. In the background is the Volkshalle, the massive dome Hitler envisioned, as well as a monorail. Those CGI elements were added in postproduction.

"The Volkshalle doesn't exist, the monorail doesn't exist. Both are fantasy elements," says executive producer Richard Heus. "We took over some roads in Berlin on an early Sunday morning, filled them with cars from that era and we made it work."

"I think it was always important for High Castle not just to do the showoff-y, 'You've got to watch this show because it's humongous,'" adds writer/producer Wesley Strick. "But I think it was always part of the strategy of the show, to portray the edifice of fascism as enormous."

Marc Resteghini, the Amazon Studios executive overseeing The Man in the High Castle, says putting in the extra effort was important. "So much of this series is about immersing audiences in a world that could have been," says Resteghini, now Amazon's Head of Drama. "The more detail that you put into that world, the more realistic and provocative the experiences for people who are coming in and watching it."

BELOW: Concept art showing how the alternate Berlin would differ from the real-life city.

ABOVE: 3D composition of Volkshalle.

BELOW: A concept sketch (left) and final still from the series (right) of the imposing building.

BELOW: Concept art (left) and final still (right) of the mansion party that serves as Joe's introduction to the elite of Berlin.

THE FUHRER'S OFFICE

Historically, Hitler ordered the construction of the New Reich Chancellery in 1938, complete with a personal office measuring 400 square meters. "We recreated Hitler's desk from the museum photos in Germany. It's a foot smaller than the original [desk]," says Lisa Lancaster. There are marble columns and dual carpeting. The desk is sparsely decorated, with two phones, a single pen, a magnifying glass, and the switch system that operates the führer's film projector. "All the props were made in-house," she says.

Replicating Hitler's wall sconces was a special challenge.

"When the Soviets took the chancellery and burned it down, only two of the original sconces were left intact. They were recently sold at auction," Lancaster says. "Luckily, there was actually a photograph, so that's how we did it. I have a very talented fellow that works with us who jumped at the chance to make them. If you look at the background and the sides in the scenes [in Hitler's office] you'll see them."

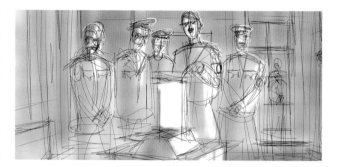

THIS PAGE: Sketch and concept art of the office (above). The final design featuring full set decoration (below).

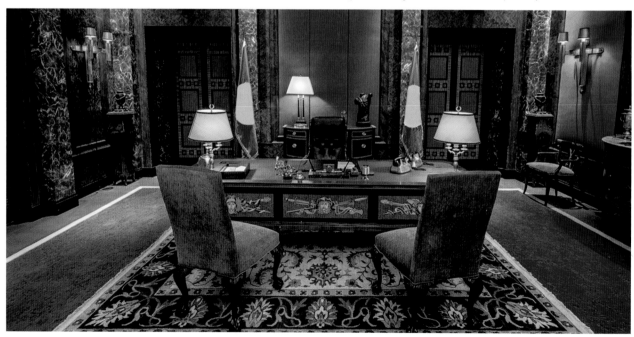

ADOLF HITLER

The decision on whether or not to actually show Hitler sparked great debate behind the scenes. "I was always wary about using historical figures because there's a degree where you risk taking the audience out," says Frank Spotnitz. "There had been talk about showing him as early as the first two episodes, and I resisted that."

"We did talk a lot about whether we should see him," adds series writer/producer Rob Williams. "The presentations of Hitler in TV and film, even when it s well done... it s such a dangerous thing to do. But we felt we had to do it."

Veteran actor Wolf Muser was cast to portray the führer in a manner that, due to the historical extrapolation of the series, has never been seen before. "He's a different Hitler than we know because he's older," Spotnitz observes. "He's in ill health and he's shaken by the knowledge that history is not inevitable, because he's seen the films. It rattles him. And I thought that was an interesting version of the character to see."

Casting director Denise Chamian praises Muser for his performance. "He was really great in the role," she says. "You don't want someone doing an impersonation, but you want somebody who looks close enough that you can imagine that they could be that person and who embodies the attitude of the character."

BELOW: Hitler's death has a huge impact on John Smith's career.

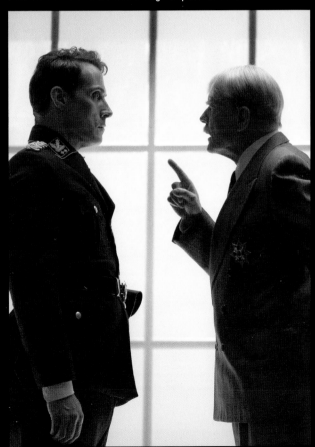

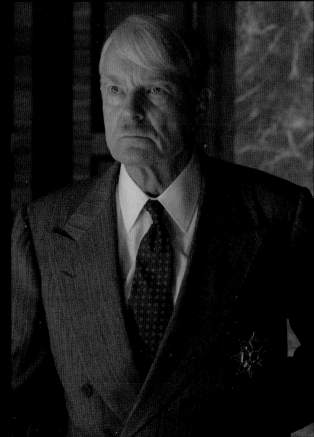

VOLKSHALLE

In our reality, the Volkshalle ("People's Hall") was to be the centerpiece of Germania, the capital city Hitler envisioned after winning World War II. "It was based on Hitler's architect Albert Speer's preliminary designs and drawings for what they intended to build if they had won the war," according to executive producer Richard Heus.

In the High Castle world, Hitler's concrete symbol of German superiority exists and towers above the Berlin skyline. The intimidating spectacle of seeing a sea of Nazi supporters chanting 'Sieg Heil' in the Volkshalle during Himmler's speech at the end of season two was enough to make the show's visual effects supervisor recoil in discomfort. "That was probably the most disturbing that it got for me," admits Lawson Deming. "Having a hundred thousand Nazi stormtroopers 'sieg heil'-ing in unison in this giant space. For the most part we were able to compartmentalize it, but that moment was tough."

The Volkshalle seen on the show is an entirely digital creation built from the few actual designs that exist, to create plausible accuracy. "The Volkshalle was a structure that was actually intended to be built and there are plans for it. There are little models that exist of it," says Deming. "It was planned to be the largest dome in the world built out of concrete and marble."

"There were lots of theoretical issues about a space that large – could it be done?" says Heus. "Would it have its own weather system inside? Was the Berlin ground strong enough to hold it up? We got deep into the granular details on what it would take to do a thing like that, and then we built it."

BELOW: Early sketches of the Volkshalle scene plotting out character placement and point of view.

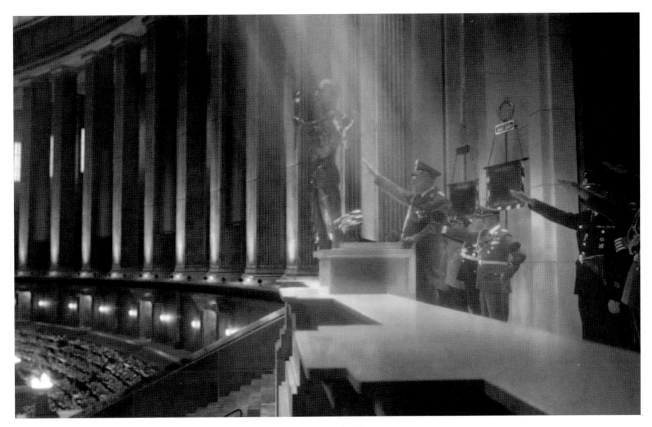

ABOVE: Final still featuring the full background created using visual effects.

BELOW: A 3D composition of the set.

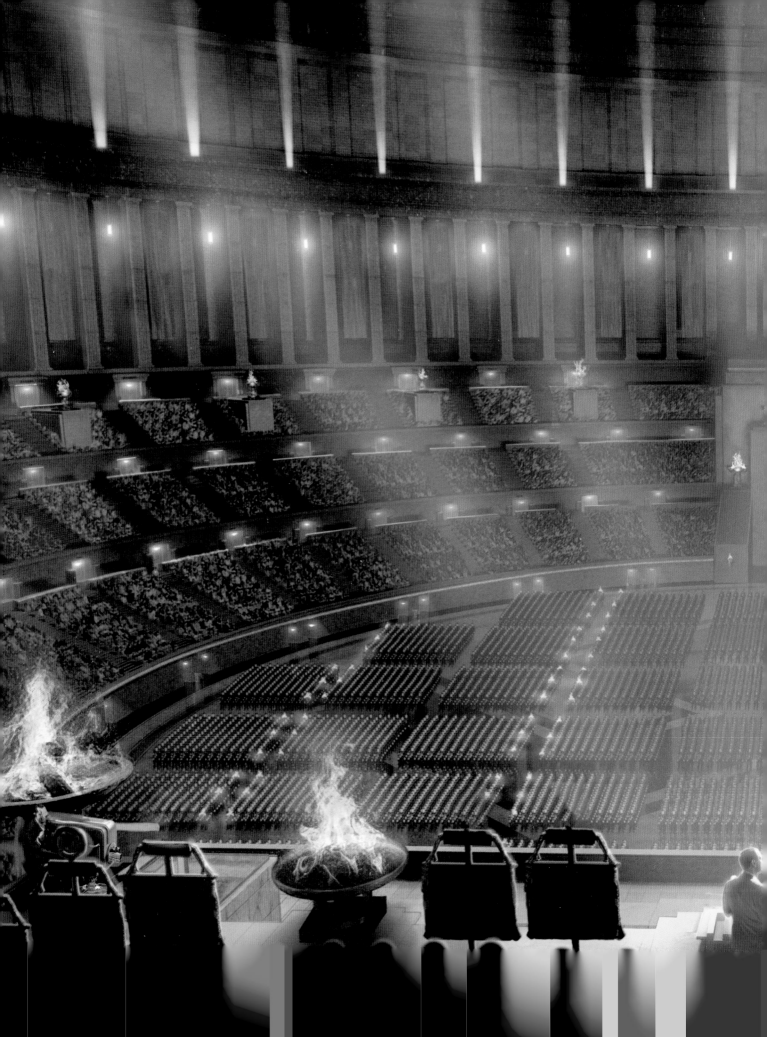

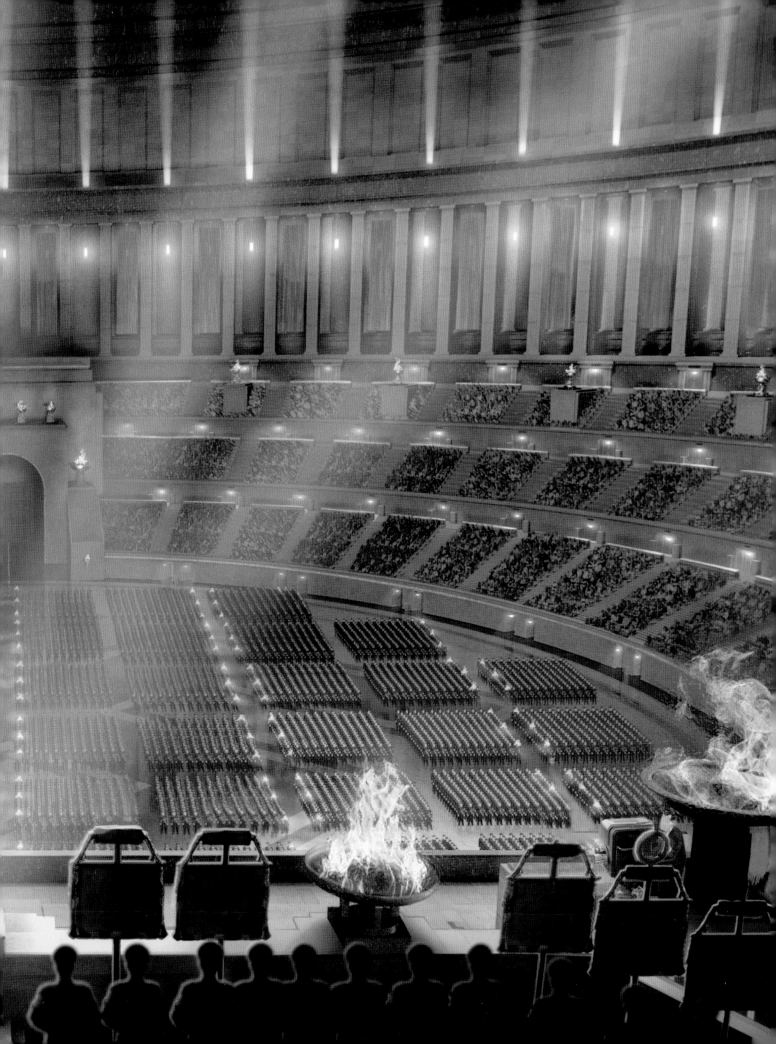

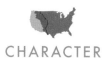
HEINRICH HIMMLER

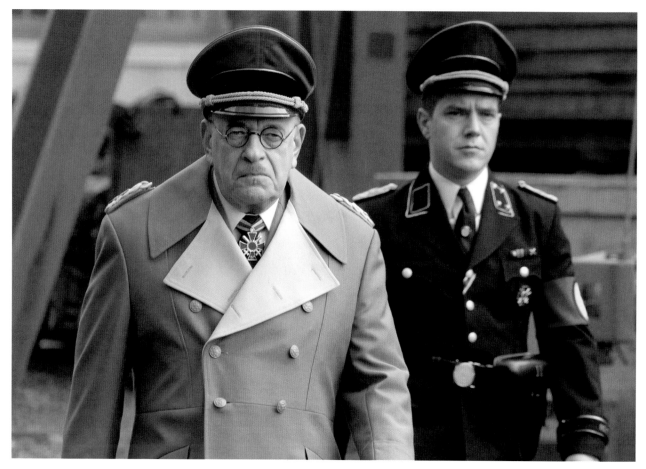

ABOVE: Himmler on his way to visit Die Nebenwelt.

Kenneth Tigar's career spans four decades and countless TV series and film roles, like 2012's *The Avengers*. But ask him about the role of Reichsführer Heinrich Himmler, and he is as surprised as anyone to have lasted as long as he did on *The Man in the High Castle*.

"I didn't think I was going to do more than one or two episodes," Tigar says. "When we got to the final episode of season two, and I saw [Himmler's] big speech and that he was taking over, I thought, 'How did I walk into this one? How did I get so lucky?'"

Himmler becomess führer after Hitler's death and the arrest of Acting Chancellor Martin Heusmann, and ratchets up plans to fulfill the Final Solution. He escalates tensions with the Japanese. He becomes obsessed with the Die Nebenwelt project and the prospect of conquering the multiverse. As he learned of Himmler becoming a bigger factor heading into the third season, Tigar, who has a degree in German literature from Harvard and speaks fluent German, read Hitler's book *Mein Kampf*. "*Mein Kampf* became very important to me as an actor to find where the backbone of Himmler's philosophy was," he says.

During the ceremony celebrating Jahr Null, the Reich's plan to erase all semblances of American history and identity, a resistance sniper shoots Himmler. That incident begins the slow erosion of Himmler's relationship with John Smith, a man the führer viewed as a protégé. "John really is the son that Himmler never had," Tigar notes. "He's a person who I'm grooming to take over, and he puts up with an awful lot, just in terms of protecting him."

By season four, as Himmler struggles with his failing health, he pits Obergruppenführer Goertzmann against Smith. "I'm really trying to play the two of them off of each other, because it makes my position stronger," he says.

It all backfires on Himmler in the series' penultimate episode, when his onetime heir apparent turns the tables and kills him. "It's an enormous shock [to Himmler] when he realizes he's the one being killed," Tigar says. "I think there was wonderful writing in that scene that really plays up the father-son relationship."

BELOW: In the midst of a war council meeting.

MARGARETE HIMMLER

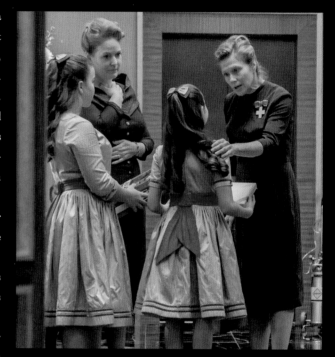

Margarete Himmler (played by Gwynyth Walsh) is a commanding woman who, like her real-life counterpart in our reality, is a colonel in the German Red Cross. The tall, blonde sixty-five year-old Reichsführer's wife wakes up at 5 a.m. for her daily workout and has little patience for pleasantries. "We decided that Himmler's wife wouldn't be concerned about makeup and all of the trappings of her position," says makeup artist Francesca von Zimmerman. "She's a very down-to-business type of person. So we kept it very minimal, with minimal makeup".

Margarete berates Helen Smith in her own home for behavior unbecoming of the Reichsmarschall's wife during the season four episode, 'Happy Trails.'

"Margarete Himmler was a complete snake. And she was just so well cast, and gave an unbelievable performance," says Rachel Leiterman, who directed the episode in question.

Margarete Himmler has a strong hand in guiding her husband's work as leader of the Reich. She edits his speeches and reviews his schedule. But the assassination attempt has left the führer weak and dependent on an oxygen tank. Margarete is a smart woman. She knows weakness and illness are tantamount to death sentences in the Reich. Helping her husband maintain his grip on power is as much about self-preservation as it is about affection.

"SHE'S A VERY DOWN-TO-BUSINESS TYPE OF PERSON"
FRANCESCA VON ZIMMERMAN
MAKEUP ARTIST

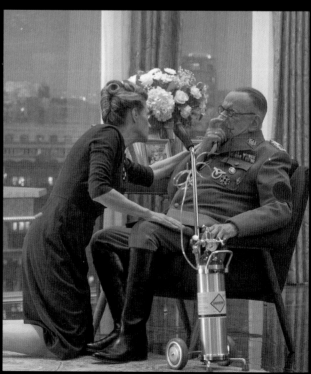

THIS PAGE: Margarete Himmler brings her commanding presence to dinner with the Smiths.

CHARACTER

MARTIN HEUSMANN

Martin Heusmann is the acting chancellor of the Reich as well as the architect of the season two plot to remove Hitler from power. Heusmann means to frame the Japanese to provoke a war between the two empires, a scheme that is stopped by John Smith.

A master of political maneuvering, Heusmann presents himself as a moderate, but in fact feels that the Nazis have grown soft as Hitler grows older and weaker. Writer and co-executive producer Kalen Egan says Heusmann believes Hitler has allowed the seeds of rebellion and dissent to grow until there is no option but another great war. "His humanity had been so thoroughly twisted and destroyed by the Nazi ideology," Egan says. "That he saw another massacre as simply a logical means to an end."

Heusmann is an example of a central theme explored on the show: how thoroughly human decency can be corrupted and infected by twisted ideals. For Joe Blake, learning the truth about his father is the ultimate betrayal. After undergoing the Nazi 're-education' program, Joe's will is ultimately broken when Himmler orders him to execute his father. He is now fully and completely under the führer's control, part of the Lebensborn black ops squad.

BELOW: Sebastian Roché as Martin Heusmann.

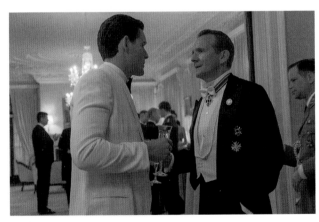

NICOLE DORMER

On the surface, Nicole Dormer appears to be the model of Aryan exceptionalism. But the actress who portrayed Dormer did not see her as just another Reich 'true believer.'

"I think she was just very ambitious. Kind of like what I imagine Leni Riefenstahl would be like," says Bella Heathcote, referencing the real-life German filmmaker who made Nazi propaganda movies.

Dormer is part of the Lebensborn program, which engineers the next generation of idealized versions of Aryan men and women. She unknowingly shares the Lebensborn experience with Joe Blake, a revelation that brings the two closer together when they meet in Berlin during season two. "He was very different from the people she grew up with," Heathcote says. "He wasn't privileged, he didn't really care about the Reich and wasn't afraid to say that. I think she saw a lot of potential in him."

Dormer moves to New York to spearhead Himmler's 'Year Zero' propaganda campaign. Her documentary on Thomas Smith and his 'sacrifice' is masterful Nazi propaganda. "I think [Nicole] is a storyteller and she was able to sell this idea of the Reich," she says. "She knows what will move people. I don't feel she necessarily believed in the propaganda, she just knew how to sell it."

Heathcote credits costume designers J.R. Hawbaker and Catherine Adair with outfits that helped make Dormer perhaps the most stylish character on *The Man in the High Castle*. "Nicole was so well put together. She was so glamorous. Even her directing outfits are so chic. It's such an easy shortcut into your character because as soon as you put on a pair of heels and a really well tailored suit, even just that shift in body language helps you find the character. I really feel like I should probably dress like that more!"

Dormer's romance with newspaper columnist Thelma Harris begins as a mutually beneficial relationship, but eventually blossoms. Homosexual relations are forbidden in the Reich, however, and eventually Himmler has enough and sends Dormer back to Berlin for re-education.

"I think Nicole thought she could get away with more because she was privileged, because she was Lebensborn, because she was wealthy. I think she thought she was kind of invincible or impervious to law."

BELOW: Nicole filming her documentary on An American Hero, Thomas Smith.

ABOVE: Nicole and Thelma's relationship at the beginning and the end.

THELMA HARRIS

While actual historical figures like J. Edgar Hoover exist in the High Castle reality, the character of Reich Herald columnist Thelma Harris is an amalgam of two notable figures from the Golden Age of Hollywood.

"When I first auditioned for Thelma, she was originally named Hedda Parsons," says actress Laura Mennell. "It's safe to assume she was inspired by Hedda Hopper and Louise Parsons. These gossip columnists could make or break careers of the film industry's elite, as well as destroy personal lives with the stories they penned."

Harris is an influential voice in the American Reich, but her personal secrets — she's a closeted lesbian in a marriage of convenience to a secretly gay man — puts her at the mercy of Obergruppenführer John Smith. Harris' lesbian relationship with filmmaker Nicole Dormer, forbidden under Nazi law, is eventually discovered. "Thelma lets her guard down and is not as careful as she should be," says Mennell.

Harris has always done whatever needed to be done to survive. It is how she thrived in the postwar Reich. But the attraction that drew her and Dormer together ultimately ruins both women's careers.

ABOVE: Thelma was the epitomy of high society style in the American Reich.

THE STATUE OF LIBERTY AND THE NEW COLOSSUS

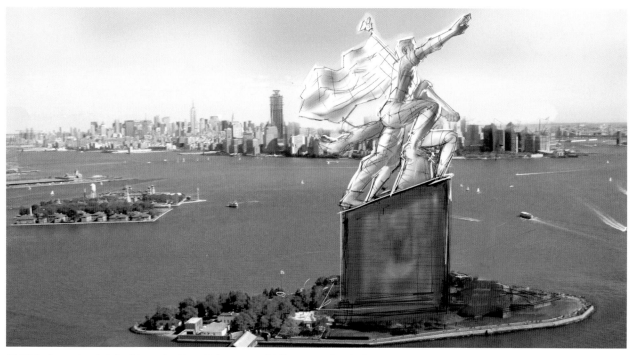

ABOVE: An early sketch of how the New Colossus would fit among the skyline.

Himmler's grand plan for North America is called Jahr Null: 'Year Zero.' Much like Hitler's unfulfilled strategy in our reality, it involves the complete assimilation of Nazi culture.

"With Himmler succeeding Hitler, we came up with this idea that the Nazis would try to eradicate the American past and start over," says Eric Overmyer, executive producer and showrunner for the third season. "That's where Year Zero comes from, that term, where you sort of burn everything down to the ground and start over."

"I still remember the first conversations with Eric about the Year Zero concept," notes co-executive producer Kalen Egan. "Disassociating or disconnecting a population from their own history is a great way to control them because they don't have any fidelity or any ties to their own independence."

The destruction of the Statue of Liberty by Nazi fighter jets at the end of season three is one of the most impactful moments in the show. In its place rises the New Colossus, a monument to the Nazi Youth that Himmler is grooming as the next generation of the Reich. The name is a perverted spin on the famous poem of the same name that reinvented Lady Liberty as a symbol of immigration. Even John Smith is taken aback at seeing the torch sink into the harbor, perhaps because he senses this move could backfire.

"Smith has mixed feelings about this, because even though he's a Nazi now, he still considers himself American," says Overmyer.

"I think what you're seeing on Smith's face [in that scene] is that he knows this strikes at the heart of patriotism. You are kicking the hornet's nest," adds Egan. "There are a lot of people here that are not quite ready to lose things like the Statue of Liberty, and you are going to be potentially fomenting more rebellion than you are squashing."

Smith would be proven correct, as Wyatt Price's rebellion would begin during Jahr Null.

THIS PAGE: Concept art of the Jahr Null ceremony (above and below). A small 3D model of the replacement statue (bottom right). A still of the demolition (bottom).

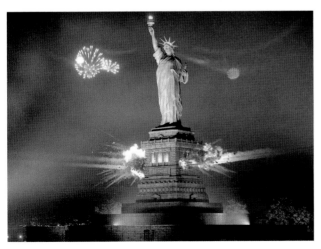

J. EDGAR HOOVER

Of the historical figures transplanted into the High Castle world, J. Edgar may have been the most intriguing. An immensely powerful figure in Washington, Hoover maintained his seat of power after the Nazis won WWII. The FBI was transformed into the American Reich Bureau of Investigation (ARBI). Hoover continues the invasive surveillance and blackmail tactics that secured his influence. "We felt the techniques of the Reich would appeal to a person who gathered information and used it against people in the way Hoover did," notes executive producer Richard Heus.

Veteran actor William Forsythe was cast because producers felt he could embody the attitude of the character. "I was impressed by his work on Boardwalk Empire. He's really such a fine character actor and can do anything," says casting director Denise Chamian.

Frank Spotnitz, who developed the series, was interested in seeing how the Americans who joined the Reich after the war adjusted to the new normal. "I was always wary about using historical figures because you risk taking the audience out. On the other hand, it's fun to imagine what these guys would have done if things had gone the other way. By taking the mirror and distorting it, you see the way history really reflects people, and who they could have been."

> ## "IT'S FUN TO IMAGINE WHAT THESE GUYS WOULD HAVE DONE IF THINGS HAD GONE THE OTHER WAY"
> ### FRANK SPOTNITZ
> *SERIES DEVELOPER*

THIS PAGE: Hoover uses his surveillance team to dig up information on Smith.

GEORGE LINCOLN ROCKWELL

The highest-ranking member of the Nazi party in America (and based on the real-life America Nazi Party founder of the same name), Reichsmarschall Rockwell (played by David Furr) nevertheless views John Smith as a threat due to his reputation and closeness to Reichsführer Himmler. He conspires with ARBI Director Hoover to prove Smith had killed Dr. Adler to cover up his son Thomas' illness. Combined with evidence Hoover finds that Helen Smith killed Adler's wife, the duo plans to expose Smith's treason.

Rockwell's downfall begins when he underestimates Smith. He blackmails Hoover into burying the evidence against him, leading Himmler to ban Rockwell from the Reich. Himmler is relieved to see Smith come out on top in this power struggle. He has invested much in Smith, and views him as a worthy successor to Rockwell.

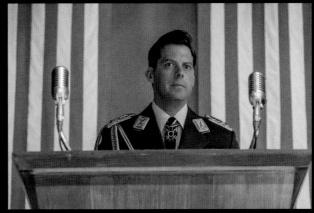

Rockwell retreats to Cuba to bide his time and, he thinks, to plan his return to power. He once again underestimated Smith, however, who ties up a loose end by having an assassin murder Rockwell.

THIS PAGE: Rockwell's alliance with Hoover, and their conspiring against Smith, doesn't end well.

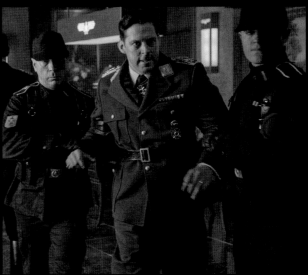

WILHELM GOERTZMANN

Wilhelm Goertzmann is a brash, self-assured man who summed up his own character in a single line in season four: "Everything I have, I've taken by strategy."

John Smith wonders what the young general's true agenda is and wants to get a better read on this potential new rival from Berlin. "He recognizes Goertzmann's skill and potential," says co-executive producer Julie Hebert. "He knows that this is a very dangerous man and that's why he tells him, 'We should get a drink.' It's so Smith can get the measure of him, so he can know what's going on."

Himmler likes Goertzmann's strategic skills but he relishes pitting his officers against each other. It's a strategy Adolf Hitler often employed to generate competition among his generals, and further solidify his power base. This is why Himmler undermines Smith's analysis of Japan's struggles with the BCR, to give Goertzmann (played by Marc Rissmann) the chance to toot his own battleground strategies. The obergruppenführer also makes pointed remarks to Smith about how the Berlin factions are still uneasy about having an American run North America.

In the end, Goertzmann conspires with Smith to pull off the Berlin coup, eliminate Himmler, and seize control of the Reich as führer.

BELOW: Goertzmann attends the dinner party at the Smiths' with the Himmlers.

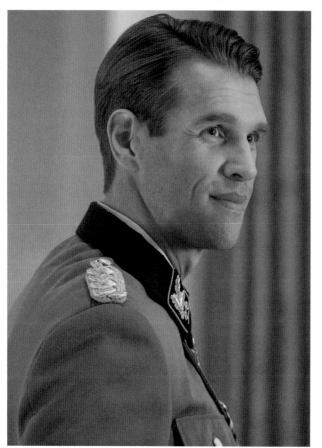

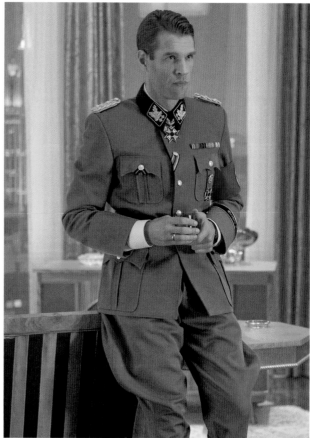

JOSEF MENGELE

Himmler is obsessed with reaching and conquering the alt-worlds, so he entrusts Dr. Josef Mengele (John Hans Tester) to spearhead the Die Nebenwelt project. One of our history's most notorious war criminals, Mengele in the High Castle world did not have to go into hiding in South America. Because the Nazis emerged victorious, he is able to continue the sadistic experiments he began in the concentration camps.

His focus now is successfully creating a quantum tunnel to allow travelers to move between worlds. He has very little regard for human life. For Mengele, the victims used for testing the viability of the portal are just another method for collecting scientific data.

"One of the things about the show that interested me is if the Nazis had won the war, who would have survived and who would have prospered?" wonders season three executive producer Eric Overmeyer. "And Mengele seemed like an interesting choice for a Nazi to come to America and lead this scientific endeavor. It was always tricky to not fall into cliché with the Nazis, to not glamorize them in some way. Thankfully, Rufus Sewell was very cognizant of that. Whenever we would stray into a Gestapo cliché, he would smell it out and save us from ourselves."

BELOW: Mengele was another of the creative teams 'what if?' characters taken from history.

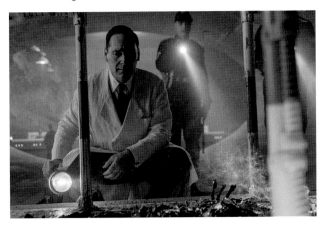

NO. 9 COALMINE

Nestled deep in the Poconos Mountains is the Lackawanna No. 9 coalmine. Located at the bottom of a valley, it is part of a massive and well-guarded Nazi compound with troops and tanks stationed by the entry points. This is the same mine where Juliana has seen the alt-world films showing her as one of the test subjects to go through the portal.

The exterior shots and the underground walking scenes were filmed in a mine north of Vancouver. "The mine seen on the show was a formerly operational mine, the former Britannia Mine," according to location manager Nicole Chartrand. Now a museum, it is designated as a National Historic Site of Canada.

THIS PAGE: The resistance searched for, surveiled, and ambushed the mine.

DIE NEBENWELT

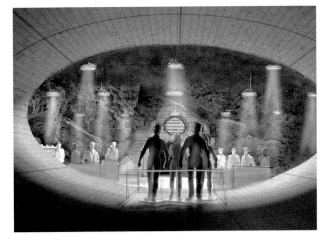

When Nazi scientists discovered the existence of travelers from alternate worlds, Die Nebenwelt, which translates in German to 'The Next World,' was born. Projekt 701, as it is classified, is led by Dr. Josef Mengele. The endgame is to create a quantum-tunneling portal to recreate the meditative means by which travelers are able to physically move between alt-worlds. The project hinges on the implementation of the concept known as the Many-Worlds Interpretation of Quantum Mechanics. This theory implies that all possible alternate histories and futures are real.

The laboratory where the Die Nebenwelt device is built was inside Mine No. 9 in the Poconos. There is a nearby electromagnetic 'anomaly,' a thin segment in the fabric of reality that makes breaching the alt-worlds possible. The device, when activated, emits powerful electro-magnetic waves, so keeping it underground is a way to contain massive damage should the device malfunction.

Drew Boughton and his production design team made all the consoles in the lab fully operational. All buttons and switches worked and the images seen on the monitors were tailored to the specific purpose of each bay. One peculiar design approach they took was to maintain a certain retro-analog aesthetic to the Nazis' advanced technology within the lab.

"Even though we had jet propulsion bullet trains, we still had things dialed back to pre-war style analog tech," notes producer Erin Smith. "The imagery we designed for the monitors inside the portal laboratory were high tech, but more like 1960s-type technology."

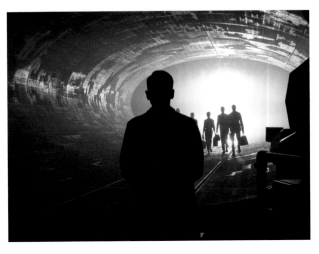

THIS PAGE: Concept art of the portal machine (top). Production photo of the final set (middle). A still of Nazi travelers returning home (bottom).

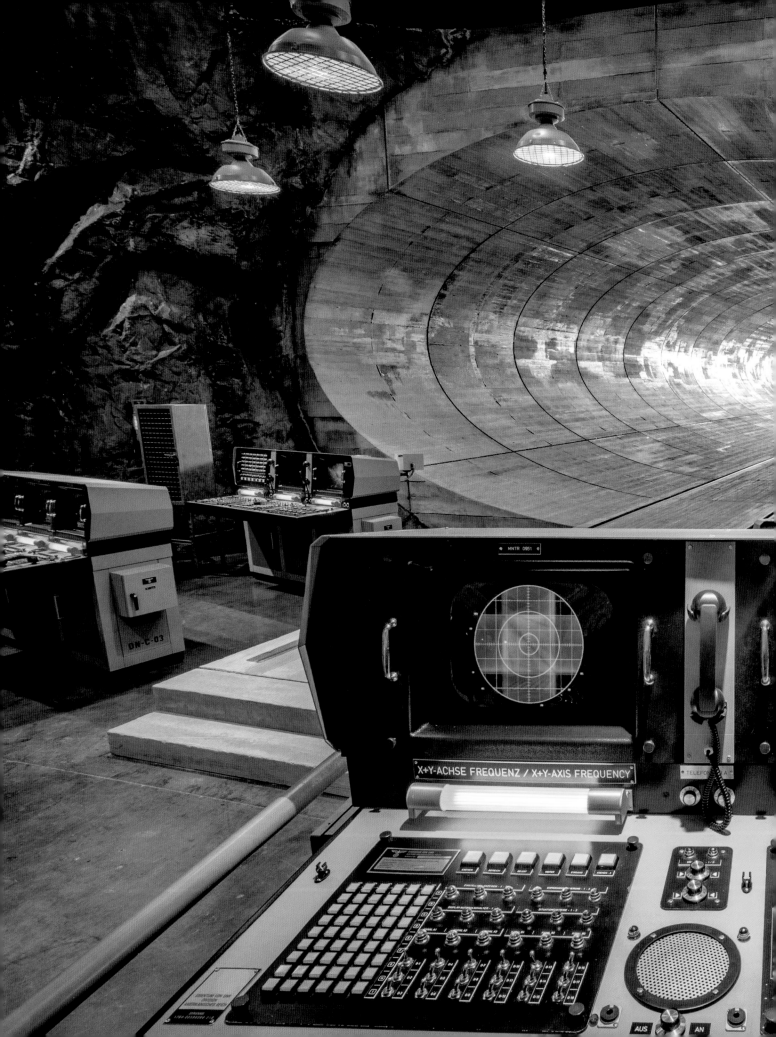

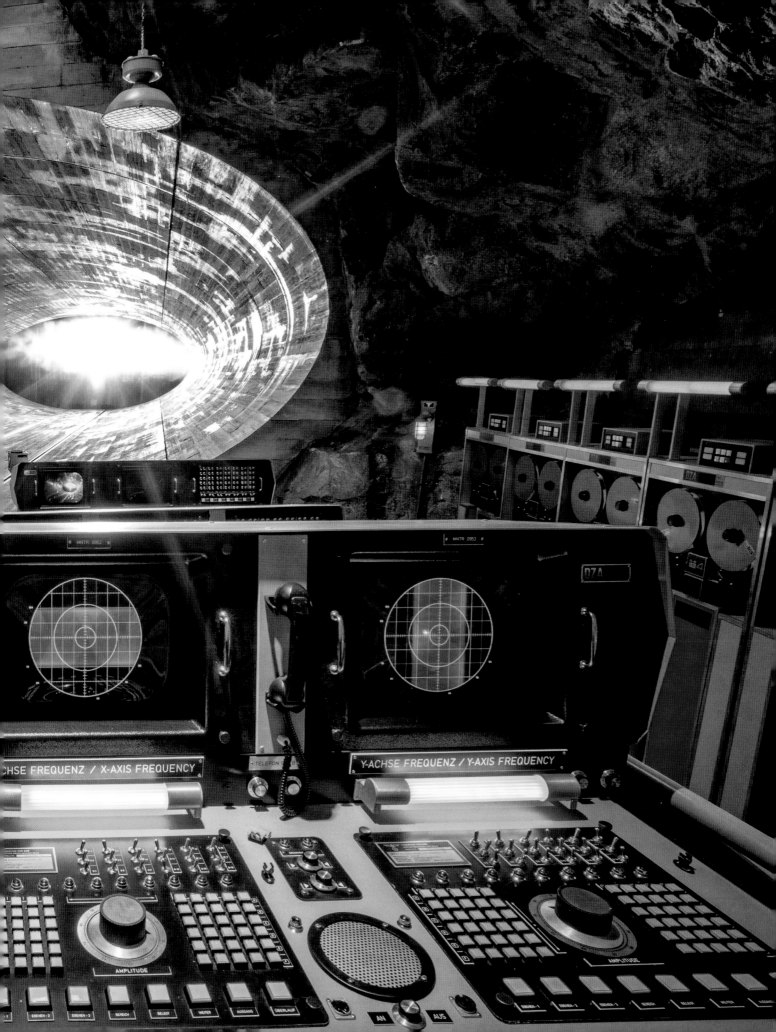

MULTIVERSE ROOM

The concept of exploring the multiverse comes from Philip K. Dick's unfinished sequel to his original novel.

"My father had started work on a sequel built around this notion of the Nazis discovering and breaking through into other universes," says executive producer Isa Dick Hackett. Although ultimately abandoned, Dick's story involved the portal and the idea that the Nazis would break through and be able to traverse the alternate realities. "As we planned season three, I said, 'I think we should use this material from these sequel chapters. It's a big idea," Hackett says. "And it advances what we've already done, and it fits together perfectly."

The multiverse room is inside an underground cavern of the Lackawanna coal mine. Large, 60s-era databanks flank rows of bulky computer monitors that face a long, wide-mouthed tunnel. It leads directly to the center of the 'anomaly' where access to the portal is possible. Everything seen onscreen in the multiverse room is an actual prop, with no added CGI visuals.

Production designer Drew Boughton based the design of the room on the reflective infinity mirror rooms done by an artist named Yayoi Kusama. "We had been discussing infinity physics when somebody pulled up a reference photo of one of her installations," remembers Boughton. He used a miniature 3D model along with mirrors and action figures to figure out how to shoot an all-mirror box without having the camera crew seen in the reflection.

The answer? An entire wall was built as a two-way mirror.

BELOW AND RIGHT: Stills of Mengele, Smith, and Abendsen inside the multiverse room.

BELOW: Concept sketches and artist manikins of the production design for the set.

THE DISTRICT OF CONTAMINATION

The deathblow struck by the Nazis during World War II was the nuclear destruction of Washington, D.C.

"The Nazis bombed Washington and once that happened, the Americans surrendered," explains Drew Boughton, who adds that it was meant to evoke the real-life atomic devastation of Hiroshima in 1945. The Reich chose to supervise their new colony from New York City. Washington, D.C. became known as the District of Contamination.

We see it for the first time in season four during a haunting scene that director Rachel Leiterman sees as a defining moment for Juliana Crain. "[When Juliana returns] I think that moment is one of immense hope and sadness for her," says Leiterman. "I think it's also the beginning of her knowing that she needs to go and make a change in the world."

The Capitol building sits damaged in the background, the Washington Monument has been toppled, and the Lincoln Memorial is destroyed. The sequence required months of coordination for realism and historical accuracy.

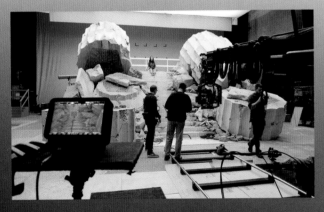

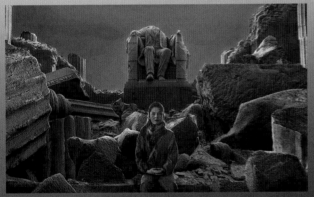

ABOVE LEFT: Setting up the green screen of Lincoln's Memorial.
BELOW AND ABOVE RIGHT: Concept art of the District of Contamination.

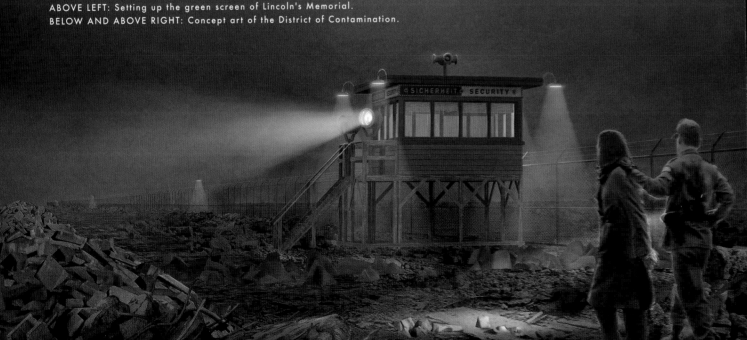

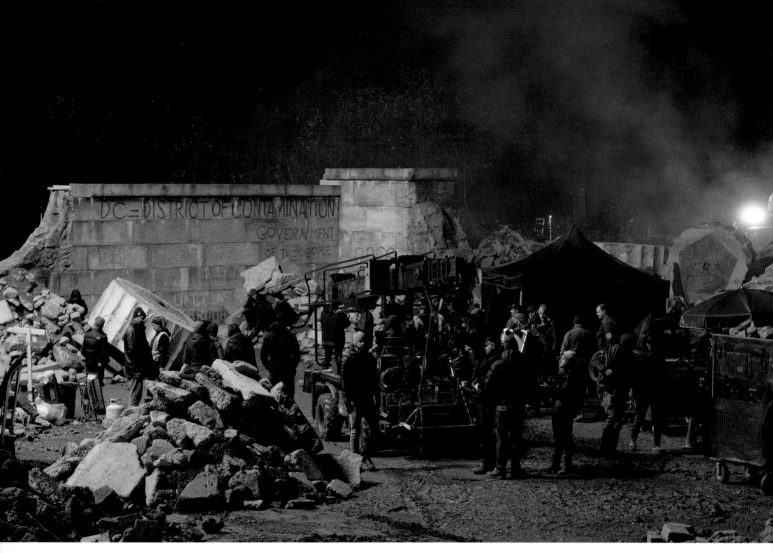

THIS PAGE: Behind-the-scenes on the District of Contamination set.

"It's a combination of both a CG environment, CG buildings, and elements like overturned cars, rubble... and we put in additional digital matte painting elements to sweeten the shot," says visual effects supervisor Lawson Deming.

Deming examined archival photos to create a digital matte painting of the Washington Mall of the mid-1940s. He also went to Washington D.C. to capture plate photography. "We brought a second unit camera operator to shoot elements in the actual Lincoln Memorial, which we did overnight," he says. "We created a fully-CGI version of the destroyed memorial from illustrations the art department had done, as well as of a decapitated Lincoln statue."

Julie Hebert, co-executive producer/writer, says the District of Contamination remains a wasteland by design. "The Nazis keep it that way. They keep it as a symbol of their destruction of the United States," Hebert observes. "It was the killing blow in the war and they have kept it largely as the symbol of their domination, without cleaning it up."

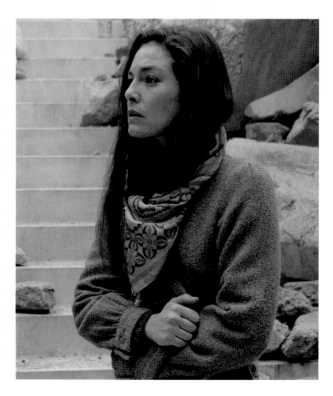

ZINA PARKS

In our world, the survivors of the 1945 Hiroshima and Nagasaki atomic bombings were left with physical and emotional scars. In the High Castle reality, Zina Parks (Nicole Oliver) survived the Nazis' nuclear destruction of Washington, D.C. In the aftermath, the Nazis took her husband Saul away because his Romanian blood made him 'impure.' While most people left, Zina stayed behind. Her bakery opens every morning at 7 a.m. The signs of radiation poisoning are on her face and body, evidence of the bomb shelter she and Saul began but couldn't finish to protect themselves from the detonation.

Zina is part of the resistance cell in the District of Contamination. The first time she meets Juliana Crain, she helps her avoid detection by Nazi patrols. She hides her in the bakery's secret room. At first she isn't sure if she believed Juliana, but this woman carrying a five-dollar bill with Abraham Lincoln's face (a remnant from her visit to the alt-world) and vivid descriptions of a reality where FDR lived and America won the war, reawakens something within Zina she hasn't felt in a long time: hope.

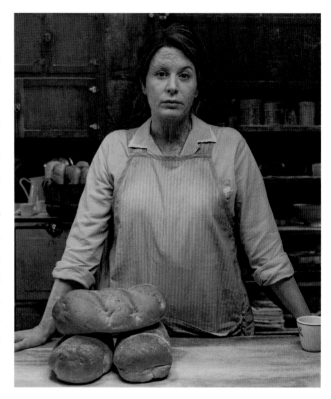

THIS PAGE: Zina helps the resistance and lets them use her back room for meetings and storage.

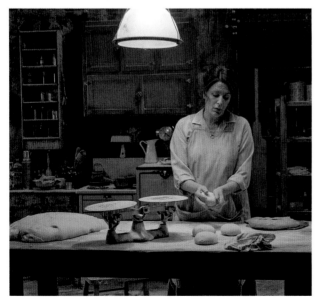

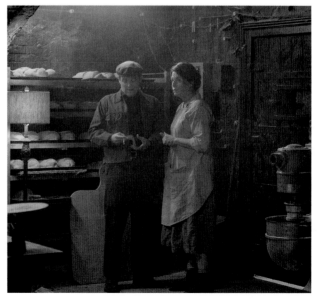

ZINA'S BAKERY

Zina's Bakery is a decaying mom-and-pop store in the District of Contamination. When Juliana winds up there as she tries to escape detection, Zina Parks initially eyes her with suspicion. But when it becomes clear she's hiding from the Reich, Juliana realizes she's found a safe place. "The people that survived the nuclear bomb who stayed in the District of Contamination are part of the resistance network underground," says co-executive producer Julie Hebert. "These people like Zina who are there,

they lost their families. They stayed because they had nowhere else to go."

The bakery basement is the meeting place of the D.C. cell of the resistance. It's where Juliana and Wyatt reunite after being separated during the botched mission in Mine No. 9. At a strategy meeting at the bakery, Juliana notifies the other resistance members that Helen Smith may be the key to gaining access to John Smith.

BELOW: Concept art of the interior and exteriors of the bakery.

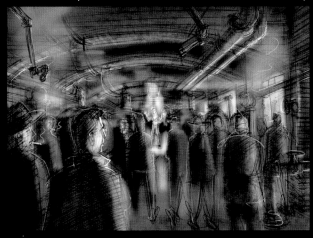

BELOW: Production still showing the industrial decor on this set.

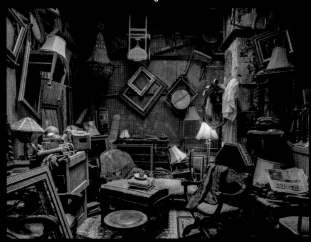
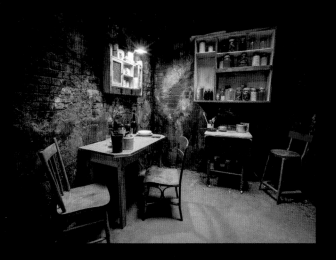

HARLEM SAFE HOUSE

When Juliana and Wyatt return to New York City to re-connect with the resistance, they go uptown to the Harlem Exclusion Zone to lay low and avoid detection by the Reich.

Harlem has been a ghost town since 1949, so Nazi forces rarely do patrols above 116th Street.

The safe house where Richie takes them has minimal light only because the resistance siphons some electricity from the Nazi power grid. Juliana notices family photos and heirlooms on the wall. "Lot of ghosts in this place," she says, aware that whoever lived here had to leave in a hurry. Wyatt notices something else: bloodstains on the rug, still dark even after so many years.

"These people put up a fight," Juliana observes. A photo inside a bible identifies the couple who lived here. Lucille and Warren Huggins, married June 19, 1933. This was someone's home before the world changed. It was their home.

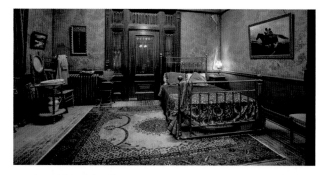

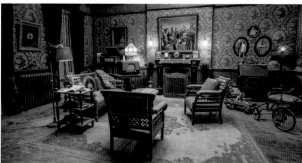

ABOVE: The details provided by the production design team painted a vivid picture of the previous residents of the home.

BELOW: Concept art of the safe house.

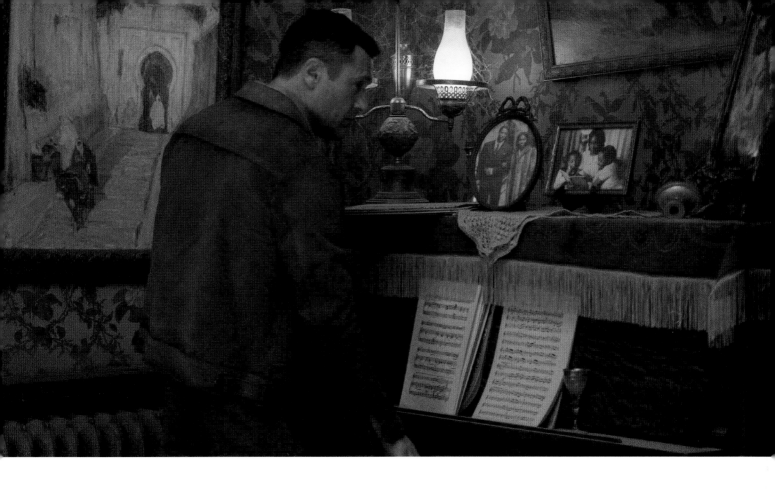

BELOW: Final stills from on set (top) and early sketches of the safe house (bottom).

ALTERNATE WORLDS

TAGOMI'S HOME

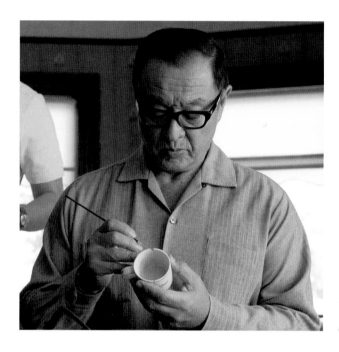

Tagomi's visit to the alt-world is a jarring experience for him. In this world, he is estranged from his family. "He's a stranger in his own home," notes set decorator Lisa Lancaster. That sense of isolation contrasts with the more vivid style of this house.

"The colors are a little different here [than in the High Castle reality]. They are the blues and greens of our real-life 1962. It was quite a happy house, the location itself. It had vibrant wallpaper," according to Lancaster.

Aside from the warmer color palette and subtle but noticeable changes in architecture, music helps capture the proper mood of the alt-world visits. "Especially with Tagomi's travels, I wanted to create the mood of not being at home," says composer Dominic Lewis. "I wanted to make San Francisco in the alt-world seem strangely familiar. I used Asian influences like bells so it's oddly familiar to Tagomi, but still odd and strange to him."

THIS PAGE: Traveling to this alternate world gives Tagomi the chance to reunite with his late family.

ABOVE: Production still of the exterior of Tagomi's alt-world home.

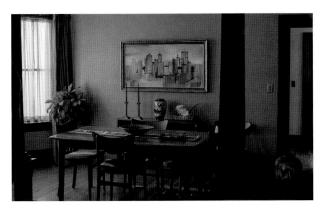

ABOVE: Tagomi tries to make amends on behalf of his alternate self and mending the broken cup was just one act.

ABOVE: The Tagomis' living room was used as a meeting place for Nori and Juliana's protestors.

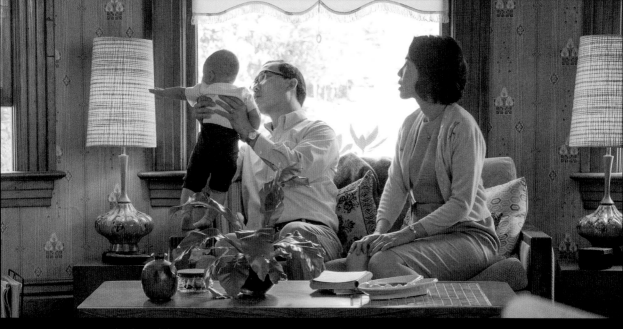

THIS PAGE: Meeting with Alt-Michiko gives Tagomi some realizations about his own marriage.

In the alt-world, Michiko Tagomi is alive and harbors deep resentment toward her husband, Nobusuke Tagomi. In that reality, the trade minister is a drunk thought to have abandoned his family. Michiko (played by Yukari Komatsu) wants to divorce him. Tagomi spends much time trying to make whatever amends he can.

In doing so, he seems to understand that in his reality, the High Castle timeline, his late wife likely felt similar feelings of abandonment. She spent years essentially as a single mother in Japan while Tagomi worked for the government. In the alt-reality, Michiko struggles to verbalize her feelings toward her estranged husband. But, she notices over time that he seems a changed man, a kinder man. When he tells her he must leave, Michiko understands it is likely the last time they will see each other. She straightens his tie and smooths his lapel in an act that seems to signify she has forgiven him.

NORIYUKI TAGOMI

Like his mother, Noriyuki Tagomi (actor Eddie Shin) has all but cut his father out of his life when he mysteriously returns. His reappearance leaves Nori feeling conflicted. He clearly loves his father, but is angry over his mistreatment of his mother. This alt-world Tagomi also did not approve of Nori marrying an American, but when Tagomi arrives and sees Juliana, they start to form a bond.

The alt-world Tagomi accidentally hurt his own grandchild in a fit of drunken rage.

Because Tagomi is able to travel to this world, it is quite likely the parallel reality's Tagomi committed suicide after the incident with his grandson. Before he returns to his world with the film reel, Tagomi re-connects with Nori. His son lets Tagomi hold his grandson again, and the trade minister seems truly happy for the first time in a very long while.

THIS PAGE: Alt-Nori's strained relationship with his father is partially healed when Tagomi traveled to this reality.

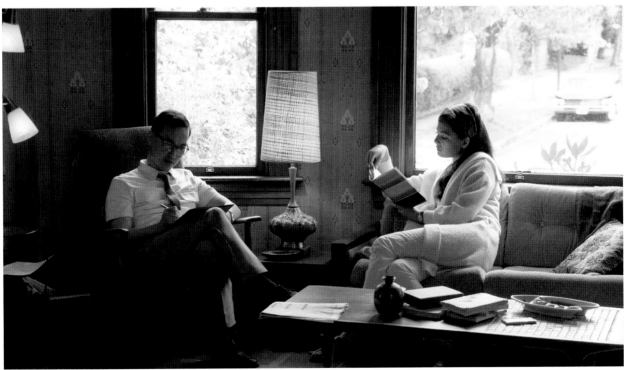

TRUDY WALKER

Alt-Trudy Walker comes from a parallel world where the Nazis dropped an atomic bomb on San Francisco..

Trudy's grief and trauma over the death of her father triggered her ability to travel between worlds. That sense of loss is necessary to be able to jump to an alt-world. Travelers can't choose the world they go to; they are drawn to where they are needed, or can serve a purpose. Because Trudy in the High Castle reality had been killed by the Kempeitai, her parallel version was able to be enter that world… with the film showing Trudy's father George Dixon and Frank Frink being executed by Joe Blake.

BELOW: Alt-Trudy struggled to return to her own reality and it wasn't till she met with Tagomi that she could travel back.

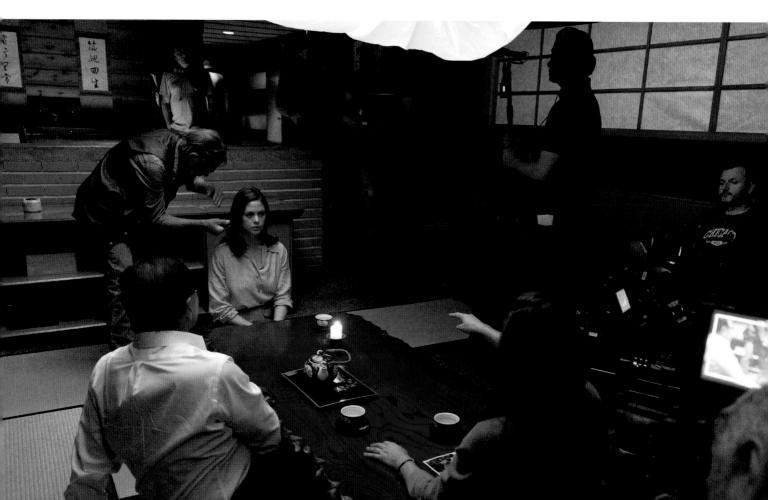

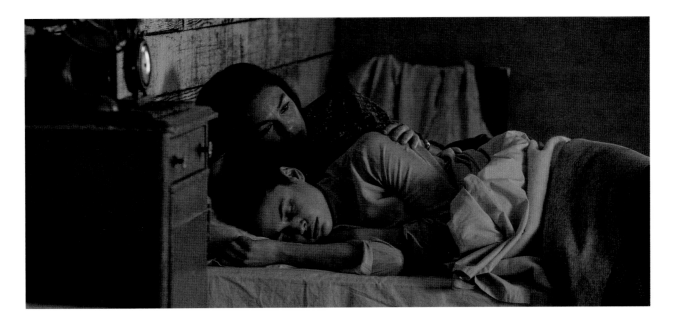

THIS PAGE: Trudy on the Abendsens' farm (top and above) and meeting Wyatt with Juliana (above right).

She connects with members of the resistance, who then lead her to Hawthorne Abendsen. Alt-Trudy and Juliana bond during their time hiding out at the Abendsens' farmhouse. But after six months of being in this reality, it is clear there was something wrong with her. At first, Hawthorne thinks it is just a type of anxiety he had noticed with other travelers he had met. But Caroline notices this is different. Trudy gets high fevers, she is confused about what reality she is in, and even more concerning, she isn't able to travel back to her world.

Caroline theorizes that the sibling connection between Trudy and Juliana is preventing her from going back to her world. Almost as if, subconsciously, she isn't ready to go back. After the sisters kill the Nazi agents who tried to kidnap the Abendsens, they flee to Denver. In their hotel room, Juliana reveals to Trudy that in this world, she killed her father, George Dixon. Her sister puts her at ease, explaining that Hawthorne had explained what happened and the reason why Juliana did what she did. The sisters' bond is as strong as ever now.

Together, they return to San Francisco, and reconnect with Tagomi. With his help — and possibly due, in part, to the unexplained spiritual link that binds Tagomi and Juliana — alt-Trudy is able to refocus and return to her world.

LOCATION

BAILEY'S CROSSROADS

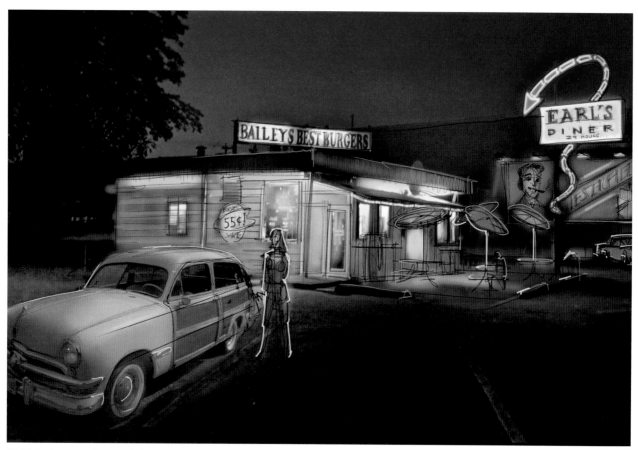

ABOVE: Concept design of the Bailey's Crossroads diner.

Bailey's Crossroads is the primary new location introduced in season four. It's the small town in alt-world Virginia that Juliana travels to after being shot by John. The scenic community provides the necessary contrast for the alt-Smith family who live here.

The real-life location that doubled for Bailey's Crossroads is the historic village of Clayburn in the Central Fraser Valley in British Columbia. It sits at the foot of Sumas Mountain, whose deposits of high-grade clay turned Clayburn into a major brickmaking location. About half the structures in town were built with locally sourced bricks, providing a taste of Americana the show's

producers wanted to infuse these alt-world scenes with.

"The village fit well for the Rockwell-esque atmosphere of the scenes set in the alt-world in the final season," says Jonathan Lancaster. There is a diner the locals visit in the show named the Lucky Run. It's where Juliana goes for morning coffee and to make small talk with Russ Gilmore. The Majestic movie house is the theater where she watches movies like *Judgment At Nuremberg*, which never existed in her world.

The community hall that Juliana calls home for the year she stayed in the alt-world also provides the location for the Aikido and meditation classes she teaches.

THIS PAGE: The community hall within Bailey's Crossroads where Juliana teaches Thomas aikido.

Bailey's
COMMUNITY HALL
———
OFFICE HOURS
MONDAY TO FRIDAY
9AM TO 4PM
SATURDAY 10AM TO 4PM
CLOSED SUNDAYS

THE SCUPPER

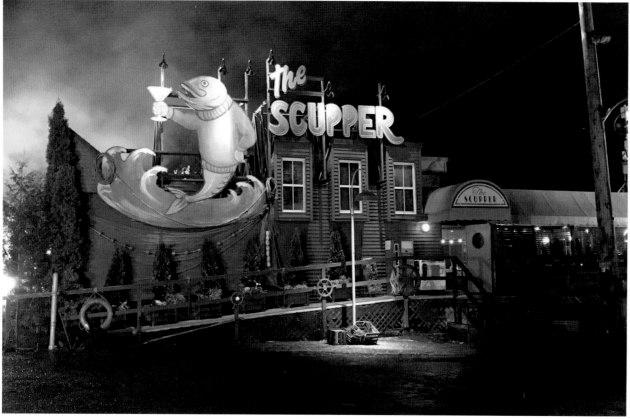

ABOVE: Final production still of the exterior set shows how detailed the opposite concept design was.

The Scupper Roadhouse is the community gathering place for people who live in this cozy, tight-knit community in the alt-world. "It's the neighborhood bar where the locals go after a long work day to enjoy a frosty beverage," says Jonathan Lancaster.

The drinks and dancing go hand-in-hand at the Scupper, which was shot on location at the tiny seaside town of Horseshoe Bay in West Vancouver. Juliana and Russ spend ample time there, as do the Smiths. Juliana's strange but close relationship with the Smiths of the alt-world mean they spend a lot of time together socially.

The nautical design of the bar is appropriately kitschy for the 1960s of the alt-world, which closely resembles the real-life era. The Scupper has much more color than say, the Grand Palace in the Neutral Zone, so certain creative choices were made to maintain stylistic differences between this world and the High Castle reality.

"It's always tricky introducing the right colors into any of the locations in the alt-worlds, so people see right away this is not the High Castle world," says Lisa Lancaster. "We put atomic top umbrellas, sun umbrellas on the patio. They're reproductions of one we found in Florida and had flown up to Vancouver. We added artwork on the walls and postcards near the bottom of the bar to make it appear as friendly and inviting as possible."

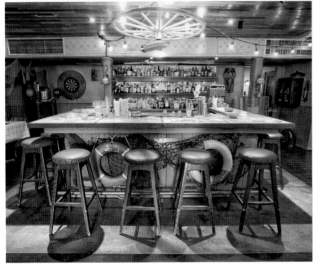

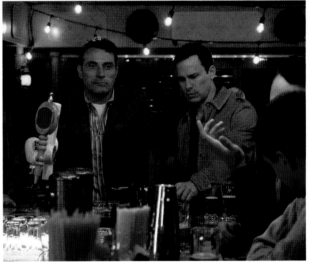

ABOVE: The nautical-themed bar as a concept (top) and a final still (bottom).

ABOVE: Alt-Smith and Russ in conversation at the bar.

BELOW: Juliana and alt-Smith dancing together, in concept.

THE SMITHS' HOME

ABOVE: The Stars and Stripes American flag would have meant an arrest, or worse, in Smith's own reality.

The Smith family in the alt-reality lives in a modest home in Bailey's Crossroads. It is predictably all-American in design and décor, with a front porch and an American flag displayed proudly.

"You have to remember, in this reality [John Smith] is a salesman. He's doing alright, but he's obviously not as affluent as a Reich leader," says Lisa Lancaster. "His home in this alternate reality reflects that." A postwar Norman Rockwell influence is apparent in many of the alt-world elements in season four. As Lancaster says, "It looks really nice from the outside, but there was probably something sinister if you peeled back the layers just a little."

Finding period-accurate furniture that didn't appear very expensive involved patience and digging through countless vintage stores, which the Lancasters say is always a fun aspect of their job. "Everything in that house was real, from the toasters and blenders to the hair curlers. There were no knockoffs," says Jonathan Lancaster.

"We have to be very careful with every piece of set dressing we use. We do lots of research, and we walk through it all [before filming], right down to opening the cupboards and making sure everything inside is accurate and consistent, just in case the actors open them up."

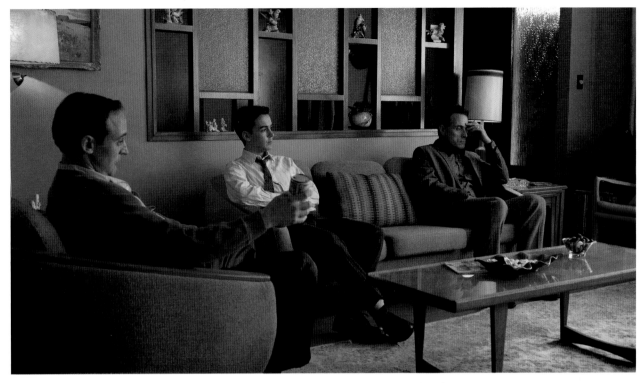

THIS PAGE: In his alternate home, Smith must recognize the wrongs he has committed in the past.

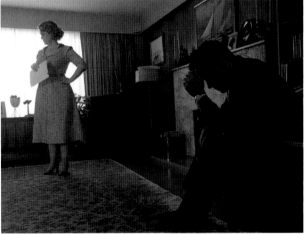

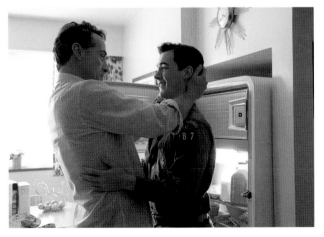

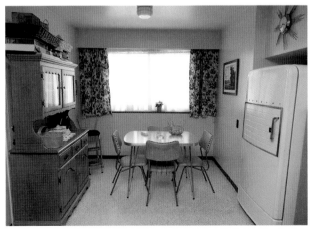

CAMPBELL

Agent Campbell (Cody Ray Thompson) is part of a squad of Nazi operatives traveling through the portal inside Mine No. 9 in the Poconos Mountains to do reconnaissance in the alt-world. They gather scientific data and military strategy that could help the Nazis form their invasion plan. Unbeknownst to the others at Die Nebenwelt, Campbell has a secret mission to accomplish while he travels: Surveillance on John Smith in the alt-world.

It is through Campbell that Smith learns he is a traveling salesman in the other reality. He learns his only child, his son Thomas, is perfectly healthy. Campbell is also sent to kill Juliana Crain in the alt-world, but inadvertently kills the alt-Smith instead during the botched assassination.

Entrusting such sensitive operations to a low-ranking operative seems uncharacteristic for Smith, but season four co-showrunner David Scarpa says Smith always has a contingency plan. "Smith has leverage on this guy," says Scarpa, hinting that the Reich leader had secured useful information to assure Campbell's discretion. "It's not really a matter of trust because he knows he has control over him."

Co-executive producer Kalen Egan agrees that Smith views mentorship as a good way to guarantee loyalty. "This seemed true of [Erich] Raeder and Joe, and is most likely true of Campbell as well," Egan notes. "He always keeps insurance."

That is why Smith is secure in trusting Campbell to aid in his unauthorized visit to the alt-world and keeping it a secret. "For Smith, this is a massive leap of faith, and something he wouldn't do unless he was absolutely sure that Campbell would never reveal this secret," adds Egan. "And from Campbell's point of view, I'm sure he saw the relationship as a hugely valuable and honorable opportunity to elevate his standing within the American Nazi party."

> ## "I'M SURE HE SAW THE RELATIONSHIP AS A HUGELY VALUABLE AND HONORABLE OPPORTUNITY"
> ### KALEN EGAN
> *CO-EXECUTIVE PRODUCER*

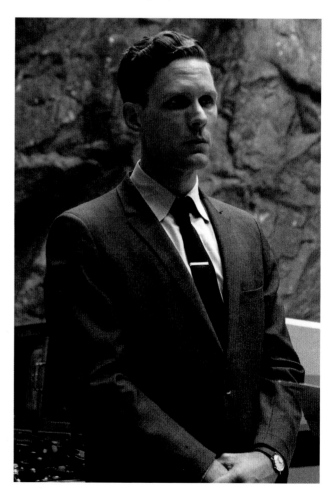

THIS SPREAD: Campbell's surveillance mission is how Smith finds out where Juliana is hiding.

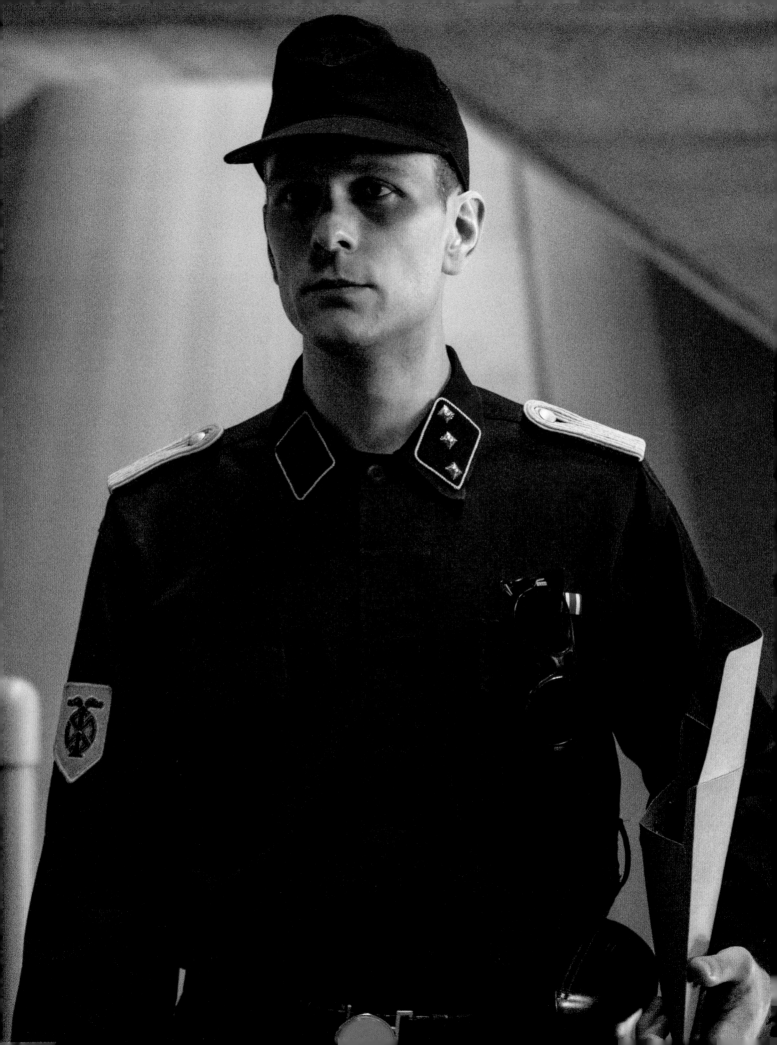

ACKNOWLEDGMENTS
MIKE AVILA

The author would like to thank Isa Dick Hackett for her invaluable help in bringing this project to fruition. To the entire cast and crew, my sincere thanks for your accessibility, insight, and honesty. Your passion for the show shined through in every interview. Thank you as well to Dan Percival and Lisa and Jonathan Lancaster for their accessibility, Nicole Chartrand for her patience with my endless follow-ups, Kalen Egan for countless extra details offered, and a special tip of the cap to Drew Boughton for not blocking my numerous phone calls to confirm yet another crucial detail.

This book couldn't have happened without the tireless work of Jamie Kampel and Mike Mera at Amazon, who overcame endless logistical hurdles and wrangled a huge group of actors and production personnel for interviews. To my Titan editor Ellie Stores, my eternal gratitude for your flexibility and guidance as this book came together. Thank you to the talented designers, Natasha MacKenzie and Tim Scrivens, for their stunning work on the book.

Thanks to my mom Luisa Avila for instilling in me, very early in life, a love and thirst for reading, especially with regards to history. Much love to my wife Cindi for her patience with my nocturnal writing habits. And to Alexia and Talia, thanks for being my inspiration and for actually being impressed by the fact Daddy is writing a book.